THE WATERCOLOR BOOK

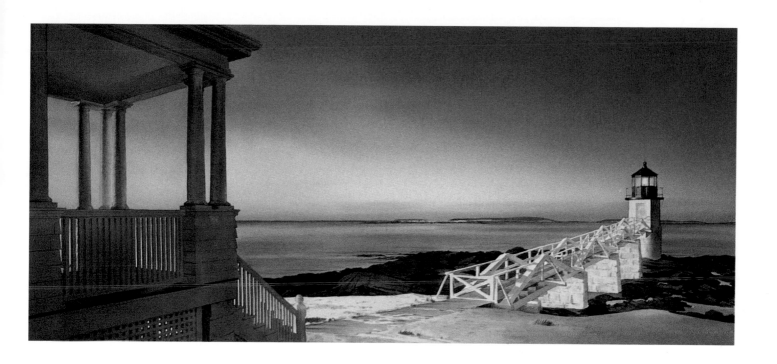

THE WATERCOLOR BOOK

Materials and Techniques for Today's Artist

DAVID DEWEY

Watson-Guptill Publications/New York

Art on page 1:
David Dewey, SUNRISE, MARSHALL'S POINT LIGHT.
Watercolor on paper, 27 × 60" (68.6 × 152.4 cm).

Art on page 5:
David Dewey, STILL LIFE.
Watercolor on paper, 4 1/2 × 7 1/2" (11.4 × 19.1 cm).

First published in 1995 in the United States by Watson-Guptill Publications,
a division of BPI Communications, Inc., 1515 Broadway, New York, N.Y. 10036.

Library of Congress Cataloging-in-Publication Data

Dewey, David.
 The watercolor book : materials and techniques for today's artist
/ David Dewey.
 p. cm.
 Includes index.
 ISBN 0-8230-5641-4
 1. Watercolor painting—Technique. 2. Artists' materials.
 I. Title.
ND2420.D49 1995
751.42'2—dc20
 95-17281
 CIP

Manufactured in Singapore

First printing, 1995

2 3 4 5 6 7 8 / 02 01 00 99 98 97 96

*This book would not have been completed
without the assistance, generosity, and support
of individuals who deserve considerable thanks
and credit. First, great appreciation is extended
to Candace Raney, Marian Appellof, Areta
Buk, Ellen Greene and the rest of the staff at
Watson-Guptill for their extraordinary efforts
and skill in assembling and getting the book into
print. A special thanks to Marian for her superb
editorial skill and insights.*

*The book did not come without a lot of
research and long hours on the computer. I'm
grateful to my friends Patricia Leaman and
Connie Godleski for their generous assistance.
I also want to extend thanks to John Bean of
New York Central Art Supply for sharing his
knowledge of art materials and also for
providing many of the materials photographed
for the book.*

*Many well-known contemporary artists
and former students generously contributed ideas
and paintings to the book, additions that can
only help deepen the reader's understanding of the
watercolor medium. I am most appreciative of
their contributions. Much of the work that went
into developing what I have presented here was
generated by my students' diligent efforts in the
studio and in my workshops. They have been of
great assistance in helping me craft my ideas and
bring them into shape. I can't thank them enough.*

*Finally, without a doubt my good friend
and wife, Kathy, deserves the most credit for her
support and patience during those long, hard,
and intense months of writing and illustrating.
Thank you, Kathy.*

This book is dedicated to my father and brother, Charles F. Dewey and Ronald C. Dewey, whose support I will always cherish and friendship I will always miss.

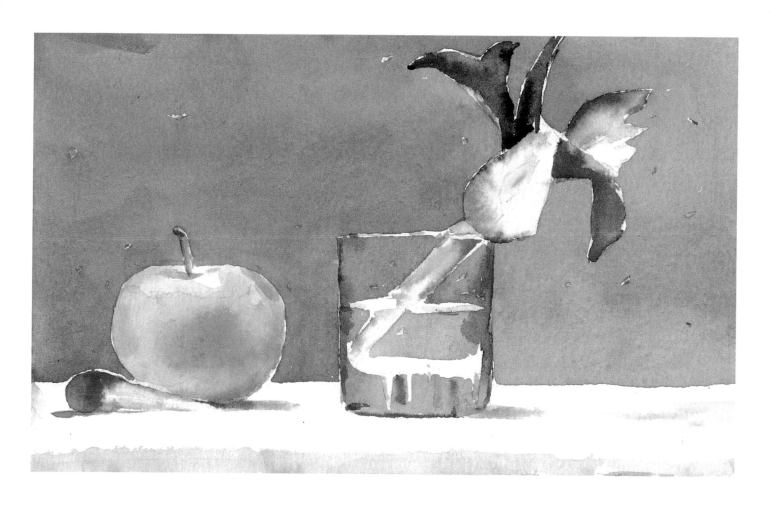

CONTENTS

FOREWORD

Equilibrium prevailed in the American art world of the late 1970s, but with the advent of the 1980s came a series of shocks that revitalized the field of watercolor. These shocks included technical advances in watercolor papers, the new perception that watercolor could be considered a master medium, and the maturing of new art markets in this country.

David Dewey is the artist with whom I have had the longest business association. By 1980 his aesthetic direction had come into focus. Given the growing interest in watercolor, it seemed somehow natural to suggest to him that he concentrate solely on that medium. What had been intimate and personal in his hands expanded naturally into masterful large-scale compositions fresh with light and brimming with the clarity that is the standout feature of watercolor. In show after show of his work, the novelty of his choices of subject matter and his expanding repertoire brought him an ever-growing audience. Coincidentally, he has been an ideal teacher of watercolor technique.

This volume, which has occupied the artist for over a year, is a fresh and forward-looking presentation of contemporary watercolor. Dewey informs and explains the latest technical advances in materials and gives artists the best possible guide to making paintings for new generations of collectors.

Peter A. Tatistcheff

Tatistcheff & Company, Inc.
New York, New York

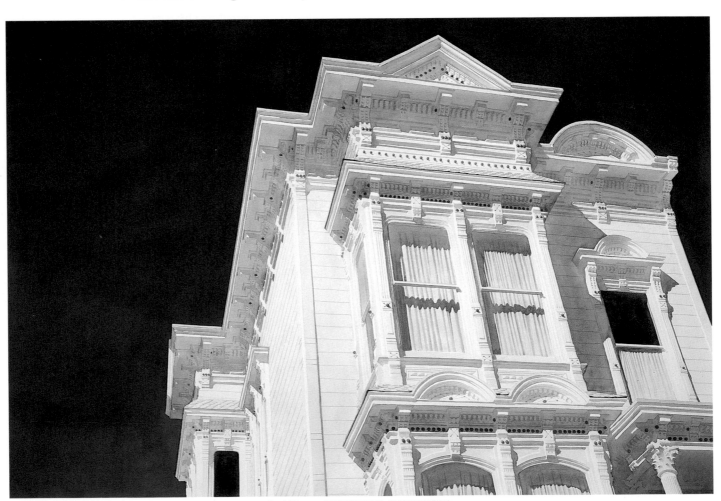

David Dewey, WHITE HOUSE, OUTER MARINA.
Watercolor on paper,
40 × 60" (101.6 × 152.4 cm), 1986.
Collection of Susann Kelly.
Photo courtesy Tatistcheff Gallery, New York City.

INTRODUCTION

Watercolor is a medium of beguiling ironies. It takes great skill to control, yet must appear to be free of control. Physically it needs room to move easily, but without running away. Painting in watercolor requires a disciplined approach that at the same time does not stifle the results. You might compare the experience of applying a watercolor wash to that of throwing a ball a long distance and being there, perhaps a little out of breath, to catch it just at the right time.

In attempting to master this uniquely diverse medium, you must first become acquainted with its tools and techniques, and then practice what you have learned over and over again. In that spirit, *The Watercolor Book* offers readers a complete, up-to-date array of the watercolor materials currently on the market and the painting methods in use among today's watercolorists. But achieving creative success with any artistic medium requires more than technical knowledge and proficiency; visual skills are also necessary, and you must hone them constantly. As a visual artist, I have learned much and grown to understand my craft more fully by studying good pictures. To look at art with discerning eyes is to deepen your comprehension of what makes it work as a means for expression. For that reason, in addition to my own work I have included in the book paintings by various past masters, contemporaries, and students who have profoundly influenced me.

Addressed in this book are the major considerations vital to constructing successful watercolor paintings:

1. *Materials and tools.* The paints, brushes, papers, and other accoutrements of the medium.
2. *Techniques.* Traditional methods as well as innovative ones for handling paint in ways that facilitate visual expression.
3. *Color, design, and composition.* The basic vocabulary of visual language that makes it possible to respond to what is felt and give form to what is seen in the mind's eye.
4. *Subject matter.* Imagery the artist chooses to depict using watercolor's unique expressive possibilities.
5. *Assimilation.* The merging of all of the above with artistic intuition and personal vision to form a cohesive whole.

For the serious student of watercolor, this book is an invaluable resource that I hope will lead to a greater command of and appreciation for the medium.

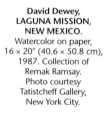

**David Dewey,
LAGUNA MISSION,
NEW MEXICO.**
Watercolor on paper,
16 × 20" (40.6 × 50.8 cm),
1987. Collection of
Remak Ramsay.
Photo courtesy
Tatistcheff Gallery,
New York City.

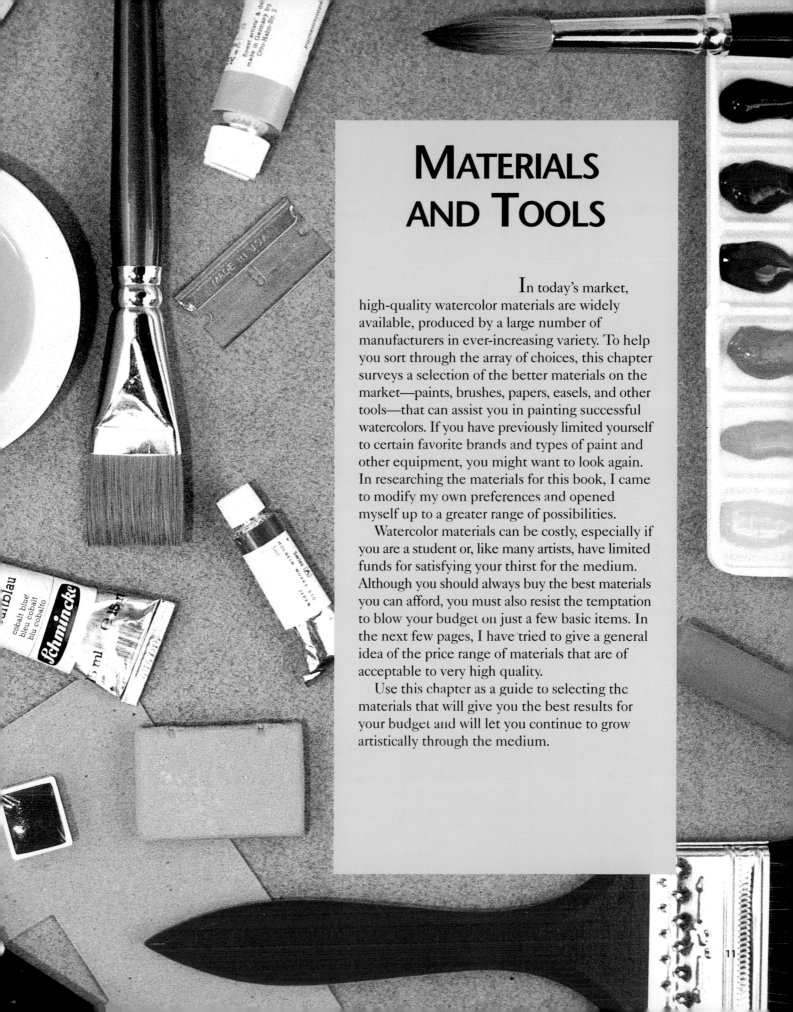

MATERIALS AND TOOLS

In today's market, high-quality watercolor materials are widely available, produced by a large number of manufacturers in ever-increasing variety. To help you sort through the array of choices, this chapter surveys a selection of the better materials on the market—paints, brushes, papers, easels, and other tools—that can assist you in painting successful watercolors. If you have previously limited yourself to certain favorite brands and types of paint and other equipment, you might want to look again. In researching the materials for this book, I came to modify my own preferences and opened myself up to a greater range of possibilities.

Watercolor materials can be costly, especially if you are a student or, like many artists, have limited funds for satisfying your thirst for the medium. Although you should always buy the best materials you can afford, you must also resist the temptation to blow your budget on just a few basic items. In the next few pages, I have tried to give a general idea of the price range of materials that are of acceptable to very high quality.

Use this chapter as a guide to selecting the materials that will give you the best results for your budget and will let you continue to grow artistically through the medium.

WATERCOLOR PAINTS

The flowering of watercolor as a medium in England from the late 18th to early 19th century resulted in three types of watercolor paints that are still in use today: dry cakes, or "pans," which came first; semimoist pans; and moist tube colors. Developed in the late 18th century by the manufacturer Colourman, dry pans were an improvement over the hand-ground, very inconsistently prepared pigments artists had been using previously. Colourman's paints were dry natural pigments pressed into hard cakes that needed to be "rubbed up," or moistened, usually with a finger, in preparation for creating washes of color.

Moist pan colors were introduced by the French in the mid–19th century. Ample proportions of glucose and glycerin were added to pigments to make paints with a soft-firm consistency that allowed the artist a greater capacity for mixing richly activated color washes. Through much of the rest of the 19th century, these sugary-based paints became preferred to the dry pan colors, although today they are not in common use. A few manufacturers still produce them, however, notably the Russian firm Yarka, whose watercolors are exclusively the semimoist type made in the French tradition.

Tubes of moist paints were introduced by Winsor & Newton in the middle of the 19th century, an innovation that gave artists immediate and satisfying access to full-strength color. Because of their oozy softness, these moist pigments were likened to oil paints and, in fact, were often extended with body color (gouache) and used as such, particularly by studio painters seeking to duplicate the look of oil paintings with this much faster-drying, water-based medium.

The popularity of moist colors pushed dry pans almost to extinction until the late 19th and early 20th centuries, when interest in them was revived by such American masters as Winslow Homer. Today dry pan paints are widely available and come in half- and full-pan sizes; colors are sold both individually and in portable kits made of plastic or enameled tin that are well suited for traveling and painting on location. (Winsor & Newton's black tin pan kits are practically the same as they were back in the 19th century when they first appeared; Homer's was one of these.) Moist paints are supplied in tubes whose capacity is measured in milliliters, with most manufacturers offering small (5ml) and medium-size (14–16ml) tubes and sometimes large (37ml) studio-size tubes. Like pan paints, tubes are also available individually or in sets.

Early English watercolor paints were often lacking in permanence, and colors faded badly in many cases. In response to the furor over this problem, Charles Field, an English chemist and colorist, published a landmark book entitled *Chromatography*, in which he analyzed these paints in terms of permanency. His study set in motion the practice of evaluating the durability of watercolor pigments, a tradition embodied today by the American Society for Testing and Materials (ASTM), whose ratings for lightfastness, health standards, and other pigment qualities are printed on the labels of most brands of paint (though unfortunately, the type is often so small as to be virtually unreadable). Nowadays all paint manufacturers put their paints through rigorous testing to ensure reliability, so artists have much less to fear than they once did.

Transparent watercolor paints basically consist of pigment (natural or synthetic) suspended in a binder of gum arabic with (usually) glycerin added as a wetting agent. The name of the color listed on the paint label is usually its common name, generally derived from the name of the pigment in the formula. Cadmium red, for example, is made from the metal cadmium. Sometimes a manufacturer assigns its own trade name to a color: Thalo blue and Winsor blue, for example, are, respectively, Grumbacher's and Winsor & Newton's trade names for phthalocyanine (phthalo) blue. If a trade name is used, the common pigment name should appear in smaller print on the tube or pan. When you're buying paints, stay with common names when possible; trade names are strictly the result of competition in the market.

Some color names are followed by the word *hue*, which indicates that the paint is made with an imitation of the genuine pigment. This means it is of lesser, though not necessarily poor, quality and accounts for a lower price. Imitation pigments are mostly used in second- and student-grade paints. Although their generally lower cost may lead you to choose some of these over the genuine article, you don't necessarily have to resort to substitutes. In today's market there are artists'-quality paints to fit every budget, even if you are a student on a very short financial leash.

With tradition and superb products to back up their reputations, the elite European paint companies have long been preferred by artists over other suppliers, but buying from them can send

you to the poorhouse. Fortunately, many new, fine-quality paints are now available (and reviewed below) that are both excellent and affordable, made by firms that have tested the exclusive hold the "Rolls-Royce" paint companies have enjoyed for so long. You should paint with what you can afford. If you are just beginning to learn how to work in watercolor, this is all that is necessary. The quality of your materials is important, but working with the very best is something you can truly appreciate and understand only as you reach a higher, more accomplished level of skill as a painter.

Listed in this section are manufacturers whose paints are widely available to artists and students through art suppliers. They have been included because of their reputations for producing superior artists'-quality and student-grade watercolors. It's an open market with good choices to be made.

DANIEL SMITH

A large, Seattle-based art materials supplier, Daniel Smith has a store in its home city and produces a very handsome, lavishly illustrated mail-order catalog that has been instrumental in winning the company a prominent place on the art materials map. Besides selling the wares of a range of manufacturers, this firm makes and markets its own superb product lines, which are as good in real life as they look in the catalog.

The man whose company now bears his name was a printmaker who in 1976 developed his own etching inks and began to market them; thus was born Daniel Smith Inc. One of the new kids on the block in the medium of watercolor, Daniel Smith started making watercolor paints in 1982 with the development of metallic colors made from microscopic flaked particles of brass and copper. In 1993 the firm introduced Daniel Smith Finest Watercolors, which now come in 88 colors. Finely milled with pure gum arabic, these professional-grade paints are densely pigmented, providing good coverage, and they wash out very well. Full disclosure of the color's common name, pigment content, and lightfast rating is provided on tube labels in accordance with ASTM standards. All of the colors but one are rated in the top two lightfastness categories; the exception is alizarin crimson, which Daniel Smith rates as fugitive and recommends substituting with anthraquinoid red,

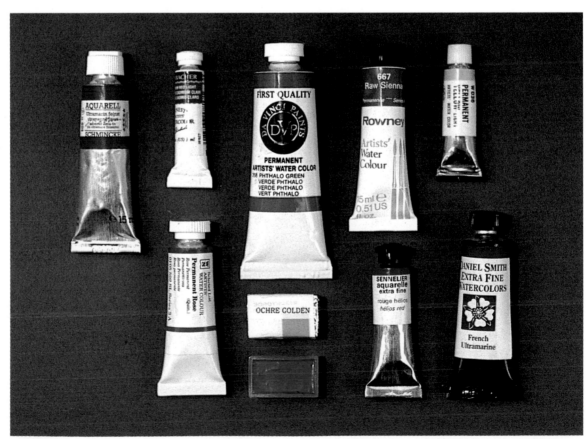

PROFESSIONAL-GRADE, ARTIST'S-QUALITY WATERCOLOR PAINTS MADE BY SCHMINCKE, GRUMBACHER, DA VINCI, ROWNEY, HOLBEIN, WINSOR & NEWTON, YARKA (the two pan colors shown), SENNELIER, AND DANIEL SMITH.

a comparable color with the highest lightfastness rating. Daniel Smith Finest Watercolors are supplied in 15ml tubes and come in four series (price categories based on a color's pigment cost) that range from moderate to expensive.

DA VINCI

Based in California, Da Vinci is a family-owned and -operated manufacturer of art materials that was founded in 1975, although the family's experience in the field stems back 60 years to northern Italy. Da Vinci offers a limited range of watercolors—a total of just 28 colors—which are sold under the label First Quality. The paints come in large, 37ml (1.25 fl. oz.) tubes, making them convenient for studio painting, especially for mixing generous amounts of color for larger-scale works. The colors flow very well and retain excellent density. Ingredients lists, durability ratings, and health information are well marked on these substantial tubes.

GRUMBACHER

The Grumbacher firm was founded in 1905 by a German immigrant named Max Grumbacher, who began by selling brushes door to door and eventually expanded his line of materials to include imported color products. In the 1930s he entered an arrangement with the German color maker Schmincke that allowed him to manufacture paints in America using Schmincke formulations under that firm's direction. As World War II began, Schmincke sold its rights to the American paint-making operation to the Grumbacher family, whose company went on to become one of the world's top art materials manufacturers. Today Grumbacher is owned by Koh-I-Noor Rapidograph, Inc.

Grumbacher has long been a popular supplier of artists' materials for the masses because of its products' wide availability and moderate pricing. Unfortunately, some professional artists have been known to look down their noses at Grumbacher paints, viewing them as second-rate mainly because the firm has gained so large a part of its reputation from the vast sea of students and beginners. But Grumbacher produces both professional-quality and student-grade watercolor paints. The professional, artists'-quality line is the "Finest" series, an excellent watercolor that is moderately priced. These colors are strong and brilliant, with a high pigment content in a gum arabic base. The pigments have good firmness, yet flow from the tube freely. Tubes are available in 5.3ml (.18 oz.) and 16ml (.54 oz.) sizes. Grumbacher's Finest series watercolors seem to be less widely available than its very popular student-grade "Academy" paints, so you may have to look a bit harder to find them.

The Academy watercolors have traditionally provided painters with good quality at very affordable prices. They release quickly from the tube into smooth, easily muted washes. If you are just beginning, these paints are very suitable. Academy watercolors come in 7.5ml tubes.

HOLBEIN

A Japanese art supply company based in Osaka, Holbein was founded at the beginning of the 20th century, taking its present name in the 1930s from the 16th-century German painter Hans Holbein. The firm developed its paint-making techniques largely independently of the West, adhering to strict quality standards that today are ensured by, among others, a dozen full-time color chemists who monitor paint manufacture.

The pigments Holbein uses for its watercolors are ground up to four times in gum arabic to give them the working characteristics of traditional hand-ground pigments. Unlike most watercolor paints, Holbein's contain absolutely no ox gall (an additive that increases wetting and paint flow), giving them unique handling capabilities. Holbein offers 84 different moist colors in both 5ml and 15ml tubes, as well as a number of colors in dry cake form. The tubes are rather generic looking and have no indication of the ingredients.

ROWNEY

The superb watercolors by Rowney have been made in Great Britain since 1783, when the brothers Thomas and Richard Rowney began their enterprise. It is thought that they supplied the great 19th-century English landscape artists John Constable and J. M. W. Turner with their paints. In 1983 Rowney merged with Daler, a manufacturer of canvas board, to form the present company, Daler-Rowney.

Traditional methods are followed in Rowney's paint-making process; pigments are ground slowly on a triple-roller granite mill to ensure a consistent quality characterized by velvety smoothness and clarity. Rowney watercolors are available in two ranges, Artists' Water Colours and the student-grade Georgian line. The artists'-quality paints are available in 15ml tubes and in half and full pans; the Georgian paints are produced in 8ml tubes, and some colors are available in half pans.

Both lines are very well priced, with, of course, the Georgian colors, like most student-grade paints, lower in price because of lower concentrations of pigment in their formulas. Rowney also offers a full range of paint kits and supporting materials for professional artists and serious students alike.

SCHMINCKE

In 1881 Herman Schmincke and Josef Horadam founded the German firm Schmincke. Four generations later the company has a modern factory in Dusseldorf and is run by direct descendants of the founding families. Schmincke produces a very high quality watercolor paint for the professional and serious student. Its Horadam watercolors are formulated with gum arabic and other water-soluble resins and have a very high concentration of pigment. The result is a paint with a firm consistency that when washed over the paper's surface retains its color intensity. Excessive use of ox gall in the formula is avoided so that the paints do not flow out of control on soft watercolor papers. Schmincke offers 118 colors; I am particularly fond of its cobalt blue and French ultramarine blue, which have a beautiful, concentrated richness and a wonderful granular quality. Schmincke watercolors are available in 8ml and 15ml tubes and in cakes of half- and full-pan size. The pan paints are powdered rather than pressed to allow for a slight moistness, so that color can be picked up with a brush more quickly for painting washes. Schmincke's colors come in three series (based on the cost and rarity of the pigment); the paints are expensive but well priced for their excellent, professional quality.

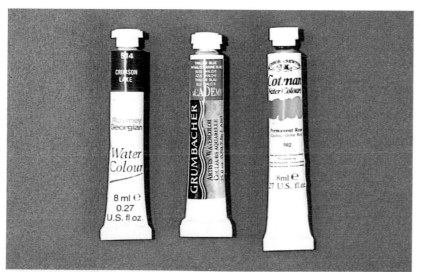

STUDENT-GRADE PAINTS INCLUDE ROWNEY'S GEORGIAN, GRUMBACHER'S ACADEMY, AND WINSOR & NEWTON'S COTMAN LINES.

SENNELIER

The Parisian chemist Gustave Sennelier founded the company that bears his name in 1887, and the Sennelier family has been producing artists' paints ever since, supplying colors to the giants of early Modernism. Though once hand-ground according to tradition, the firm's pigments are now machine-ground, but the paint formulas remain unchanged from the originals. In the 18th century many artists began to add sugar or honey to their watercolor paints to alleviate the gum arabic binder's tendency to crack. Adding sugar or honey helped the paints retain humidity and increased fluidity. Today glycerin is generally used in their place, but Sennelier still mixes honey in its watercolor paints, which accounts for their oozy, runny quality. Because of this characteristic, the paint tends to run out of the tube very quickly, and you do go through more of it, but if you have a well-stocked supply, this shouldn't be a problem. These professional-quality paints are fairly high priced, however, so if you are concerned about cost, you should factor in having to replenish your supply more often.

Sennelier watercolors are available in 80 colors in 10ml (.35 oz.) tubes labeled with very little information—nothing about the pigments or other ingredients in the paints appears. The pigments are very finely ground, and colors are on the intense side. My personal favorite is cerulean blue. It's much more intense and closer to turquoise than other brands of this usually delicate color, and it combines well with other blues and with yellows, yielding rich, vibrant secondary color mixtures.

WINSOR & NEWTON

The name Winsor & Newton is almost synonymous with watercolor. Founded in 1832, the firm has long been a major player in the history and development of the medium in both England and America, where many of the greatest watercolor masters have preferred Winsor & Newton paints. Winsor & Newton was, in 1892, the first manufacturer of artists' paints to produce a complete list of colors detailing their chemical composition and permanence. Now owned by Col-Art, the company no longer has the distinction of being a family-run business, but it continues to maintain its high standards of quality.

Winsor & Newton's professional-grade paints, labeled Artists' Water Colour, come in 5ml and 14ml tubes as well as in half and whole pans. These superb watercolors are grouped in series according to pigment content, with Series 1 being

the least expensive and Series 5 the costliest. When you get to Series 3, things begin to get very expensive; Series 5 is in the stratosphere! Winsor & Newton's Artists' Water Colours are the highest-priced of all the professional paints on the market. Although the tube paints are most popular among artists, the company's beautiful pan sets in classic black enameled tin boxes are widely used too, but they are also pricey. The tube colors are firm and have very good pigment density, retaining strong saturation in washes. They also seem to last—you don't go through these paints as quickly as you do softer, runnier brands of moist colors. Some of the 85 colors available today are still made according to original formulas, while others are the result of the gradual introduction of modern synthetic pigments. The gums, wetting agents, and preservatives used in the manufacture of these paints allow the various pigments to retain their individual characteristics and color intensity.

Winsor & Newton also offers Cotman Water Colours, a second-tier line of 50 colors containing traditional and alternative hue pigments. They are quite inexpensive, perfect for the student of the medium. The paints are sold in 8ml tubes and in various pan sets, notably the Cotman field box, which is one of the most ingenious painting kits on the market. It contains 12 half-pan colors, a sponge, a water container, and a tiny retractable brush. Kits like these are easily concealed and can be whipped out and set up quickly with very little fuss. I've been able to use them to work on little studies even during air travel. Their almost

toy- and gadget-like quality appeals to those of us who still feel like kids, and they make great little gifts.

YARKA

With a name that means "shining color," Yarka is a line of traditional Russian artists' materials now available in the United States, thanks to Fostport Imports of Massachusetts. Yarka products are actually the collective effort of a group of small Russian factories—some of them dating back to when the czars ruled—that have banded together to market their wares. With labor costs low and raw pigment sources abundant in Russia, Yarka paints are produced very economically and are priced accordingly.

The professional-grade watercolors, called St. Petersburg, are semimoist cakes in the 19th-century French tradition. There are 24 colors in all, many of which have Russian trade names, so it takes a bit of effort to identify the common names. Beautiful, rich, and intense, these paints wash very easily over large surfaces, and all colors are rated high for lightfastness. On the down side, the pans are difficult to unwrap because the paints are sticky, and they come in a poorly designed plastic kit with areas too small for mixing washes. Also, the paints sometimes stick to the plastic lid when you cover them. I have tried to adapt the pans to other kits that have better mixing areas, but still encounter the same problem—a real shame, because these are wonderful colors. Someday soon, I hope, Yarka's palette design will catch up to the paint quality.

WINSOR & NEWTON'S COTMAN RETRACTABLE BRUSH SET AND WATERCOLOR FIELD KIT.

RELATED WATERCOLOR MEDIUMS

Besides the more traditional transparent watercolor paints, there are some related mediums that can be used in the same way as watercolor or in conjunction with it. Some of these products, however, are intended for commercial use, not fine art, and thus may not be of archival quality. Read labels to be certain.

GOUACHE

Also called opaque watercolor or body color, gouache is made from the same ingredients as transparent watercolor but has a higher pigment density and contains white chalk for opacity. Most of the manufacturers of transparent watercolor paint listed in this book produce gouache for fine-art applications as well, notably Da Vinci, Holbein, Schmincke, and Winsor & Newton. Read labels carefully, however; some products designated as designer's gouache may not be totally lightfast, since their intended use is generally not for works of fine art but for illustration and other graphics that are meant to be reproduced. Such paints are formulated for brilliance (sometimes with soluble dyes), not for permanence.

Holbein offers 63 finely ground gouache colors that are rated high for permanence, hue, value, and chroma and that mix freely without loss of brilliance or opacity. Another brand suitable for the fine artist is Schmincke's Artists Gouache, offered in a range of 60 colors. The paints contain a high concentration of pigment and have earned a good reputation for ensuring smooth, even coverage.

LIQUID WATERCOLORS

Liquid watercolors, which resemble inks and are sold in small dropper bottles, are meant for use by designers, illustrators, and other graphic artists creating work for reproduction. They can be applied with a brush, dip pen, technical pen, or airbrush. Formulated for the brilliance and intensity required of commercial work, these colors often contain dyes rather than pigments and are impermanent to varying degrees when exposed to light. They are therefore not recommended for fine-art watercolor painting.

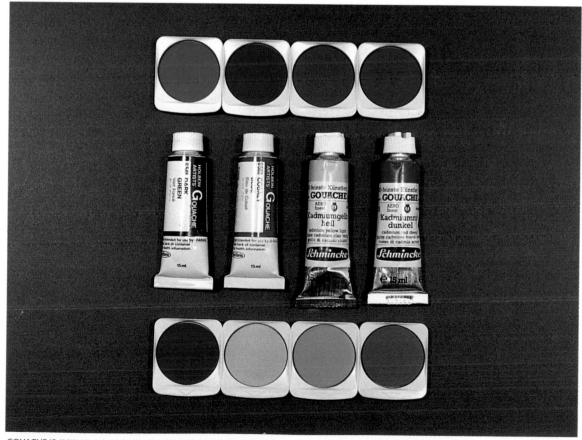

GOUACHE IS AVAILABLE IN TUBES AND DRY CAKE FORM; HOLBEIN AND SCHMINCKE ARE TWO WELL-KNOWN MAKERS.

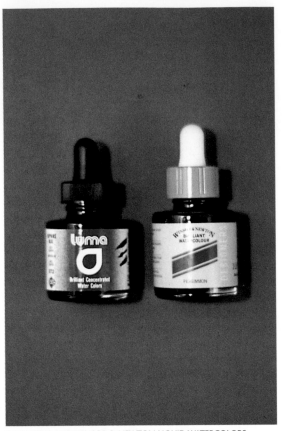

STEIG LUMA AND WINSOR & NEWTON LIQUID WATERCOLORS.

WATERCOLOR STICKS

Relatively new to the market are water-soluble sticks of color that you can apply to paper like crayon or pastel for graphic effects or blend with a wet brush for rich, painterly watercolor effects. On rough-surfaced paper they will leave a textural mark even when water is applied, with a result that looks like watercolor and pastel combined. One such product, made by Holbein, resembles dry pastel and can be worked in the usual pastel way and blended with a wet brush to give a transparent textural effect. Colors are lightfast and formulated for optimum painting and drawing performance. Another is the Aqua Crayon, a waxy water-soluble crayon developed by New York Central Art Supply in New York City. It is a multipurpose painting and drawing medium that permits the graphic spontaneity of a drawing medium and the fluidity and covering power of paint. Made with pure pigments and available in some 50 colors plus iridescents, metallics, and pearlescents, Aqua Crayon is 100 percent archival and does not require the use of any toxic solvents. Both brands of watercolor stick can be layered transparently, and both are excellent for direct painting and drawing techniques.

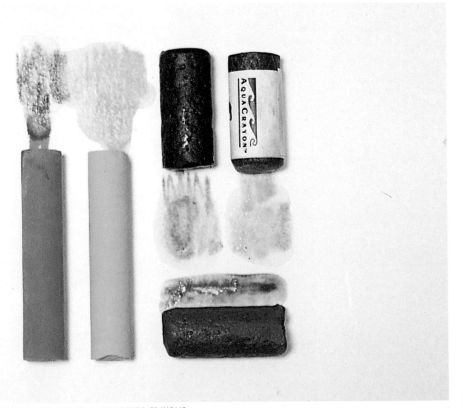

HOLBEIN WATER-SOLUBLE PASTELS AND AQUA CRAYON WATERCOLOR CRAYONS.

BRUSHES

Most artists seem to fall into one of two groups when it comes to choosing watercolor brushes. The first will work with only the best available: classic, handcrafted brushes made of the finest natural kolinsky sable and squirrel hair—the most beautiful racehorses in the stable. The other group prefers worn, blunted, unattractive-looking brushes made with lower-quality natural hairs, or brushes made with synthetic blends. Which group is right? The answer, of course, is both. The best brushes for you are whatever you are comfortable with and whatever works for you. It is not always how fast you get the horse around the track and into the barn; sometimes just getting to the barn can be perfectly satisfactory. Watercolor brushes come in a wide array of styles designed for specific tasks, and good ones can facilitate your workmanship. Natural skills and personal vision, however, not the quality of your materials, are the primary requirements for creating well-defined watercolor paintings.

BRUSH FIBERS

Watercolor brushes are made with a variety of fibers, and the type used is generally what determines the cost of the brush. They range from kolinsky sable, the costliest, to other natural hairs, such as squirrel, goat, badger, mongoose, and camel (which actually does not come from camels but is a trade name for hair or blends of it from other animals, such as goat, sheep, pony, or squirrel), to synthetics and natural-synthetic blends. All have their strengths and offer the artist good to excellent painting capacity. Those described below are the most commonly used.

SABLE

Sable is actually a misnomer for brush hairs that come from various animals in the weasel and mink family. Kolinsky hair, the finest so-called sable, comes from the tails of minks native to Siberia and northern China. Long, soft, and golden brown, this hair is thick and highly resilient because of the climate where the animals are indigenous. Red sable, from a related species, is golden red; thinner and less resilient than kolinsky, it is also much less costly and is commonly used to manufacture lower-priced sable brushes, like blunt rounds and oval flats. All sables have the best water-retaining capacity and spring when wet.

SQUIRREL

The best squirrel hair for watercolor brushes is brown and comes from the tails of Russian squirrels; Canadian squirrel is used for lesser-quality brushes. Squirrel hair is very soft, retains water well, and holds a point when wet, but it does not have nearly the spring of sable. It is best used to make flat wash and especially oval wash brushes.

OX

Ox hair comes from the animals' ears. Though it doesn't form a good point, it has good snap and water-retaining capacity and is often blended with other fibers. Sabeline, also used in blends, is the name given to fine grades of light ox hair that have been dyed to resemble red sable.

GOAT

With its cylindrical shape, goat hair has no tip potential; more commonly it is used for cosmetic brushes because of its relatively poor water-retaining capacity. Goat hair, like pony hair, is used mostly for mop brushes, which are used to wash in large areas of color but, because they lack point sharpness, have little ability to define shapes and details.

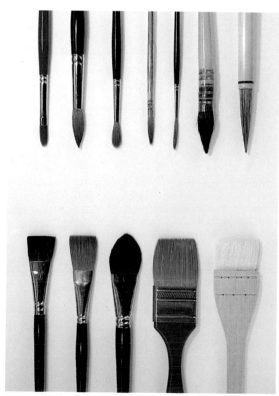

LEFT TO RIGHT, TOP: FILBERT, SABLE ROUND, BLUNT ROUND, SCRIPT, RIGGER, SQUIRREL MOP, BAMBOO ROUND. BOTTOM: SQUIRREL BRIGHT, SABLE FLAT, OVAL MOP, SABLE BLEND LARGE FLAT, HAKE.

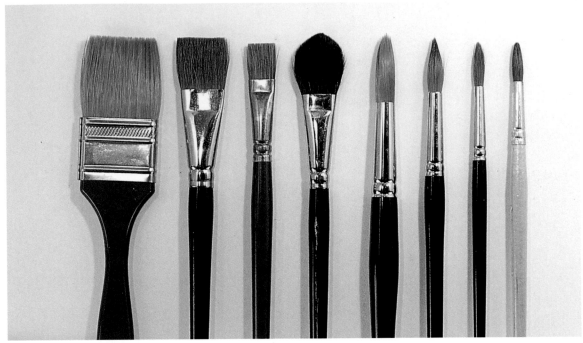

BASIC BRUSH SET. Left to right: Large wash brush; bright; flat; oval mop; and rounds in four different sizes.

SABELINE

As mentioned above, sabeline is an imitation red sable made from the finest grades of ox hair dyed to look like the real thing. It is used to make blunt round and flat wash brushes. Sabeline, of course, isn't as resilient as genuine sable, meaning that brush tips will become worn after lengthy use. But if their construction is good, sabeline brushes are very effective—and much less expensive—natural-hair substitutes for fine sable brushes.

SYNTHETICS

Such materials as nylon and acrylic are commonly used in the manufacture of round and flat watercolor brushes. Synthetic brushes are the least expensive of all, but they fray and soften quickly and most have very poor tip retention. Fortunately, innovations are being made in synthetic materials to meet the growing needs of artists and, of course, the differing sizes of their pocketbooks. Synthetic fibers perform much better in situations that call for wetter paint handling, such as in laying flat washes. They retain a good amount of water and can hold a hard edge. Synthetic flats measuring 2" to 3" wide are especially effective for washing paint over large areas of paper.

BLENDS

Brushes made with a combination of natural and synthetic hairs offer a bit of both worlds at an affordable price. They have more spring and

retain a better edge and point than all-synthetic brushes. Blends often have a better appearance, too, if that's important to you. The natural-synthetic brush is a man for all seasons.

BRUSH STYLES

Watercolor brushes, which generally have shorter handles than brushes used for oil and acrylic painting, are designed in a variety of shapes and sizes to perform different tasks and suit different formats. Having a selection of the basic ones—rounds, flats, ovals, and larger wash brushes—will enable you to paint everything from small plein-air studies to large studio works. Other types of brushes, such as liners, quills, fitches, and spotters, have their own unique functions but are less commonly used by today's artists and so are not described here.

ROUNDS

Round brushes are the virtuosos of watercolor. They are designed to do everything, from drawing fine, thin curlicues with the tip to painting broad washes. Just by changing the pressure with which you apply a round brush to the paper, you can make fluid strokes or textural ones. Rounds range in size from 00 (the smallest) to 16 (the largest). They have a long, fine tip and a full belly for maximum water retention. Blunt rounds also have a full belly but are shorter, with the hairs set so they form a blunt tip rather than the

sharp, pointed one needed for more precise brushwork. Blunt rounds make a blunter stroke and are effective for laying in washes and working wet-on-wet.

Flats

A flat brush has long, soft hairs forming a flat, wide shape that is squared at the tip so it can leave a precise, hard-edged stroke. Flats can hold a lot of paint and are used to make broad sweeps across the paper, commonly when rendering big areas such as backgrounds and skies. They range in size from ¼" to 4" or 5" wide, the latter being ideal for applying washes in large-scale works. The flat is an indispensable brush for blending and wet-on-wet techniques.

Brights

A bright brush is a shorter-haired flat. Because of its shortness, the bright is very springy—that is, it has more strength for pushing and pressing color on the paper in flat strokes; for the same reason it is generally not used as a wash brush.

Filberts

A filbert is a flat with a rounded tip that looks as if it has been worn out. It makes thin to thick blunt, soft-edged strokes, and because it can carry a fair amount of paint, it can also be used for washes.

Oval Mops

Made from soft, natural hairs such as squirrel, oval mops are very full brushes used for applying large amounts of loose, wet paint. The oval has a

controllable tip and can be used to shape washes, but it has less articulating ability than a round brush. Moving one of these brushes loaded with paint around on a wet paper surface has a very satisfying, sumptuous feel.

Scripts and Riggers

Both scripts and riggers are made with long hairs that come to a very fine point. Their elongated shape provides the control needed for lettering and other linear work and makes them ideal for rendering fine details in landscapes and portraits. The script brush is a traditional calligrapher's tool; the rigger actually got its name from being used to paint rigging in pictures of ships. Both types of brushes have great flexibility, permitting gestural, calligraphic strokes.

Bamboo

Round bamboo brushes, among the oldest style known, were in use in China as long ago as 2000 B.C. Available in various sizes, they are made of natural hair set into bamboo and range in price according to the quality of the hair used and the method of construction. Bamboo brushes are very flexible, allowing a great range of technical possibilities, from extremely delicate brushwork to broad washes.

Hake

The hake (pronounced hah-kay) is a flat brush used for applying washes. Hakes are made with goat, sheep, deer, rabbit, or wolf hair, which is glued and sewn into a flat wooden handle. Very large, thick-haired hake brushes, like the one in the lower right corner of the photograph shown below, have handles made of joined bamboo cylinders. This type will hold a lot more water than a flat hake brush. Hakes may be up to 5" or 6" wide. When used to lay in a large, wet wash, the hake should be held almost perpendicular to the paper. These brushes have very little to no spring but move smoothly when loaded with color. They must be kept very wet to be most effective; when water is pulled out of the fibers they stay bent until loaded again. Hakes can also be used for sweeping drybrush strokes.

Large Wash Brushes

For the watercolorist who paints large-scale works, large wash brushes are indispensable for laying down expansive, wet washes. Various types are available (as illustrated at left), each with a specific function to perform at different

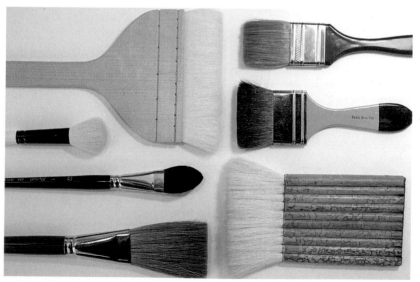

LARGE WASH BRUSHES, INCLUDING HAKES, MOPS, AND FLATS.

stages of work. Heavier brushes made with stiffer, coarser types of natural hair can lift paint when stroked across the paper and may leave scratch marks, whereas softer-haired brushes will not.

RETRACTABLE BRUSHES

There are a number of retractable brushes on the market that are especially handy for travel and for sketching in the field. Ranging from kolinsky sable to sabeline and blends, they are designed with a hollow handle that unscrews to fit over the brush tip for protection. Winsor & Newton offers a line of retractable brushes in different sizes under the Cotman name. These models are superior to the tiny brush that comes with the firm's otherwise ingenious Cotman field painting kit.

THE BRUSH MARKET

Whether you can afford the break-the-bank prices of the finest kolinsky sables (the undisputed crown jewels) or just a few dollars for some of the synthetics, you should select your brushes according to good standards of construction. Good workmanship is expected in the finest sable and other natural-hair brushes, and usually that's what you get. But with less expensive to cheaper brushes you are sometimes taking a chance. However, low cost is not necessarily an indictment of quality if the brush is well made.

WHAT TO LOOK FOR

Carefully examine any brush you are considering buying. Does it have a good clean shape without hairs popping out? Avoid brushes that appear to be shedding; they are not as carefully constructed. Some art supply stores let you dip the brush in water to see how it holds water and shape.

There are some very good buys out there, but generally you get what you pay for. Before making a purchase, talk to other artists or seek the advice of an informed salesperson. Many art materials suppliers have knowledgeable staff who can help you find the brushes that will meet your technical and stylistic needs and who can apprise you intelligently and in an unbiased way of the strengths and weaknesses of different kinds of brushes and their construction. Ultimately, you may need some firsthand experience with a brush to discover its qualities.

What is the perfect, best-made brush? If I had to select just one as an archetype possessing every desirable characteristic for watercolor painting—a fine, sharp tip, a full body capable of retaining sizable amounts of water for painting large areas, springy resilience, and longevity—it would probably be a #12 kolinsky round.

For centuries kolinsky brushes have been made by hand using the construction methods described here, which should serve as models when you are evaluating brushes for purchase. For round (pointed) kolinsky brushes, the hairs are carefully selected, with short and irregular ones removed, then bundled together, laid out, twisted, shaped, and fitted snugly into the metal ferrule. The hairs are then crimped together, steamed clean, and straightened. The rounded tip shape comes from the twisting. As the hairs extend from the ferrule, they should form a full, round belly, then gradually curve in toward the tip, with no hairs standing out beyond it. Flat brushes are assembled the same way, but the hairs are arranged so that their tips are all aligned perfectly to form a straight, chisel edge and the ends to be enclosed by the ferrule are cut, crimped, and glued or sewn into place. In good natural-hair brushes, the hairs that extend beyond the ferrule are never cut, whereas synthetic fibers require cutting to taper properly.

The finest kolinsky brushes are an investment—and a good one that won't fail to be appreciated over time, since these brushes offer years of superb performance. Accidentally losing

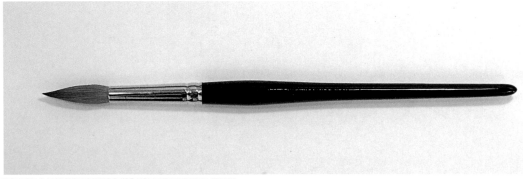

WINSOR & NEWTON SERIES 7 #12 KOLINSKY ROUND BRUSH.

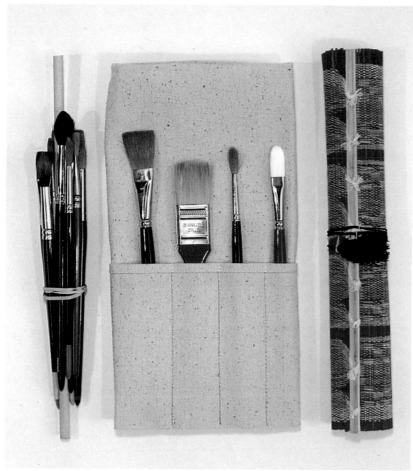

BRUSH HOLDERS: RUBBER BAND, POCKETED CANVAS HOLDER, ROLLED-UP BAMBOO MAT.

hair large flats are some of the best available. The Winsor & Newton Series 7 brushes have been viewed in the past as the finest of all, with a design that is said to have been suggested by Queen Victoria herself. While they may not be the best in the world today, their price is certainly the highest.

The anomaly among fine brush manufacturers is Yarka, because it manages to produce handcrafted brushes made with genuine Siberian kolinsky hair that cost a small fraction of its competitors' prices for similar goods. Yarka's round brushes are shorter in length and have a very full belly that paints larger than its size, which is only as large as #5. The handle is lacquered plain wood with a crimped ferrule. A Yarka looks like a cheap craft brush, but its tip is superb.

Large art materials manufacturers like Daler-Rowney, which recently bought the Robert Simmons line of fine brushes, and Grumbacher offer excellent lines of well-priced brushes ranging in fiber content from the finest natural materials to synthetics and blends. Many art materials suppliers, such as Daniel Smith, have brushes produced specially for them by fine European brush makers who know what they are doing.

ORGANIZING AND CARING FOR BRUSHES

Brushes need to be held, carried, and stored so that the tips are protected. The natural way to hold brushes that are not in use while you're painting with another one is what became known as the Sargent style—crossing them between the teeth. But better options exist in the form of various holders and organizers like the ones described here.

One way to prevent the working end of your brushes from touching another surface when they are not in use is simply to lay a dowel across your paintbox horizontally and place the brushes on top of it. A simple solution for transporting brushes is to roll them up in a slatted bamboo brush holder (resembling a placemat) and fasten this rigid casing with string or a rubber band. Another handy device is a compartmented canvas carrier, which also serves to keep your brushes organized and ready for use while you're painting.

Caring for your brushes is important in maintaining their quality and extending their life. Before putting them away after a painting session or placing them in any kind of holder, clean them thoroughly in clear or soapy water, making sure the tips of your rounds form a point and your flats square off.

a kolinsky brush while painting on location can be a serious blow; it's not quite like leaving your umbrella behind, as we all have been known to do on occasion. If you are forgetful, don't buy expensive brushes, or at least don't take them out of your studio.

BRUSH MANUFACTURERS

Who makes the best brushes? Today there is a multitude of brush manufacturers as well as art materials companies that have brushes made under their own labels. Most of them offer a complete range of brush styles in various price ranges.

The tradition of fine handmade brush making is being continued by such long-established companies as Raphael and Winsor & Newton, as well as several manufacturers that began in the 20th century, including Cosmos (a part of the Dalknier Company), Manet, Isabey, and Rekab (formerly Percy Baker). Raphael and Cosmos produce superb brushes handcrafted by people who are trained for years before they are allowed to make a top-quality brush. Manet's squirrel-

PAPER

The support for watercolor is paper, and its surface qualities—including whiteness, texture, and sizing—have a profound influence on how the medium behaves and the way finished paintings look. The ascendancy of watercolor in the early 19th century is linked to the development of paper that was more receptive to controlled washes of color than the rough, irregularly textured papers available prior to that time. One innovation was the introduction of wove paper, which has a smooth, even surface produced by processing wet pulp in a mold with a finely woven mesh screen. (Laid paper, by contrast, bears a strong pattern of vertical lines that results from its being formed in a mold composed of vertical wires held in place by very thin wires known as chainlines.)

Wove paper and other advancements in paper technology deeply influenced the stylistic approach taken by the early modern masters of watercolor, opening the door for the superbly painted, layered washes that became especially characteristic of the work of such artists as J. M. W. Turner (1775–1851). Wove paper rapidly gained popularity, but because it was all handmade at the time and the process was slow (sometimes taking up to several months), it was hard to come by. Mold-made papers eventually became more widely available with the advent of machine production in the mid–19th century, a development that changed the paper-making industry forever.

High-quality machine-made and handmade paper can be distinguished by a trade watermark, a translucent image resulting from a raised wire design affixed to the mold in which the paper is formed. The mark can be observed by holding the paper up to a light.

SIZING

Sizing is an important ingredient in the production of handmade and molded papers. Without it, watercolor washes are absorbed directly into the fibers of the paper like a sponge. Sizing is a gelatin that is added to paper in the pulp stage (internal sizing) or applied to the sheet after it has been formed (external sizing). Once dried, this gelatin works as a protective agent that allows watercolor washes to move and mingle before settling into the paper's fibrous surface.

The amount of sizing was critical to early British watercolorists such as Turner, John Sell Cotman (1782–1842), and Thomas Girtin (1775–1802).

Cotman in particular was known for painting on undersized paper that absorbed washes, giving his watercolors a rich tonal depth. This approach to painting is unforgiving: the color cannot be lifted or wiped once it has been put down. Absorbent papers require more glazing for depth and brilliance than thoroughly sized papers.

Papers with different sizing react differently in variable weather conditions. In damp conditions, papers that are more absorbent (have less sizing) will dry more quickly, whereas hard-sized papers (with heavy sizing) will seem never to dry. Fabriano, for example, is a very absorbent paper that works well in a cold, damp climate, while Arches, a hard-sized paper, seems better in drier conditions.

If you are used to a hard-sized paper, then a soft, absorbent one will seem very slow-reacting and appear to soak up your washes. When trying out papers, find one that is sized to match your needs. It may take some time to determine what works best for you. The ideal paper for most artists is a fairly soft, cold-pressed sheet with just the right sizing to allow for flow yet retain slight absorption for good saturation of glazes.

TEXTURE (GRAIN)

Watercolor paper surfaces fall into three categories: rough, hot-pressed, and cold-pressed. Although these categories are used as a general rating system by all paper makers, surfaces vary considerably from company to company.

Rough paper has the most surface texture, with "peaks" and deep hollows that influence the look of paint applied to it. When color is stroked onto a sheet of rough paper, it adheres to the raised areas of its surface but, depending on how it is applied, may not penetrate into the hollows, which remain white and result in a sparkling effect. Color that does settle into the paper's hollows appears darker than usual because of the way pigment collects in these little "pools." Rough paper requires special brushwork and a good feel for how its surface will give texture to washes of color. This paper exposes everything: brushstrokes, stainy wet washes, and gradations show as clearly as the dust on a highly polished surface.

Hot-pressed paper has a very smooth surface that gives height and brilliance to colors but keeps you on the edge of your seat. Spots, puddles, and other organic effects happen almost accidentally, adding to the overall textural expression of a watercolor painting.

LEFT TO RIGHT: ROUGH, COLD-PRESSED, AND HOT-PRESSED WATERCOLOR PAPER.

IMPERIAL, ELEPHANT, AND DOUBLE ELEPHANT SHEETS.

Cold-pressed paper has a less pronounced texture than rough paper and is the most commonly used by students and professionals alike. It allows for easy wash applications yet has enough grain to show brushstroke textures and pigment granulation. It also permits layering, and color is easily lifted from its surface. Cold-pressed is the most versatile of watercolor papers. If you are trying to gain control of your washes and get good paint dispersion, this is the paper for you.

The grain of a good-quality paper should have a handmade unevenness. Poor-quality papers often have an even grain that is predictable-looking and distracts from paintings executed on them. They have no natural character. Many of the fine-quality machine-made molded papers have a deckle edge and, of course, try to imitate handmade naturalness—quite successfully in many cases but never totally. Any paper you choose to paint on must be acid-free and pH neutral to ensure the longevity and color purity of your work.

WEIGHTS AND SIZES

Machine-made watercolor paper is designated as 90 lb., 140 lb., 200 lb., 300 lb., and so on according to what a ream—500 sheets—weighs. (It is also measured in grams per square meter, or g/gm^2, which is more accurate because it takes into account the size and not just the thickness of an individual sheet.) The higher the number, the heavier the paper. Heavier papers are more durable; they can be worked over with washes and other techniques without buckling or losing surface quality. They also do not need stretching, although some artists stretch them to get a perfectly flat surface for graded washes. Even the heavier 300-lb. and 555-lb. papers, which are practically cardboard, will buckle slightly if saturated with too much water.

Watercolor papers come in standard sizes that vary only slightly from company to company. The traditional categories are royal ($19 \times 24"$), imperial ($22 \times 30"$), elephant ($29^1/2 \times 40"$), and double elephant ($40 \times 60"$). The double elephant size, made by Arches, Lana, and T. H. Saunders, was developed just within the past 20 years and has opened up opportunities for creating very large, ambitious works.

HANDMADE PAPERS

Made with natural fibers such as cotton and linen rag, handmade papers are produced in the traditional manner that predates the mechanized process. They vary greatly in texture depending on the papermaking process, ranging from smooth to very coarse and irregular. The rough deckle edges of handmade papers give them a natural beauty that makes them seem almost too fine to paint on. Handmades look especially attractive when free-floated behind glass in a frame.

There has been a resurgence of handmade paper makers in the last decade or two. Among such producers are Twinrocker (United States), whose papers are noted for their exaggerated deckle edges; St. Armand (Canada); and Indian

Village (India), whose papers are known for their very rough, uniquely irregular surfaces. Handmade papers have long been produced in Europe; in England J. B. Green has been around for a few generations, and two other mills carrying on this tradition are Fabriano in Italy and Larroque in France.

All of these papers are internally sized to different degrees and are neutral pH. Handmade papers can be expensive, owing to the time-consuming process of producing them. Although every artist should experience painting on them, the beginner needs to acquire some skill before having a run at these superb papers.

BLOCKS

Cold-pressed, rough, and hot-pressed watercolor paper in 90-lb. and 140-lb. weights is available in 20- to 25-sheet blocks ranging in size from 4 × 6" to 18 × 24". The sheets in a block are bound together on all four sides, which keeps them rigid and eliminates the need to stretch the paper, making them convenient for traveling and working on location. When you finish a painting you simply slice the sheet off the block in the manner you might use to open a letter.

SKETCHBOOKS

A sketchbook is a very personal item that an artist chooses for its shape, binding, and paper quality. Sketchbooks may be ring-bound, glued and taped, or hand-bound and sewn, and may contain anything from high-quality watercolor paper to an all-purpose paper that can be used with most mediums. Many watercolor paper manufacturers make moderately priced sketchbooks containing 90-lb. to 140-lb. watercolor paper in all three surfaces. Art materials suppliers also offer sketchbooks under their own labels, which are usually quite affordable. Ring-bound books of all-purpose paper are the least expensive and suitable for most uses—just be sure the paper is acid-free.

Besides using relatively inexpensive hinged books of cold-pressed paper for watercolor studies, I like to work in the handsomely sewn and bound, linen-covered sketchbooks of Arches text laid paper that are made exclusively for New York Central Art Supply in New York City. Arches text laid is a very lightweight, soft rag paper—similar to soft charcoal drawing paper—that takes washes well, with surprisingly little buckling. It has a light and beautiful touch. Sketchbooks of this paper come in both landscape (horizontal) and portrait (vertical) shapes and range in price from $18 to $60 U.S.

CHOOSING A WATERCOLOR PAPER

You need to experiment with a number of different brands and types of papers to become acquainted with their characteristics and eventually identify those that seem right for your painting approach. Look for a surface and weight that will hold up to

HANDMADE WATERCOLOR PAPERS.

BLOCKS OF WATERCOLOR PAPER.

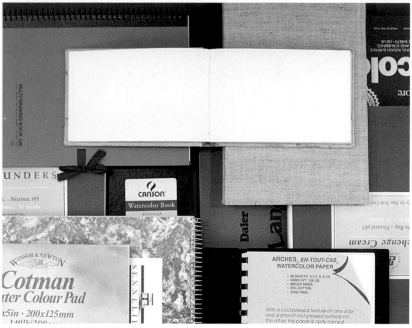

WATERCOLOR SKETCHBOOKS.

the techniques you use. I work primarily on heavily sized 300- to 555-lb. Arches cold-pressed because I need all of its strength to support the excessive layering and masking that I use to build up my paintings. If you overwork a paper as I do, then a heavy weight may be right for you. If you work directly and effortlessly, then a lighter weight will serve you well. Besides weight, you also need to consider texture and sizing, as discussed above. You shouldn't limit yourself to just one paper, however. You want to keep your paintings fresh. Listed here are offerings from some of the leading manufacturers of watercolor paper.

ARCHES

Located in France, the Arches mill has been making fine watercolor paper for some five centuries; today Arches cold-pressed paper is perhaps the most popular on the market. Cold-pressed, rough, and hot-pressed surfaces are available in sheets—all with four deckle edges—ranging in size from 22 × 30" to 40 × 60" and in weight from 90 to 1,114 lb. Blocks of 140-lb. paper in all three surfaces are also available in various sizes, as are 10-yd. rolls. Arches paper is hard-sized, making it a durable yet sensitive surface that is very receptive to washes and especially multiple layers of glazes. It can withstand considerable abuse in the form of lifting, scrubbing, and scraping.

FABRIANO

This Italian mill produces fine machine-made and handmade watercolor papers. Esportazione, the firm's handmade line, is available in cold-pressed and rough surfaces in both 147-lb. (315 gm/m²) and 300-lb. (600 gm/m²) weights; sheets measure 22 × 30" and have four deckle edges. Its machine-made, 100 percent cotton Artistico paper comes in 22 × 30" sheets; cold-pressed is available in 90-lb. (200 gm/m²), 140-lb. (300 gm/m²), and 300-lb. (600 gm/m²) weights, and hot-pressed and rough surfaces are available in 140- and 300-lb. weights. Artistico paper is off-white; the cold-pressed surface is very absorbent and soft, with an even, somewhat predictable texture. Its softness does not permit a great deal of reworking.

LANA

Lana, a French mill that has been in operation for over four centuries, makes Lanaquarelle watercolor paper. Acid-free, 100 percent cotton, and with four deckle edges, this paper is available in all three surfaces. Standard-size 22 × 30" sheets come in 90- , 140- , and 300-lb. weights; other choices include 29 × 41", 555-lb. (640 gm/m²) sheets, 26 × 40", 220-lb. (300 gm/m²) sheets, and 40 × 60", 1,114-lb. (640 gm/m²) sheets. The 140- and 300-lb. weights are also offered in rolls measuring 51" × 11 yd.; blocks, pads, and postcards in various sizes are available as well. Lanaquarelle has very good internal and external sizing and takes quite a bit of work—washes and layering—fairly well. The texture of the cold-pressed paper feels soft; the hot-pressed is absorbent.

T. H. SAUNDERS

Saunders watercolor paper, made in Great Britain, comes in all three surfaces in 90- , 300- , and 500-lb. weights, in sheets measuring from 22 × 30" to 40 × 60". This paper has good internal and external sizing and is very durable, with a dependable surface that takes quite a bit of glazing and masking.

WHATMAN

Also made in Great Britain, Whatman watercolor paper is available in all three surfaces and three different weights; it is supplied in 22 × 30" sheets as well as in blocks. This paper has weak to moderate sizing, resulting in a soft, absorbent surface that doesn't take washes easily; its limited workability suits it better for drybrush techniques.

PAPER STRETCHING

To prevent buckling when washes of paint are applied to it, watercolor paper usually needs to be stretched before use. This is done by soaking the sheet, then fastening it to a sturdy board and letting it dry thoroughly, a process that causes it to tighten and shrink somewhat. The weight and size of the paper must be taken into consideration when you do this so that once the wet sheet is fastened to the board it doesn't overstretch, pulling away from the paper tape or staples used to attach its edges to this surface.

Lighter-weight papers—25- to 80-lb., for instance—can simply be wet with a sponge or flat brush, then attached around the edges to your board. The heavier the paper, the more thoroughly it must be soaked before stretching.

Heavier papers, such as the 300-lb. weight, don't necessarily have to be stretched, since they are generally stiff enough to withstand buckling. However, even heavy paper will buckle if saturated with watercolor too often in the painting process. Three methods for various paper weights are described here.

WHEAT PASTE METHOD
Wheat paste is used to attach very light (20- to 40-lb.) wove paper to a board for stretching. This is the traditional method. Prepare the wheat paste by slowly heating it in water (check proportions on the container) until it reaches a jelly consistency. Wet your board and the back of the paper, then brush the wheat paste around the edges of the sheet and smooth it flat onto the board. With a damp sponge, wipe over the top edges of the paper to flatten it, then let it dry.

PAPER TAPE METHOD
Lightweight to 140-lb. paper can be stretched safely by using paper tape to to attach it to the board, as it generally won't pull away from the tape as it tightens and shrinks. Dunk the paper in water or soak it on both sides with a wet sponge, lay it on a rigid Masonite or plywood board, and wipe it flat with a damp sponge. Moisten the tape and apply it to all four sides of the paper ¹/₂–1" in from each edge. Then wipe the paper again with a damp sponge to flatten it. Take care not to wet the paper for too long, as this will cause overstretching. If the paper begins to pull away from the tape as it dries, sometimes you can reinforce the tape with staples.

WHEAT PASTE METHOD.

PAPER TAPE METHOD.

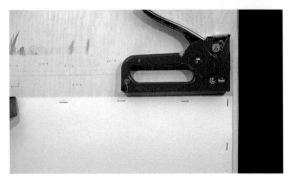

STAPLING METHOD.

STAPLING METHOD
Place the paper in a tub of water to soak; the length of time this takes depends on the weight of the paper. I leave my largest, heaviest paper—30 × 40" to 40 × 60" sheets of the 555-lb. weight—in the soaking bath for about 25 to 30 minutes. Once the paper is wet enough, lay it flat on a stiff, ¹/₂–³/₄"-thick plywood board (I roll the sheet flat with a very soft paint roller). While the paper is very wet, staple it to the board around all four sides, but not too close to the edges of the sheet; leave a border of at least ¹/₂–³/₄" on each side. The heavier the paper, the tighter together you should space the staples, since as the sheet shrinks it may be strong enough to pull away from them. Allow plenty of time for the paper to dry; I leave mine attached to the board to dry overnight.

Mediums, Masking Fluids, and Glues

Water is the primary agent used to dilute and wet watercolor paints. Tap water, however, may contain chemicals and pollutants that could eventually be harmful to your artwork. Too much chemical residue and other impurities can affect the colors and the paper. If you are unsure what the water from your kitchen faucet contains, then use bottled distilled water. But in most places tap water is fine, and so is the water from lakes and streams when you are working on location.

Besides water, various additives and paint-related products can be used to alter the way watercolor paints behave. The major ones are listed below.

Ox Gall, Glycerin, and Gum Arabic

Ox gall and glycerin are wetting agents that extend the length of time your washes will stay wet and give them more flow. Several drops in a cup of water (see recommended mixing proportions on the bottle) are all that is necessary. Painting in hot, dry conditions is an appropriate time to use a wetting agent, or whenever you want to prolong the wetness of your washes. Ox gall also helps watercolor adhere to less absorbent surfaces but does not enhance paint transparency. You should use it only in small amounts; the same is true for glycerin, since today most brands of watercolor paint contain an adequate amount.

Gum arabic, the binding ingredient in watercolor paints, is another potential additive. This natural substance, available in solution form, can be thinned with water and used with paints to increase their luster and transparency.

Alcohol

Alcohol can be added to watercolor paint to speed up the drying process. It can be used in damp weather to shorten the drying time or whenever you want to move more rapidly through a painting stage such as laying in a wash or a glaze. Artists in the 19th century were known to add cognac and gin to their water, which may have satisfied their personal needs more than their artistic ones.

Masking Fluids and Glues

To preserve white areas of paper while painting in washes, you can brush on an opaque latex masking fluid. Masking out areas, especially small ones in the middle of large washes, lets you flow the paint on freely. Use an inexpensive small brush to apply masking fluid and clean it between uses by dipping it in water, rubbing it on a bar of soap down to the heel, and wiping it with a clean rag. Otherwise, you get a buildup of masking fluid in the heel. Ethyl alcohol can be used to clean the brush, but if you rub it on soap after every use, this won't be necessary.

There are a number of masking fluids on the market—some thin, some thick, and a few tinted with color so they can be seen on the paper more easily. Do not leave masking fluid on the paper too long; it can be difficult to remove from softer papers. Tinted fluids can leave a stain and may cause an oil blemish when they are removed and painted over. I use Grumbacher Miskit, which has a pink tint, because it covers well, leaves very little stain, and removes easily when rubbed with a finger or an eraser.

Glues are used for either mounting and stretching paper or pasting pieces of collage materials to the surface of watercolor paper. Wheat paste has long been the choice for stretching and mounting paper. White glue that is acid-free and neutral pH can be used for tacking watercolor paper to boards for framing or attaching collage materials to watercolor paper.

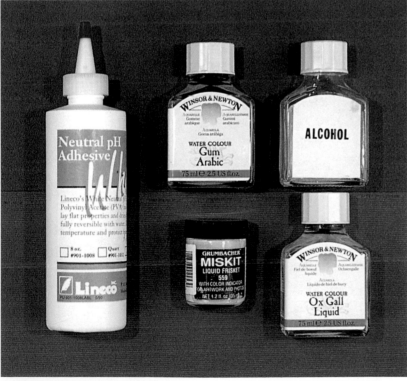

WHITE GLUE; WINSOR & NEWTON GUM ARABIC; ALCOHOL; GRUMBACHER MISKIT LIQUID FRISKET; WINSOR & NEWTON OX GALL LIQUID.

PAINTING EQUIPMENT

What do you need if you fully intend to be serious about painting with watercolor in the studio and outdoors? In addition to the basic painting materials—paints, brushes, and paper—there are a good number of supporting materials that are necessary to support your ambitions with the medium.

PALETTES

The type of palette you use determines how you are going to set up to paint. Palettes are either hand-held or large studio trays, some with compartments for holding your pigments and larger areas for mixing colors. They are made from enameled tin, plastic, paper, and other materials like Formica. The palette is an important tool not only for preparing your paints but also for arranging them in a way that allows you to mix colors easily and understand the mixtures. Colors should be laid out on the palette as if they were in a color wheel so that you can see their relationships.

Metal is preferred for both hand-held palettes and the larger flat studio trays, because it allows the paint for washes to flow and puddle naturally on its surface. Plastic is cheaper and more readily available, but paint tends to bead up on its surface. This can be remedied somewhat by scuffing the surface with a steel cleansing pad. The "stay-wet" palettes on the market have covers that seal the palette and keep your wash mixtures from drying out. Made of a glossy metal that imitates tin palettes, they are very lightweight, which can be an advantage for outdoor painters who have a lot to carry.

Although Formica is not used in palette designs on the market, you can adapt it by cutting a piece to the shape and size you want, tacking it to a stiff board to flatten, and placing your colors around the outside edge. Formica can also be glued to a plastic hand-held palette to expand its very limited mixing areas. I have a very

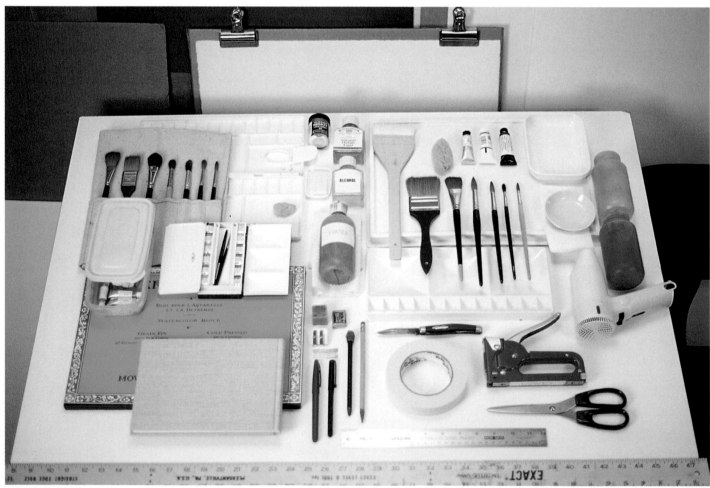

BASIC EQUIPMENT FOR STUDIO AND OUTDOOR WATERCOLOR PAINTING.

FOLDING PALETTES.

PLASTIC PALETTES AND METAL MIXING TRAY.

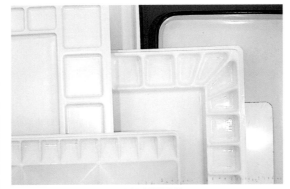

SCHMINCKE AND WINSOR & NEWTON WATERCOLOR KITS.

large—approximately 24 × 30"—Formica palette set up in my studio that I use for my large watercolors. Diluted paint will drip off the edges, so be prepared.

Most of the plastic hand-held palettes are designed for tube colors. The ones made of enameled tin are usually for dry cake colors, and many of them are generic enough to be used with any manufacturer's half- or full-pan cakes. Most of the hand-helds, especially the cheap fold-out plastic models in varying sizes, are not laid out very well. They are broken up into too many mixing compartments, which stifles the feeling needed for creating flowy wash mixtures.

Tin kits, whether equipped for dry cake or tube colors, have long been the ideal models among hand-held palettes, starting with the classic Winsor & Newton half-pan set used by Winslow Homer. Its design has the pigment pans in the middle, a fold-out mixing palette on one side, and three wash basins on the other. Some kits even come with small sable or sable-blend round brushes. Many artists like the folding enameled tin palettes offered by H. K. Holbein, which come in various sizes to suit differing needs. While expensive, metal palettes are durable and long-lasting. They are a lifetime investment.

SPONGES

Sponges have a multitude of functions in watercolor: lifting out colors, wetting down paper, laying in washes, blotting colors, making textures, and more. For painting purposes, use natural sponges, which come in different textures—fine to rough—and sizes and can hold an enormous amount of water and paint. The finer-textured sponges move more smoothly across a cold-pressed surface. Man-made sponges are suitable for cleaning palettes and brushes but not for painting, because they are too unresponsive on paper.

EASELS AND FURNITURE

Unless you are one of those artists who, like Turner, packs your humble art materials and belongings in a small sack or box and ventures out into the landscape, you probably need a little furniture to set up your work and make you more comfortable when painting. Stools and easels are the primary furniture needed to paint in the open air. You may want to sit on a stool and put your paint board on your lap and your palette on the ground or another stool, or you may prefer to stand in front of your easel. For the most part, I'm a sack carrier. When I find a scene I want to

NATURAL AND MAN-MADE SPONGES.

paint, I settle on a spot—rock, stump, or step, for instance—where I can sit and work. I especially like to stand next to a wall where I can lay my things out at waist level.

STOOLS

One of the most practical stools is the folding type shown below, which is lightweight and easy to carry. It has the additional convenience of a carrying case with pockets for brushes and equipment. There are a number of stools like this on the market.

WATERCOLOR EASELS

Watercolor easels come in a variety of styles in wood or aluminum. Many of them are rather flimsy and move too much while you are painting. The one I like most is the WC-10 Stanrite, which is based on a camera tripod design. It has a tilted bar with clamps that hold the painting board snugly. A screwdriver-like handle is used to adjust the tilt of the painting board, which can easily be changed even while you are in the midst of a painting. I have modified my easel by clamping my palette and cups to the bar on the side, making a very handy setup. It works great!

French-style, portable folding easels are great for working in the field because they set up

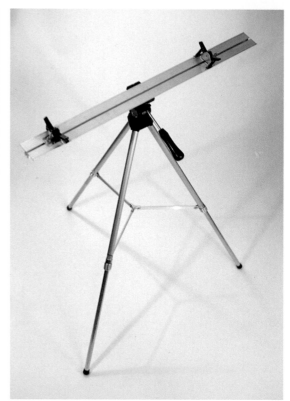

TRIPOD-TYPE EASEL.

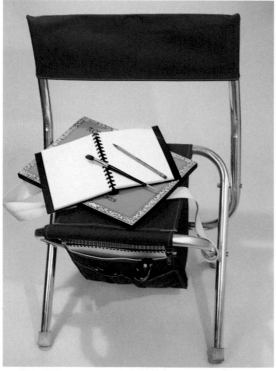

FOLDING STOOL.

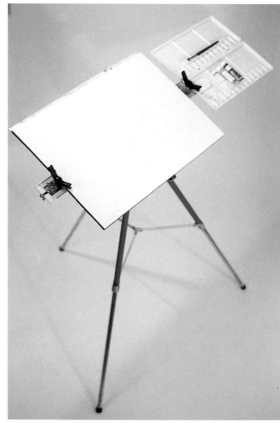

TRIPOD EASEL WITH PAINTING BOARD AND PALETTE CLAMPED IN PLACE.

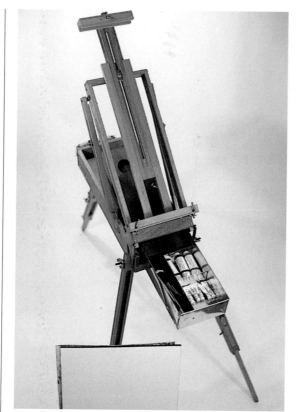

PORTABLE FOLDING FRENCH EASEL.

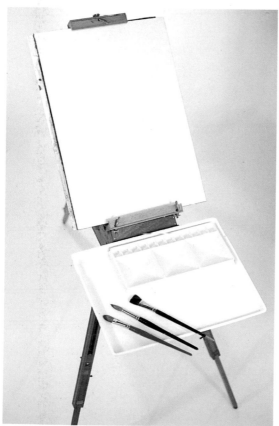

FRENCH EASEL SET UP FOR PAINTING.

easily. Made of wood, they have a drawer that holds your paints and slides out to hold your palette. The smaller, lighter models are more convenient for travel.

STUDIO ORGANIZATION

Your studio is an important space that should be organized to suit your personal working habits. The lighting—natural or artificial or both— and arrangement of all furniture and materials should create an atmosphere that not only feels comfortable but also facilitates the painting process. Watercolor is such a demanding medium that you should avoid any distractions that might interfere with your work. Arrange materials so you don't have to waste time and energy looking for things. Setting up and preparing your equipment can be used as a way of warming up for the start of a painting session, almost as if you were getting physically and mentally ready for a race. This is a method I use almost daily.

Organizing yourself to paint outdoors is just as important as efficient indoor studio setup but should involve less equipment. As discussed above, outdoor equipment should be chosen to support your working habits. Do you sit or stand in front of an easel or sit on a rock or wall? Do you cart everything out but the kitchen sink— practically the entire studio? How do you transport your equipment to the location? Get into a routine by setting up ahead of the moment you want to capture so that you don't bumble through the beginning of your painting trying to catch up with nature's changing effects. Setting up and painting outdoors exposes you to natural elements and passing observers. This goes with the territory, so get used to it!

Most artists organize their tools differently for working outdoors. Some even appear to have no organization, but they know where everything is and have developed a consistent, practical, habitual working approach. The placement of your brushes, water, and palette is the very first order of business. Brushes should be laid out in an order so that each can be used for its specific purpose. The rounds should be separated for light and dark color use, and the flats the same way. The arrangement of your brushes should become natural to you—like a knife, fork, and spoon on a table—so that you can change them without thought. With consistent organization of your tools, you will be able to move fluidly through the process of developing and completing your painting.

BASIC SKILLS

Before you can begin painting in watercolor, you need to gain a grasp of certain key artistic principles that make it possible to communicate your visual ideas successfully. Among these basic concepts are line and shape, value, design, perspective, and composition. Drawing, of course, is always an important tool no matter what medium you choose to work in, so I have emphasized it here; with drawing you can explore the ideas in your mind's eye freely before committing them to paint. Altogether, this chapter is meant to help you hone your visual skills in preparation for creating fully realized watercolor paintings.

THE SKETCHBOOK

The sketchbook is an artist's personal diary of the visual events he or she finds significant. Using whatever medium is convenient, you draw or otherwise record information vital to expressing your thoughts and first impressions in a kind of shorthand. The idea is to "get it down" in a language that sometimes only you yourself can decipher. Drawing, note taking, and sketching in watercolor in a sketchbook can be a useful means for sharpening your visual skills and developing painting ideas. There is nothing on the line when you're working in your sketchbook; you're accountable only to yourself.

Shown here are a few pages from the sketchbooks of several different artists, giving you a glimpse into each one's unique and highly personal approach to visual thinking.

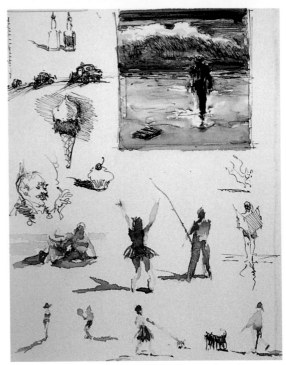

Wayne Thiebaud, SKETCHBOOK. Courtesy the artist.

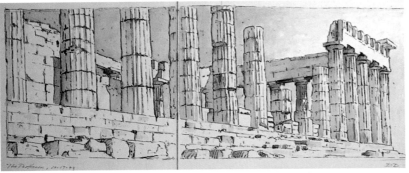

David Dewey, SKETCHBOOK, THE PARTHENON, 10-17-93.

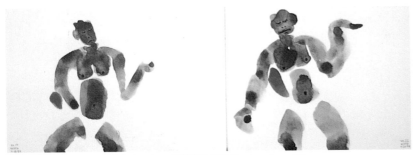

Chris Annalora, SKETCHBOOK. Courtesy the artist.

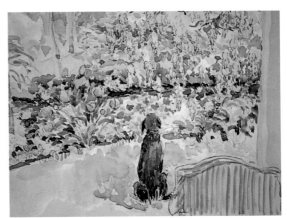

Joan Brady, GARDEN SKETCHBOOK. Courtesy the artist.

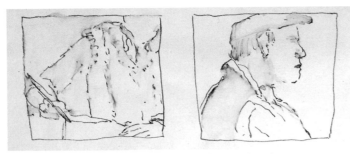

George Wingate, SKETCHBOOK. Courtesy the artist.

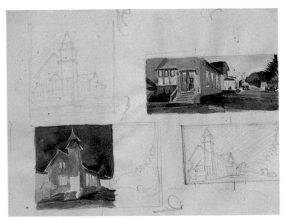

Paul Rickert, SKETCHBOOK. Courtesy the artist.

Drawing: A Visual Language

Drawing is a graphic language and a valuable tool of preparation for watercolor. It's a skill of the eye, the hand, and the mind's eye. The eye perceives images in space, the mind's eye interprets and configures an idea (a process called visual thinking), and the hand brings graphic life to the perceived idea. Though eye-to-hand skill deserves great respect and requires constant practice, it is the mind's eye, the inner eye, that must be at work constantly to give credible form to visual impressions.

To convey your vision clearly, you must use the language of drawing in a visually coherent way. Its vocabulary—line, value, shape, depth, symmetry, and design—are the terms through which visual responses must be perceived and graphically stated. Naturally, you have to understand these terms and certain governing principles before you can use them effectively in communication.

Drawing lets you lay a groundwork that will facilitate the painting process. With drawing, you can establish the basic shapes of your composition while anticipating the painting's eventual color activity; in turn, the painting responds to the drawing's direction. Drawing and painting are partners eternally linked together by a common visual purpose. If painting is the heart, then drawing is the head that steadies the emotion, allowing it full yet thoughtful expression.

Demonstration: Line and Shape

Line and shape are the written words of drawing that define the boundaries of perceived images in the field of view. When line encloses the contour of a form on a two-dimensional surface, it creates a shape-pattern that conveys the form's primary visual character. For the shape to appear, it must first be clear in your mind's eye. If you don't understand what you are observing, then you cannot write it down with clarity. The drawn shape, then, is a highly crystallized pattern that is easily interpreted with the eye. It must have a simplicity of an almost geometric nature.

For this reason, drawing courses traditionally begin with the drawing of basic geometric forms. Beginning students learn to recognize that these familiar forms are common to all objects, animate and inanimate. They are the abstract building blocks of drawing and painting and enable you to look at a scene as a collection of shapes, not as it

is normally viewed. By learning to apply basic geometric forms to complex subjects, you can comprehend what and how to draw. For this reason, I have chosen the paper cup, a simple form, as a means of conveying the basic language of drawing.

This photo shows a paper cup as a three-dimensional form in space. Since drawing and painting are done on a two-dimensional surface, the cup must first be seen as a two-dimensional shape.

The shape of the cup is drawn with a contour line. Learning to look past the natural appearance of an object and seeing only its shape takes visual discipline and is the first step in drawing and painting.

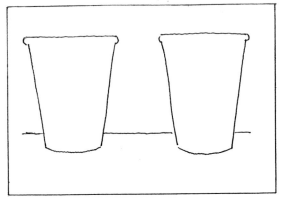

Proximity and connection. *In this illustration, two cups drawn in contour line are placed next to each other, giving shape to the space between them, which is called a negative shape. The proximity of objects to each other should allow the eye to perceive the inner and outer, or positive and negative, shapes almost equally. You should feel visually comfortable on both sides of the lines. Line is also used to connect objects to space; here, the horizontal line joins the cups to the surrounding space. The cups' contours link up with the horizontal line outside their shapes, merging into a unit and creating a composition.*

Closure and negative contour drawing. *In this drawing, the shapes of the cups are drawn with negative contour line. The eye mentally fills in the line on the outside of each cup, creating a sense of closure. This technique enhances the visualization of compositional space. It leaves the eye to wander freely throughout the pictorial space of the drawing.*

**Giorgio Morandi,
UNTITLED, STILL LIFE.**
Graphite on paper,
5³/4 × 9¹/4"
(14.6 × 23.5 cm).
Courtesy Stephen Haller
Gallery, New York City.

In this drawing, Giorgio Morandi uses proximity and linear connection to tie still life forms together in space. Space and objects are given equal attention: the character of each shape is defined by its adjacent space and is written into a poetic whole. This approach is important in laying the foundation for painting watercolors. In a composition, individual shapes must give way to an overall pattern.

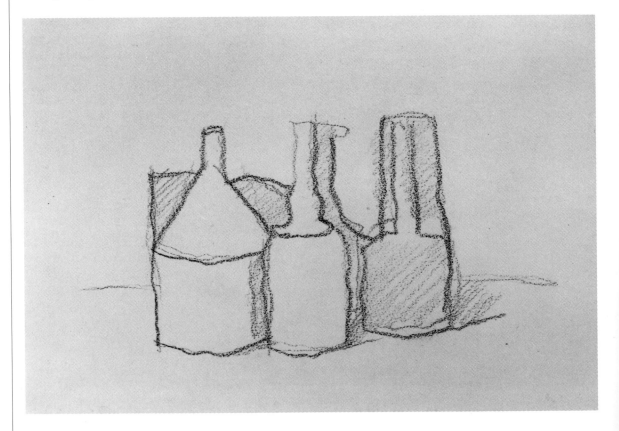

LIGHT AND DARK

Value, or tone, refers to lightness and darkness. In terms of black and white, white represents the lightest value and black the darkest, with virtually infinite gradations of gray between them. All values are relative, with each value made to seem lighter or darker by contrast with its neighboring tone.

A myriad of values is what we usually see first when observing the surface of an object, and what we see depends on the light source and its effect on the object in view. The type of light and the angle of its rays relative to a given object result in the various shadows and highlights that allow us to read the object's form and the space it occupies. For this reason, understanding value, light, and shadow is key to being able to express volume, depth, and weight in drawing and painting.

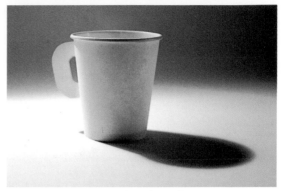

Light and shadow. *In this photo, the paper cup is defined by light and shadow. A predetermined scale of values must be applied to simplify and restate the observed form in space.*

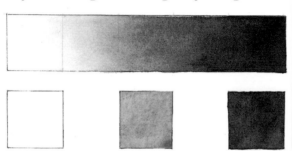

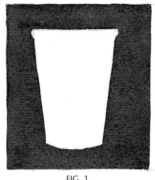

Value scale. *A gray scale showing the light, middle, and dark tonal transitions between the extremes of white and black is helpful in measuring the values of your subject and in planning the visual direction your composition will take. Use it like a sextant to navigate your way through your subject—to break down observed tones and organize and balance them in your composition.*

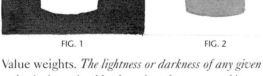
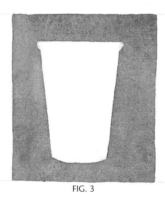

FIG. 1	FIG. 2	FIG. 3	FIG. 4

Value weights. *The lightness or darkness of any given value is determined by the values that surround it, and in such a relationship, each value has an assigned weight that is important in compositional arrangement. The higher the contrast between two values, the greater the weighted presence of each, as in fig. 1, where white, the lightest value, is placed against black, the darkest, and in fig. 4, where the opposite occurs. A lesser contrast diminishes the weight of both values, as in fig. 2, where a middle gray value is placed against white and, in fig. 3, vice-versa. However, the way lighter and darker values are juxtaposed affects optical perception. Note here how* in figs. 1 and 3, *the white cup appears larger against the black and gray backgrounds than the gray and black cups do against the white backgrounds; this is due to the magnifying effect of a dark surrounding space and the constricting pressure of a white environment. White against black is the most forceful weight and demands the most consideration in design. When composing pictures, you may need to adjust the proportions of the shapes according to these value dynamics. Depth—the feeling of three-dimensional space—is also dependent on value contrast. The wider the range of contrasting values, the greater the sense of depth in a composition.*

LIGHT AND DARK

A contour line drawing establishes the relationship between the inner and outer patterns of the objects and the space they occupy in anticipation of the value-weight contrasts in the composition.

Generally in watercolor you work from light to dark, but here I did the opposite as I painted in the background at left and the cup at right. Note how the dark, negative space around the white cups appears to define their shapes as volumes, projecting them forward.

I added middle tones next, moving back and forth across the picture plane to get a feeling for the balance of value weights in the composition.

The final tones, applied with attention to the preceding ones, were added to give volume to the cups and increase the richness of the drawing. Notice the closure effect in the lower left of the middle cup.

DEMONSTRATION: FROM LINE TO VALUE

Let's continue with the paper cup as our subject in attempting to grasp the importance and uses of value in composition. In this demonstration, we progress from a line drawing of four paper cups that establishes their shapes and positions in the composition to incorporating value gradations that express their weight and volume in three-dimensional space.

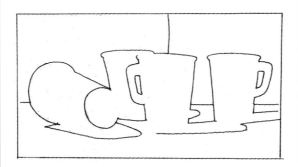

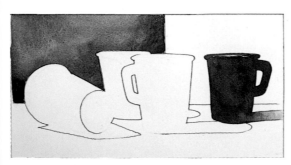

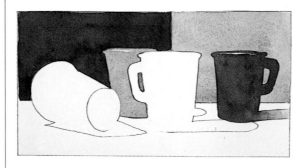

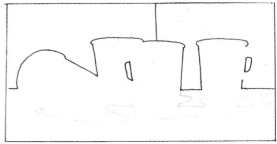

Here, in another approach to the same composition, the negative contour lines are drawn across the top "skyline" of the cups, binding the key negative and positive shapes together.

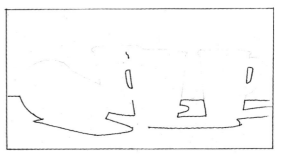

In this example the outer negative patterns of the composition's lower profile are developed. Since working monochromatically—in one color—is done almost entirely through negative means, starting this way will help you think of your drawing more visually than descriptively.

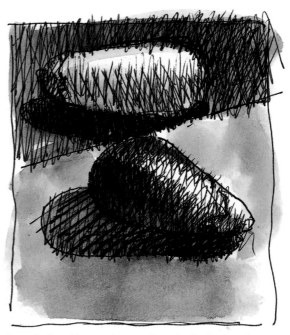

I made the white eggplant against the dark ground smaller than the dark eggplant against the light ground for balance: although the white shape is smaller, its value weight is increased by the dark background to equal the larger eggplant, thus creating a more successful design.

Design

To design is to identify shapes and arrange them in a cohesive order, or composition. Designing is both a right- and left-brain process. It draws on the artist's understanding of the principles governing good design, as well as on intuition, the innate sense that allows one to come to successful visual conclusions. Although the latter is more important, it does not work well without the influence of the former. The intuitive eye, however, has the final say in all decisions. Knowledge alone is not a prescription for good design.

Symmetry—the balancing of opposing parts in size, shape, and position—is at the very heart of design. Asymmetry refers to imbalance and disorder. These opposing concepts work together in a paradoxical tension that is essential to good design. A picture that has symmetry without this tension is predictable and boring, whereas a design that feels balanced yet looks asymmetrically off-balance is exciting. Good design keeps you on the edge of your seat!

Design must take into account the division of the picture plane, or two-dimensional surface, and the shape and value patterns of your subject. It is how you combine and order these elements that determines the success of your composition.

Demonstration: Spatial Division

The way you divide the picture plane, or two-dimensional surface of your composition, is key to successful design. With the paper cup as our subject once again, let's take a look at three different possible spatial divisions.

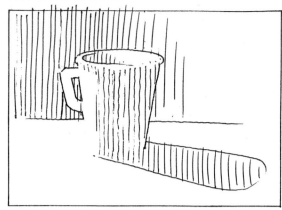

Here, the symmetrical division of the picture plane is used to give a pivotal balance to staggered, uneven weights. This is an asymmetrical design solution. In this off-balance approach, the uneven weights are kept from becoming completely asymmetrical by the central pivot of the picture plane. This creates a tension in the design and increases visual interest. The values move the eye back and forth across the middle, as does the linear direction of the shadow and cup handle—almost, but not quite, losing balance. This makes for exciting design.

In this example the visual tension is increased by the addition of a second cup and greater value extension. An off-center or staggered design must be given a symmetrical stability without spoiling the fun.

Dividing the picture plane into two equal parts gives it a central point on which to balance the composition. Although an evenly divided composition is balanced, it is also static and boring, as this example shows.

OPEN AND CLOSED COMPOSITION

The way the picture plane frames the objects within it determines whether the composition is "open" or "closed." The composition shown below is an open one; it is cropped the way a photograph might be so that shapes inside the picture plane are partially to completely cut off by its edges, resulting in an abstract, two-dimensional positive-negative effect. The edges of the drawing become important to the design and are considered equal to the contour edges of the interior shapes. As the line of a shape in an open design is stopped by the cropping edge of the picture plane, the eye follows the edge until it meets another line to bring it back into the picture plane, thus creating a shape. Open compositions are difficult to see with the naked eye, but using a viewfinder or camera can help.

Closed compositions are more traditional; in them, all of the shapes are contained within the picture plane. Compare the open composition shown here with its closed counterpart on page 40. The shape of the picture plane itself is just as important to design considerations as the shapes within it.

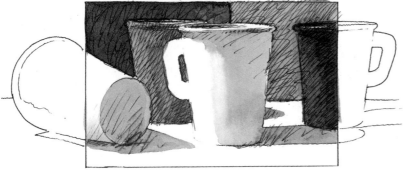

In an open composition, objects are cropped by the edges of the picture plane.

DEMONSTRATION: CREATING BALANCE WITH SHAPE AND VALUE

As mentioned above, design also involves organizing shapes and values so that their various weights balance one another to form a pleasing whole. This demonstration shows how linear and value patterns are made to work in concert in building a composition that is visually satisfying.

This abstract design, done as a study for the finished wash drawing Cristoforo Arches with Cypress *opposite, illustrates how light, dark, and middle-value shapes vary in weight according to their proportionate sizes and juxtapositions.*

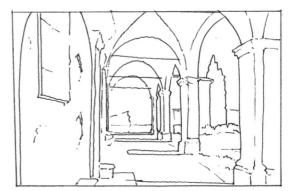

In this contour drawing, line is used to indicate patterns of light and shadow, not just the architecture.

This is an example of what I call "painting the light," which is the foundation of tone drawings and watercolors. The middle values are painted in to establish a feeling of the total design.

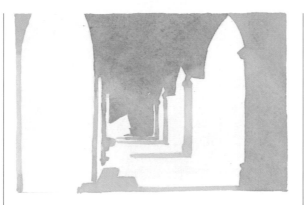

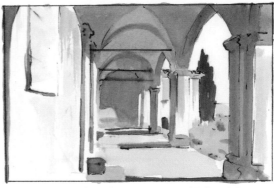

The dark tones are placed mostly in light spaces. They move the eye around the composition and give greater brilliance to the white sunlight and add depth to the drawing.

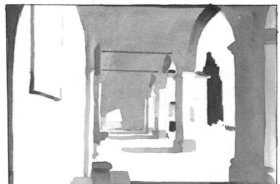

Line and layered touches of tone are added to define the physical characteristics of the subject and give more depth and visual richness to the drawing. When adding descriptive touches, always keep the visual integrity of the design in mind, and never do it for description alone.

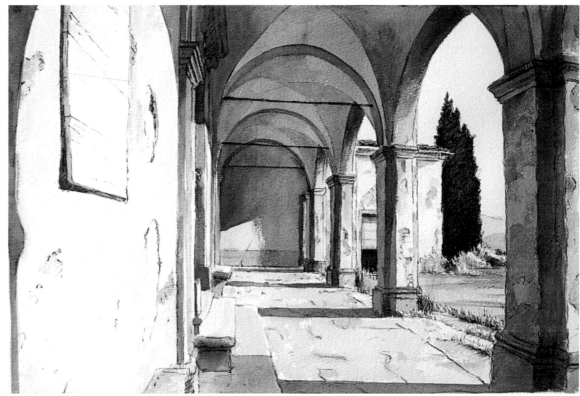

David Dewey, CRISTOFORO ARCHES WITH CYPRESS.
Pen and wash on paper,
15¹/2 × 21¹/2" (39.4 × 54.6 cm), 1992.
Collection of Ann Bernhard.

PERSPECTIVE

Perspective is the system of representing three-dimensional objects on a two-dimensional surface. Often called linear perspective, it uses geometry to show how near and far objects appear to the eye. Perspective was first applied to artwork during the Renaissance, beginning with the pioneering efforts of the great Italian masters Filippo Brunelleschi and Leon Battista Alberti. Since perspective's primary function is on the picture plane, the shape of the picture plane has come to be used in perspective drawing as a frame for viewing and reading space. The picture frame, or window, is useful in two ways when you are working with perspective. Seeing the subject through the frame makes linear perspective readable, and it also helps you visualize the scene as a design.

The two types of perspective that are illustrated here are one- and two-point. Each is viewed through a frame to clarify both the visual and the design aspects of perspective.

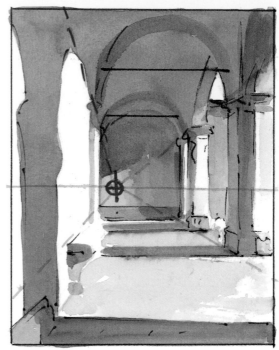

In this one-point perspective drawing, everything moves toward the vanishing point in the central square.

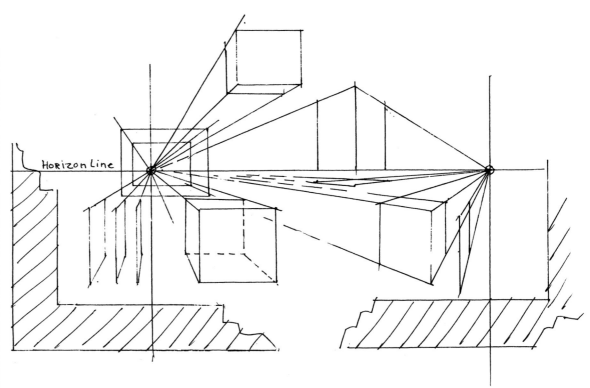

Horizon Line

One- and two-point perspective. *In the left-hand part of this illustration, the horizontals are parallel to the viewer; the point on the horizon line is established by your vertical position in space. Points on geometric shapes are lined up and drawn toward the point on the horizon line, giving a one-point view. In a two-point perspective view, as shown here at right, shapes are at an oblique angle to the picture plane. Their angles are read against the horizontal of the picture plane, then followed to their two points on the horizon line. You must accurately read the angle at the base or top of the shape to find your points.*

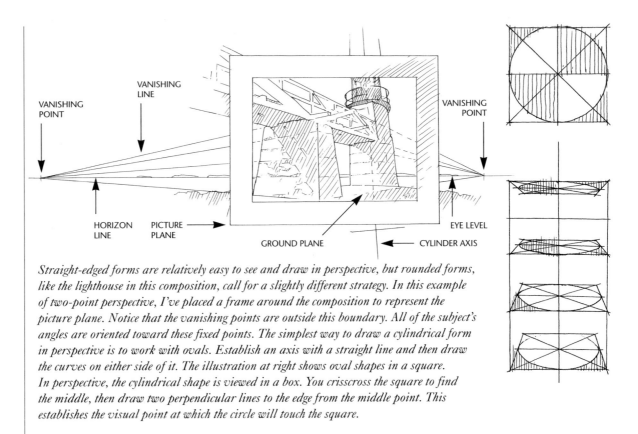

VANISHING
POINT

VANISHING
LINE

VANISHING
POINT

HORIZON
LINE

PICTURE
PLANE

EYE LEVEL

GROUND PLANE

CYLINDER AXIS

Straight-edged forms are relatively easy to see and draw in perspective, but rounded forms, like the lighthouse in this composition, call for a slightly different strategy. In this example of two-point perspective, I've placed a frame around the composition to represent the picture plane. Notice that the vanishing points are outside this boundary. All of the subject's angles are oriented toward these fixed points. The simplest way to draw a cylindrical form in perspective is to work with ovals. Establish an axis with a straight line and then draw the curves on either side of it. The illustration at right shows oval shapes in a square. In perspective, the cylindrical shape is viewed in a box. You crisscross the square to find the middle, then draw two perpendicular lines to the edge from the middle point. This establishes the visual point at which the circle will touch the square.

**David Dewey,
MARSHALL'S POINT
LIGHT, A.M.**
Watercolor on paper,
12¹/₄ × 16"
(31.1 × 40.6 cm).
Collection of Phillip
Descind.

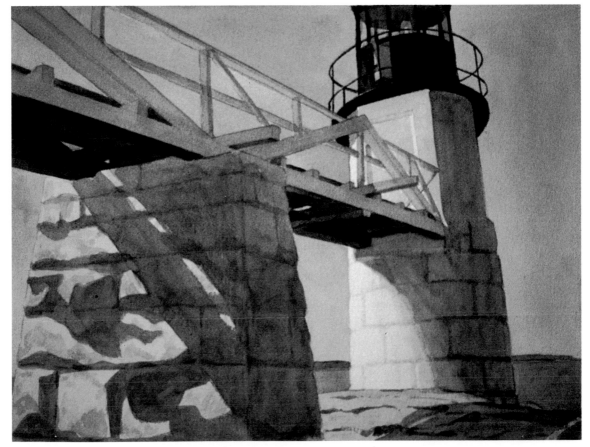

COMPOSING IN PRACTICE

The first step in composing a picture is to find the rhythmic relationships in your subject and capture them in a drawing that addresses the arrangement of all elements in two-dimensional space. Establishing these things in a drawing before you begin to paint is vital to achieving a satisfying conclusion in watercolor.

DEMONSTRATION

The following demonstration, with a rocky harbor as my subject, shows the drawing and design methods used to organize the picture plane and lay the foundation for a watercolor composition.

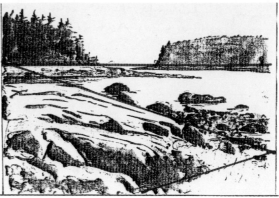

The zigzag line represents the division of the compositional space and also the rhythmic alignment of the parts of the harborscape.

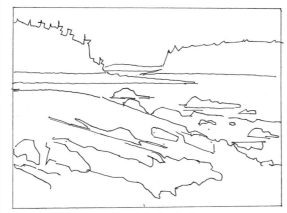

I began with a drawing of the harbor's contour patterns.

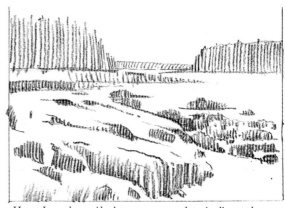

Here, I used pencil almost as a wash to indicate the patterns of light and dark and establish their balance for the final watercolor.

David Dewey,
EARLY MORNING,
TENANTS HARBOR, ME.
Watercolor on paper,
8 × 10" (20.3 × 25.4 cm).

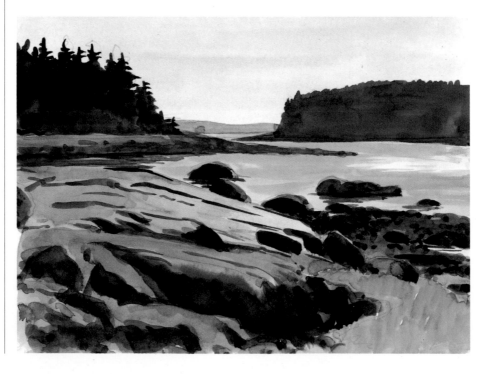

SEEING ABSTRACT STRUCTURE

One the most difficult concepts for drawing and painting students to understand is the underlying abstract character of their subjects. To represent a subject in watercolor, you must peel away its descriptive surface to see its abstract structure. This can be done by identifying the patterns of light and dark on the surfaces of objects and letting those patterns form a compositional scheme in your mind's eye. Once you have a clear vision of this structure, you can then translate your subject's patterns into paint. The ability to see abstractly is critical to how you begin a painting.

I have always felt that this initial stage of composition is best illustrated by an incident that happened while I was painting a watercolor outdoors. A man came upon me while my painting was at an early stage of development. I had laid in the first colored wash patterns and was about to paint into their shapes. The man, after looking at the painting from every conceivable angle, exclaimed as he walked away, "I can't make head or tail out of that picture." He was right! The painting was in its infant stage of development. The man was seeing the painting through literal eyes, whereas the watercolor at that time expressed only the patterns of its subject.

I based this study in indigo on a Paul Strand photograph titled Abstraction, *which is a beautiful composition of white and dark tones. The representational forms give way to the strong influence of light and dark shapes in the design. I have always found this example to be an excellent aid to understanding the abstract influence of light and dark in design.*

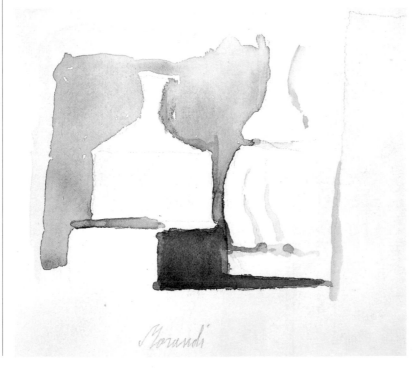

**Giorgio Morandi,
UNTITLED, STILL LIFE.**
Watercolor on paper,
7³/₄ × 8¹/₄" (19.7 × 21 cm), 1958.
Courtesy Stephen Haller Gallery,
New York City.

In the watercolors of Giorgio Morandi, representational forms are painted with such simplicity that abstraction and reality become one.

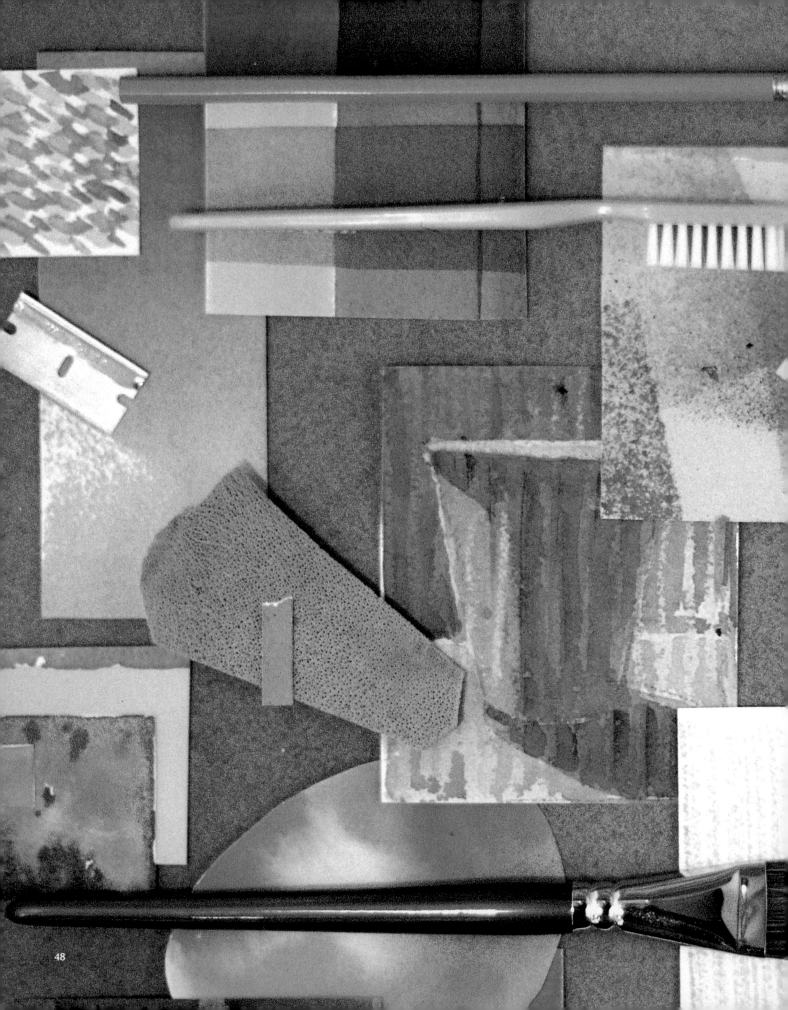

WATERCOLOR PAINTING TECHNIQUES

Painting with watercolor is a paradoxical experience, one in which you are caught between the conflicting goals of attempting to maintain skillful control of the medium while also allowing it to flow freely and expressively. When you are just beginning, this paradox proves very frustrating, but in time, once you become more comfortable with the medium's contradictions, you will begin to achieve satisfying results. There are numerous technical skills and visual concepts to be learned and mastered in this process, yet as you put them into practice, you will be trying simultaneously to set the medium free in your paintings. Such widely admired masters as Winslow Homer, John Singer Sargent, and Edward Hopper handled the technical aspects of watercolor with a seeming ease that allowed them to attain the medium's fullest potential in their work.

This chapter covers the basic techniques for handling watercolor paint, from laying various types of washes to glazing and layering, preserving white, working with different brushstrokes, creating textural effects, and using lifting and resist techniques.

Traditional Wash Drawings

Traditional wash drawings done with earth pigments are the precursor to and no doubt the inspiration for modern watercolor. The transparent, luminous quality of wash drawings done by such 17th-century masters as Claude Lorrain, Nicolas Poussin, and Rembrandt represents the very essence of watercolor's communicative power. In these drawings, sunlight was expressed as white paper, and brushed-in washes of contrasting darks created subtle to vibrant tonal structures. These early masters were succeeded by 18th-century artists like Francesco Guardi and Giovanni Canaletto, who added radiant red ink lines to gray earth colors in stunning interpretations of Venice. The combination of red and blue tones that became popular brought us a step closer to the warm and cool effects used in modern watercolor paintings.

I have found these drawing methods to be an exciting way of creating expressive works of art, as well as a means of developing on-location ideas for studio watercolors. The pens and pigments I use are modern-day materials, but my inspiration comes from tradition.

The combination of red pen with blue-gray watercolor creates fluid warm and cool effects. The darker lines are drawn over the semiwet washes to give greater depth and color.

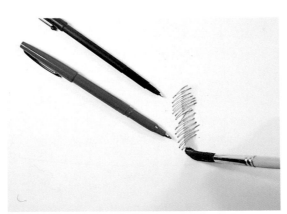

The materials used in traditional wash methods are common ceramic- and acrylic-tipped pens with water-soluble brown and black ink, the kind sold in most stationery and art supply stores. After the pen lines are drawn on the paper, a brush loaded with water is quickly washed over them to create a toned wash. The more lines there are, the more intense the wash.

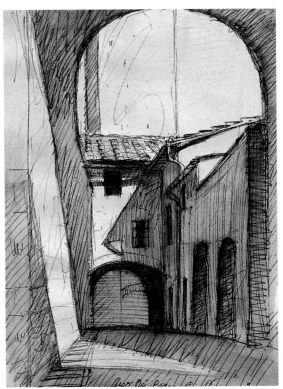

David Dewey,
SAN GIMIGNANO ARCH, ITALY.
Pen and wash (sketchbook drawing), 1992.

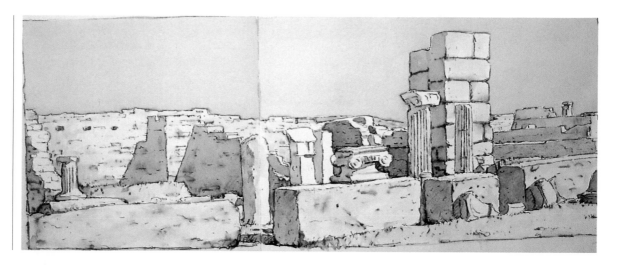

David Dewey,
RUINS AT DELOS.
Red ink and watercolor
(sketchbook painting),
1992.

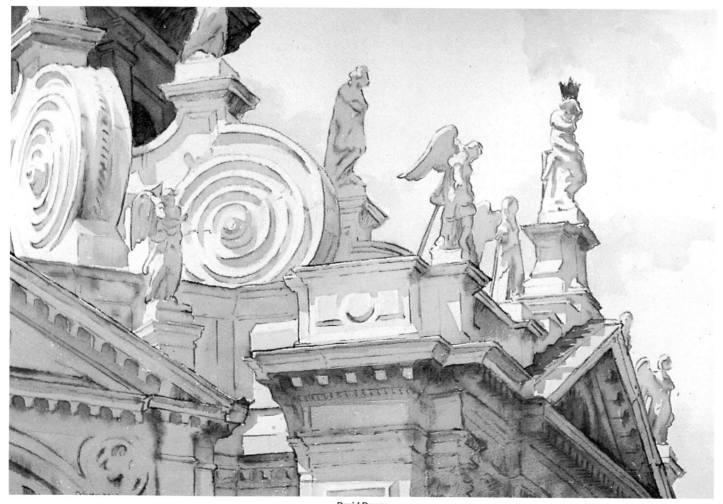

David Dewey,
SANTA MARIA DELLA SALUTE, VENICE.
Ink and watercolor,
13 × 19¹/₂" (33 × 49.5 cm), 1992.
Courtesy Tatistcheff Gallery, New York City.

Basic Wash Methods

Washes can be applied in a number of ways to achieve different effects. The wet-on-wet and wet-on-dry wash methods demonstrated here and on the following pages are the most demanding of watercolor techniques, calling for great skill and discipline and resulting in the finest expression of this medium's fundamental qualities. The ability to employ several skills at once must be mastered for consistently good results—no small task! The physical appearance of a wash is dependent on three important factors:

Brush speed and control. The brush should always move across the paper in a smooth, deft, horizontal stroke. It should touch the paper softly—at the tip, not the heel. The speed of the stroke depends on the weight, texture, and sizing of the paper and the wash method being used. The brush you use is also important; it should be a soft flat, round, or oval one-stroke brush in a size that fits the paper's dimensions.

Wash mixture. The proportion of paint to water is critical to the consistency of graded and flat washes; just the right amount—depending on the method used—of paint and water is needed to allow the brush to move fluidly.

Painting surface position. The angle of the painting surface is critical to the direction and movement of the applied wash. One or several angles may be necessary in any given wash; timing is important!

The materials you will need for painting are as follows:
- Drawing board
- Watercolor paints
- Brushes: round #10, 12, 14; 1" flat; 1/2" oval wash brush
- Palette and color mixing pans
- Two cups for water
- Paper: 140-lb. cold-pressed or watercolor block
- Pencil and eraser
- Soft paper towels
- Natural sponge

Demonstration: Wet-on-Wet Flat Wash

With this type of wash you wet the paper with water first, which makes it possible to create a seamless, perfectly uniform value without evidence of individual brushstrokes. Practice making sweeping strokes to get a flat, even tone.

Lay a sheet of watercolor paper flat on the painting board and sponge down the surface until it is moist.

Using an oval brush, pick up diluted color and apply it to the paper's surface, moving the brush smoothly back and forth from top to bottom to get an even, continuous tone.

Tilt the board up at a slight angle to let the paint bleed evenly.

Completed wash.

DEMONSTRATION: WET-ON-WET GRADED WASH

A graded wash—one that goes from dark to light—starts out the same way as a flat wash, but as it progresses you add water to your paint mixture with each successive brushstroke, thereby lightening the color.

Stroke the top of the surface one more time if a stronger gradation is desired.

Moisten the surface of your paper evenly with a sponge until it is damp to wet.

Lay the painting board flat and, using an oval brush loaded with your wash mixture, stroke color across the top of the paper, moving quickly and smoothly back and forth two or three times.

Finally, tilt the board up at a 40-degree angle and let the wet paint run downward. Sometimes it is necessary to pick up excess paint at the bottom with a brush or paper towel.

Quickly dilute the paint in the brush with water to lighten the value, then continue stroking evenly back and forth about halfway down the paper. The brush should not be too loaded or the paint will bleed unevenly.

Completed wash.

BASIC WASH METHODS

Tilt the painting board slightly and, using an oval brush, stroke color across the paper (but not too fast) to make an even tone, leaving a bead of wet paint at the bottom of the stroke. The brush should be loaded enough to leave the bead, but the paint should not run. A few drops of ox gall can be added to the wash for better flow and evenness of tone.

Apply the paint carefully each time, moving across the paper and touching the previous bead so as to maintain an even, seamless tone. If the paper seems to drag the brush as it moves across the paper and pricks of white start to show, slow the stroke down to allow for better coverage. In this technique, it is critical to make the brushstrokes with a light, deft touch. You should try to move the brush rhythmically and experience a sensual feeling in touching the paint surface.

DEMONSTRATION: WET-ON-DRY FLAT WASH

When you lay a wash on dry paper, individual brushstrokes may remain visible, but this can contribute a lively quality to your work. Be sure to drag your brush across the full width of the area you want to cover, and work quickly so that the bottom of each brushstroke doesn't have time to dry and form a hard edge before you continue with the next one.

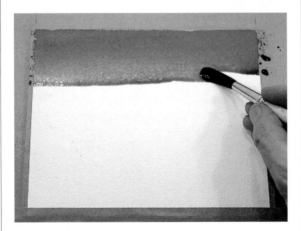

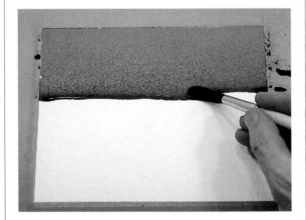

Pick up the excess paint with a clean, damp brush.

Completed wash.

DEMONSTRATION: WET-ON-DRY GRADED WASH

When laying a graded wash on dry paper, it's critical that you add more water gradually every two to three strokes to keep the gradation as even you can. Too radical a jump in the value level will result in uneven bands of tone.

The last few strokes should be very light-toned to clear washes, since the deeper, upper tone will tend to bleed downward.

Tilt the painting board up at a 40-degree angle and, with an oval brush loaded with color, move the brush across the top of the paper and back.

Completed wash.

Continue brushing across the paper with a lighter tone (paint diluted with more water), overlapping each brushstroke with the bead of wet paint from the preceding one and moving at an even pace across the paper.

Preserving White

The whiteness of the watercolor paper is the light source beneath transparent colors. It illuminates and transforms the colors painted on its surface. Although the texture, sizing, weight, and shape of the paper are all important, nothing affects watercolor more than the brilliance of the white surface.

There are two important watercolor principles regarding the white of the paper: the first is to maintain the transparency of the colors you apply to it; the second is to utilize the powerful effect of pure white shapes and highlights in the overall design of the painting. It is the latter principle that is focused on here.

White is most brilliant when it is strategically juxtaposed with dark color. In watercolor, using white to represent light as well as an object's local (actual) color can add great impact to a painting, an effect sometimes referred to as "popping the whites." Early masters of the medium used white freely throughout their wash drawings, especially to indicate areas of direct sunlight.

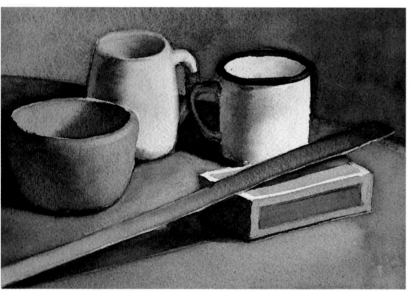

Mary Bucher, STILL LIFE.
Watercolor on paper,
6 × 8¼" (15.2 × 21 cm).
Courtesy the artist.

In this work, executed in monochromatic washes of French ultramarine blue, whites are preserved as the lightest value and appear especially brilliant where juxtaposed with a very dark value.

Demonstration

In the following three-step sequence, emphasis is placed on the way light and shadow patterns on the contours of the various objects reveal their forms. White is my lightest value and represents the direction of the composition's light source.

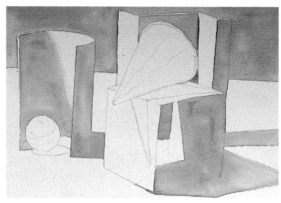

This first illustration shows the middle-toned wash patterns laid in to establish the underlying compositional character of the painting. Note how this stage determines the influence of the weight of the whites in the picture.

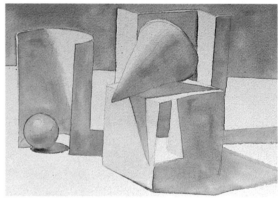

Here the forms are more complete and the darks begin to give depth and noticeable power to the composition.

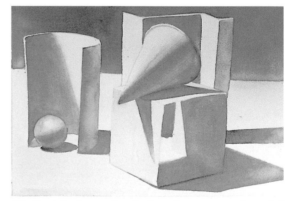

The final darks are placed where sharp contrast is needed to boost the role of the whites in the painting's design.

PAINTING GEOMETRIC FORMS

Observing geometric forms and capturing them on paper conditions you to look beneath the skin of the real world and identify its underlying structures, which are just variations of these basic geometric components. Seeing real objects in these terms helps you simplify what you are attempting to paint.

Describing three-dimensional forms on a two-dimensional surface calls for arranging light, middle, and dark values so that they accurately express the contours, angles, and depth of your subject and its position in space. The next few demonstrations, based on the photograph shown below, illustrate how to build form with value using monochromatic washes. Each begins with a line drawing of the specific group of shapes and their shadow patterns.

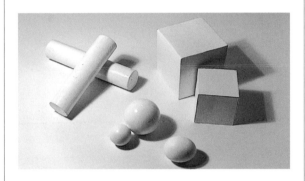

Three basic geometric forms: the cube, sphere, and cylinder.

DEMONSTRATION: CUBES

Learning to paint the cube will enable you to render buildings, tables, and any other objects that have sides joining at right angles. Here, I paint two cubes in values of French ultramarine using the wet-on-dry technique.

Tilting my painting board up slightly and using a round brush loaded with diluted color, I paint in the front plane and cast shadow of the background cube as a single, continuous shape. I start at the top and move downward, then soften the outside edges of the shadows.

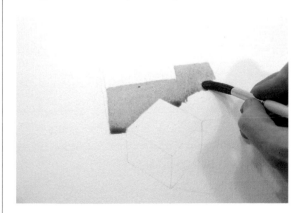

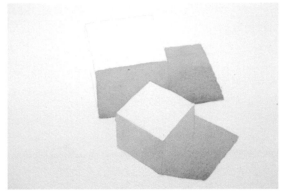

Using the same light value and technique, I paint in the two side planes and cast shadow of the foreground cube, rendering them as a single shape.

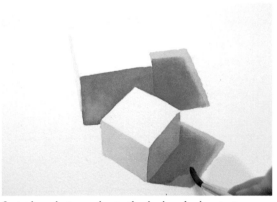

I apply a deeper value to the darker shadow pattern on the background cube and quickly soften the inner edge with a clean, wet brush. This pushes the foreground cube closer to the viewer, creating a sense of spatial depth. Then I apply a middle-value wash to the right-hand plane of the foreground cube, softening the edges with water. I add a darker value to the foreground cube's cast shadow and soften the edge where it meets the form. This final value contrast gives the painting depth.

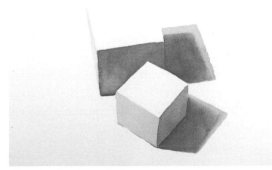

Completed value painting.

PAINTING GEOMETRIC FORMS

DEMONSTRATION: SPHERES

Spheres are present in the world all around us—from the obvious form of a baseball or an orange to the less evident spherical form of a cat's head or a walnut. The techniques you use to create the illusion of a three-dimensional sphere can also be applied to less perfectly round objects, such as a football or an avocado, and to half-round objects like an umbrella or a bowl.

With the spheres' shadow patterns facing toward me, I wet the area just above the middle edge of the top sphere with clear water, keeping the brush at hand. I apply a middle-value wash of raw sienna, starting just below the dampened area and working quickly down and around to the bottom of the egg shape. Color will bleed up toward the dampened area, creating a soft edge between the highlight and shadow on the form. (I call this technique wet-over/paint-under the contour.) With a clean, wet brush, I soften the bottom edge of the egg to create a seamless appearance.

While the paint is still wet, I soften the lower edges of the shadow patterns. I then wet the area above the inside contour of the third sphere and paint it, moving up to just below the drawn contour. I let the color bleed and soften, reshaping edges with a clean, wet brush.

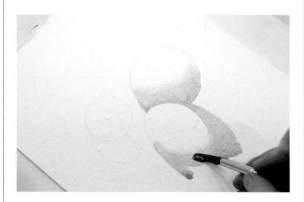

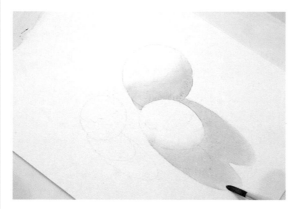

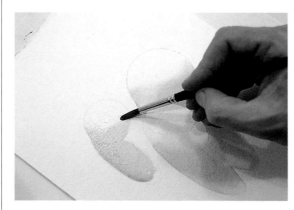

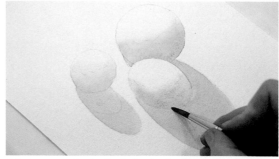

I begin to apply the darks in the shadows, which give depth and form. I move in the same sequence as with the lighter-toned washes.

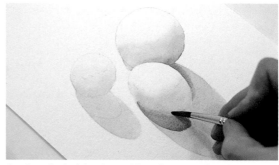

I soften the inside edges with a clean, wet brush.

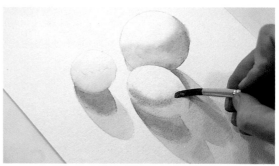

With my board at a lesser angle and the paint less diluted, I add dark touches of color for the core shadows, giving the spheres volume. This is done by wetting both sides of the middle contour lines and then painting right on the lines. The tone will then bleed both ways.

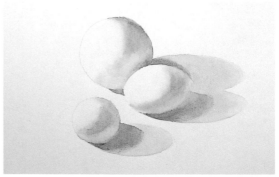

Completed value painting.

DEMONSTRATION: CYLINDERS

Cylinders have rounded edges like spheres, but they also have flat planes on their ends. So they require a combination of skills you have learned from rendering spheres and cubes. By mastering the cylinder, you will be able to take on simple cylindrical forms like telephone poles and pencils, then apply your experience to more complex forms like fingers and other parts of the body.

After drawing the shapes of the cylinders and their light and shadow patterns, I dampen the highlight area (upper contour) of the top cylinder with a brush dipped in clear water. Then I apply a middle tone of mauve just below the dampened area and allow the color to stain upward.

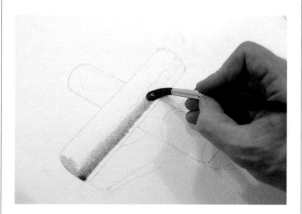

Continuing with the same cylinder, I seam its contour shadow to the bottom of the form and, using the wet-on-dry technique, quickly paint the cast shadow, bringing it up and over the middle of the second cylinder's form. I stop, then soften the outside parts of the shadows.

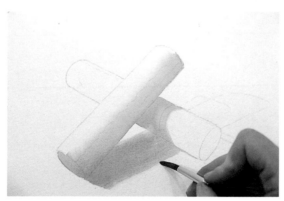

Working wet-on-dry, I paint the rest of the cast shadow behind the lower cylinder, then move down to paint the front end of this form. I keep the bead of wet wash active so the paint continues to move fluidly to the end of the shape. Then I soften the edges.

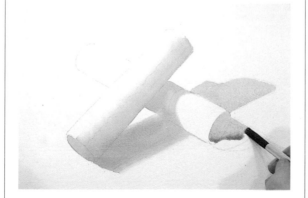

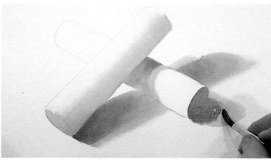

With a darker value, I add the dark inner shadows, using a clean, wet brush to soften and blend where needed.

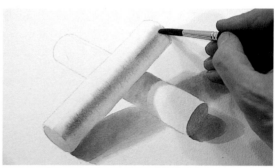

I lower the angle of my board slightly. On the first (top) cylinder, I wet the areas on either side of the contour lines indicating the transition between highlight and shadow on the form, then paint a dark stroke over the line, as in the sphere demonstration.

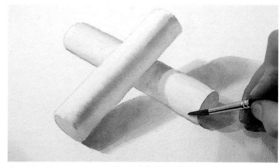

I add a few more touches of light color to give the image its final form.

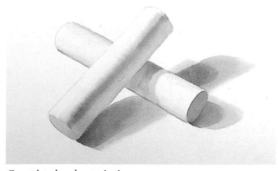

Completed value painting.

Variegated Washes

A variegated wash is one in which two or more colors are blended together on watercolor paper that is very wet. After the paint is applied, the wet paper is tilted in a way that allows the colors to flow together, resulting in an effect that resembles a sunset.

To create a variegated wash with two colors, first wet a sheet of paper with a flat brush or sponge. Make sure it is very wet. Tilt your painting board at an angle, then quickly apply the lighter color across the top of the paper, letting it flow down toward the middle. Next, turn the paper upside down and, with the board tilted, apply the second color across what is now the top. Let the second color run down and blend into the first. You can control the amount of blending you want by adjusting the length of time you leave the paper tilted. When you want to slow a variegated bleed, lay the paper down flat. As long as the paper is very wet, the colors will blend. The longer you leave the paper tilted at an angle—and the steeper the angle—the more the colors will mix together.

For greater depth and luminosity, you can repeat this process by applying a second variegated wash over the first. Make sure the first wash is completely dry before you do this; then rewet the paper and apply color as before. Always let the paint move by itself over the wet surface. The bleed should look very free-flowing.

I lay a sheet of watercolor paper on my board and wet it thoroughly with a sponge. Then, tilting the board at an angle, I apply a yellow wash across the top of the paper, letting the paint flow downward.

While the paper is still very wet, I turn it upside-down and quickly apply a blue wash across the top, letting this color run down and blend with the yellow.

**David Dewey, SUNRISE (top) and
SUNSET (bottom), from four-part
LIGHT OF DAY series.**
Watercolor on paper, 4¹/₂ × 10"
(11.4 × 25.4 cm) each. Corporate art collection,
Reader's Digest Association, Inc.

I used the variegated wash method to achieve the luminous color effects in these sunrise and sunset studies. In each, I applied the warm color first and the cool color second. I laid the paper flat when I felt that the cool color had moved far enough into the warm, thus stopping the bleed.

GLAZING

Glazing is a transparent painting technique that is often used to create luminous atmospheric effects. A layer of transparent color (which may be variegated) is applied to a wet surface and allowed to dry. This underpainting then serves as a backdrop for shapes to be painted onto it directly with a brush, or for further transparent layers, or glazes, to be applied over it. Before applying a glaze over another layer of color, make sure the paper is absolutely dry or you will get opaque results.

When you are ready to apply the glaze, rewet the paper by stroking water on with a brush using a light, quick touch so you don't saturate the surface. When the paper becomes too wet, the layers of paint are absorbed into each other, appearing dirty and overmixed, and thus opaque.

Applying warm colors first will give you more luminous glazing effects, whereas using cooler colors first results in a denser, more opaque effect. Either way, for maximum transparency in glazing, use transparent and semitransparent colors. They will always give a painting greater light and depth.

I glaze warm transparent colors onto a wet surface and allow them to bleed down the paper.

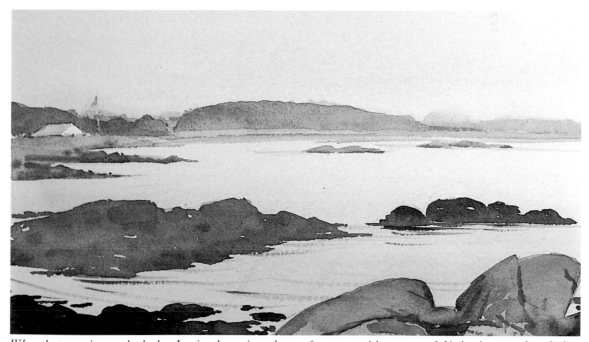

When the paper is completely dry, I paint the various shapes of my composition on top of this luminous underpainting without lifting any of its color. I begin with the shapes in the background and move toward the foreground. The warm, stainy light wash of my underpainting influences the colors painted over it, making them part of its atmosphere.

LAYERING

Layering is basically a glazing technique but is used more specifically to build depth and three-dimensional form. This is done in stages. The large, two-dimensional shapes of a subject are washed in and allowed to dry, then smaller shapes are layered over them to create the illusion of three-dimensional form. Only in the latest stages can you attend to the descriptive details; you must build toward those final touches of reality.

Here, I established the basic architectural shape of my subject with an initial wash of yellow. When it was completely dry, I added a layer of blue below the railing. Note how this second layer seems to push the area under the railing forward, giving the subject some depth.

With the addition of further layers of transparent paint, the simple three-dimensional structure and identity of my subject is revealed. Layering requires patience. The temptation is to rush things and not allow one layer to dry before applying the next.

This study for the painting below shows the first stage in the layering process—an initial wash defining the big two-dimensional shapes of my subject.

David Dewey, FINNISH CONGREGATIONAL CHURCH AND PARSONAGE. Watercolor on paper, 12 × 17³/₄" (30.5 × 45.1 cm), 1994. Collection of Mr. and Mrs. Thomas Norton.

By using the layering process, I was able to create the value gradations that help describe three-dimensional form in this painting.

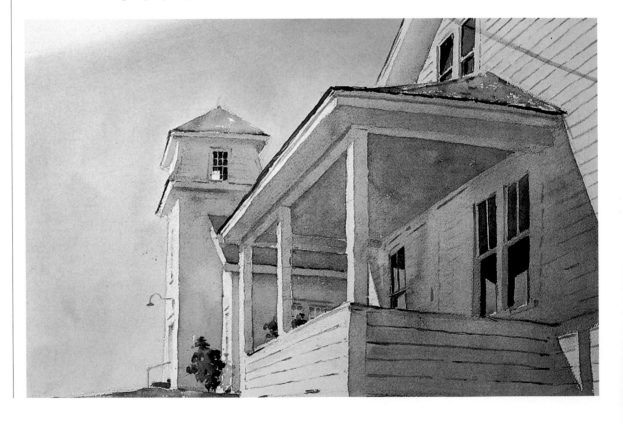

GRAPHIC BRUSHSTROKES

Besides applying watercolor paint in the form of washes, you can take a more graphic approach to building an image by using strokes of different shapes. One possibility is dot-shaped strokes like those the Pointillists used; another is hatching, linear strokes like those you might make with a pen. Just as with washes, value structure must be built in layers, starting with light tones and working toward the darks.

I apply linear strokes of my light value to the forms, their cast shadows, and the background, leaving highlighted areas white.

Here are some of the graphic brushstrokes you might want to try: dots, hatching strokes, and random, lozenge-shaped strokes. I made the lightest marks first, followed by the middle-value and then the dark strokes.

DEMONSTRATION

This step-by-step sequence shows how to build an image using overlapping linear strokes. The first value applied is the lightest, with progressively darker values layered in succession. The graphic quality of this approach is in some ways closer to drawing than to painting.

Next come the middle values. Note how I space my strokes so lighter-value areas show through.

Here is my line drawing of the various forms in the composition. The four-part value scale in the foreground illustrates the sequence in which I will apply the various tones, using the white of the paper as my lightest light.

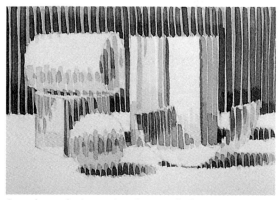

I apply my darkest values last, again leaving spaces between strokes to reveal parts of the underlying tones.

TEXTURAL EFFECTS

Textural effects can be the result of the natural granular characteristics of the pigments you work with or the type of paper you paint on. They can also be initiated by the artist using techniques that alter the physical appearance of watercolor and add tactile interest to a painting. Textural effects should be introduced in a composition not for their own sake but as integral parts of the whole, as elements to be woven into the fabric of the picture to add richness and depth.

GRANULATION

Certain watercolor pigments are naturally coarse. When these colors are spread across a sheet of rough or cold-pressed paper, their granular particles settle into the paper's little hollows, resulting in a mottled effect. On smooth paper, the pigment particles appear to float freely. Rich textural effects and color combinations can be achieved by floating granular pigments over a wet surface and allowing them to mottle naturally into chromatic mixtures. The chart shown below illustrates how four sets of granular pigments behave in combination on different paper surfaces.

The small squares indicate the pairs of colors used to create the mixtures in the larger squares adjacent to them. All colors were applied wet-on-wet. The paper surfaces used in both columns are indicated at center.

COLOR PAIRS	MIXTURES		MIXTURES	COLOR PAIRS
FRENCH ULTRAMARINE BLUE / BURNT UMBER		SAUNDERS COLD-PRESSED		CERULEAN BLUE / BURNT SIENNA
FRENCH ULTRAMARINE BLUE / BURNT UMBER		LANA HOT-PRESSED		CERULEAN BLUE / BURNT SIENNA
FRENCH ULTRAMARINE BLUE / BURNT UMBER		ARCHES COLD-PRESSED		CERULEAN BLUE / BURNT SIENNA
FRENCH ULTRAMARINE BLUE / BURNT UMBER		FABRIANO ROUGH		CERULEAN BLUE / BURNT SIENNA
TERRE VERTE / CERULEAN BLUE		FABRIANO ROUGH		WINSOR GREEN / BROWN MADDER ALIZARIN

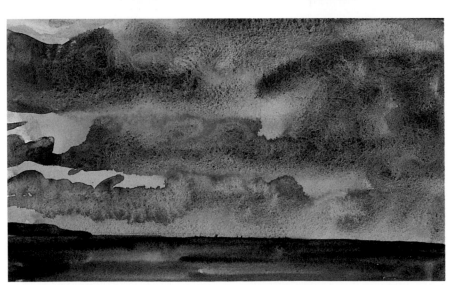

David Dewey, DISCOVERY BAY, JAMAICA SUNSET. Watercolor on paper (sketchbook), 5 × 9" (12.7 × 22.9 cm), 1981.

I attained the atmospheric feeling in this sky study by floating French ultramarine blue over a warm orange and yellow underpainting and letting granulation occur.

SPATTERING

This is a method of flicking paint off the stiff hairs of a paintbrush or toothbrush to create random sprays or spatters of color. Spots are created by touching the tip of a round brush to the paper, or by shaking the brush over the paper, causing drops of color to fall onto the surface. Spattering and spots can be used to add expressive textural effects to watercolor paintings.

I created these spattered effects by flicking paint off a stiff brush; the spots were simply done by touching the tip of a round brush to the paper. Cover any areas of your painting with a piece of paper or other protective mask where you don't want the spatters to fall; likewise, use paper templates as stencils where you want spatters to take specific shapes.

**John Marin,
APPLE ORCHARD
IN BLOOM.**
Watercolor on paper,
15¹/₄ × 20¹/₂"
(38.7 × 52.1 cm), 1949.
Private collection.

Spots and drybrush effects create a lively, airy, spatial feeling in this watercolor by John Marin.

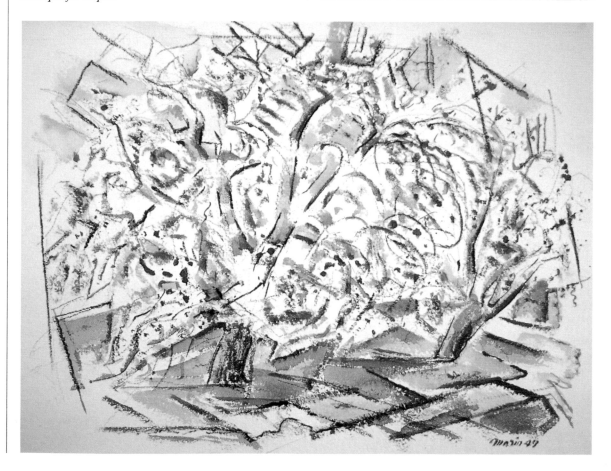

PUDDLING

Puddling is an "accidental" painting method in which diluted color or water is dripped onto a colored surface, resulting in a stainy watermark or tie-dye effect. The wet puddle bleeds into the drier surrounding area and pushes pigment outward to cause a backwash that looks somewhat like a coffee stain. Soft puddled stains are created by dropping color onto very wet areas; dropping color onto less wet surfaces results in more firmly defined stains.

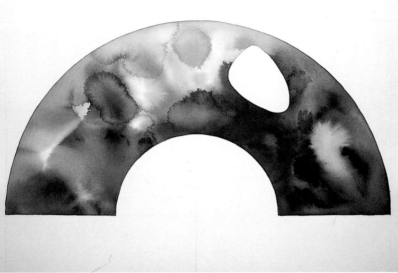

**Chris Annalora,
UNTITLED.**
Watercolor, 20 × 26"
(50.8 × 66 cm), 1992.
Courtesy the artist.

In Chris Annalora's painting, sharply defined puddle stains have been placed over softer ones that play against the edges of the white oval and curved fan shape of the composition, creating a primordial-like spatial effect.

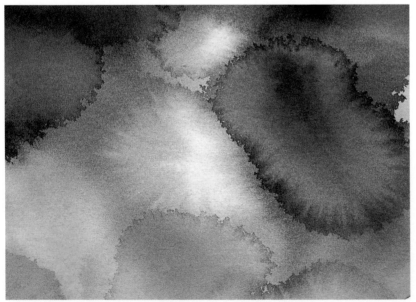

In this detail of Chris Annalora's painting Untitled, *you can clearly see the interplay between soft and sharply defined stain effects.*

BRUSHWORK AND PAPER SURFACE

The brush is an expressive tool. Loaded with paint or nearly dry, moved quickly or slowly over the paper's surface with a light touch or a heavy one, it articulates a broad range of effects. For example, the drybrush technique, which calls for very little paint and quick, deft strokes, can be used to describe the sparkle of sunlight on water or the rustic texture of an old wooden building, adding physical character to your paintings.

The surface of the paper you work on also affects the look of the brushstrokes applied to it; hot-pressed (smooth), cold-pressed (medium-textured), and rough papers accept paint in different ways. Thus, you should choose a surface that accords with your subject matter and with the effects you are trying to achieve.

Each of these three examples of brushwork was done on a different type of paper surface: at top, rough; at left, cold-pressed; and at bottom, hot-pressed. I made all of the red strokes with a ³/₄" flat brush and all of the blue ones with a #12 round, dipping each brush in the same amount of color every time. In each example, the top stroke was done by moving the brush slowly and evenly across the paper; the middle stroke was painted faster, with a slight lift at the end; and the third stroke was applied very quickly with a light touch and lift of the brush at the end. The rough paper has the strongest textural effect on the brushstrokes, while the cold-pressed surface shows more of the character of the brush hairs. The textural effects that can be achieved on hot-pressed paper depend completely on the amount of water and paint on the brush and the movement and touch of each stroke. Each paper has its own physical properties, so brushstrokes and wetness should be adjusted accordingly.

In executing the painting Blue Barn Door *at right, I worked on rough paper and used the drybrush technique to describe the weathered texture of the barn boards. I dipped a flat brush into color but kept it fairly dry, splitting the hairs apart and stroking it lightly across the surface following the grain of the wood.*

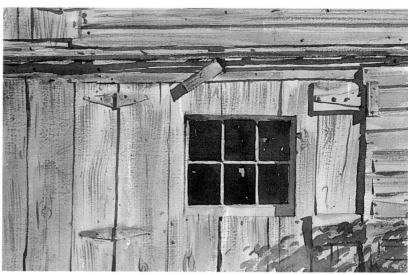

David Dewey, BLUE BARN DOOR.
Watercolor on rough paper, 9¹/₂ × 13¹/₄" (24.1 × 33.7 cm), 1994.
Collection of the artist.

Brushwork not only adds descriptive character to the boards of my subject, but more importantly, heightens the color brilliance and feeling of light in the painting.

The amount of sizing in a textured paper affects how the surface accepts paint. Heavily sized paper is less absorbent, so that when watercolor is brushed over it, little "pinpricks" of white remain where the paint does not adhere. Such effects can add sparkle to a painting. The example at far left, done on Arches rough, has a pronounced pinprick texture because this paper is highly sized, while the example at near left, done on Lanaquarelle rough, has less sparkle because this paper is more absorbent.

**Paul Rickert,
REFLECTIONS, STONINGTON.**
Watercolor, 12 × 16"
(30.5 × 40.6 cm), 1993.
Courtesy the artist.

Paul Rickert captured the brilliant reflected light on Stonington Harbor by brushing very little paint onto a rough surface using a brisk lateral movement, resulting in pinprick effects that convey the sunlight's sparkle on the water.

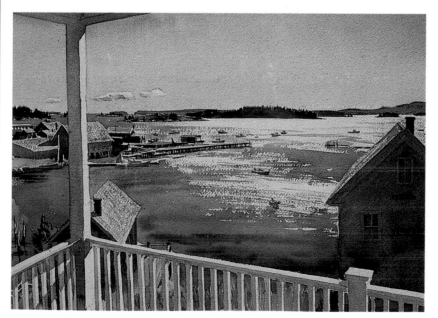

LIFTING METHODS

Using tools such as a sponge, soft paper, or a sharp instrument like a razor or knife, you can remove color from the surface of watercolor paper not only for corrective purposes, but also to create lightened passages or highlights in a painting. The English landscape painter J. M. W. Turner scratched, scraped, and wiped a great deal in his watercolors, pioneering most of the lifting techniques watercolorists use today.

USING A KNIFE, SANDPAPER, OR RAZOR

You can use the point of a knife to gouge or the flat side for softened effects. You must be careful when scraping and scratching with a knife so as not to poke through the paper; for this reason it's recommended that you use these techniques only on heavier paper.

Using sandpaper to remove color leaves soft, textural shaded tones. With this technique you can brighten areas with highlights and otherwise model forms, creating the appearance of volume by subtly sanding away paint.

A razor blade is used like a knife; you can gouge with the point and scrape with the flat side. When using either of these tools, dexterity in touch is important so you don't overdo it, marring your painting surface with an ugly, scarred effect.

When you need to make a correction in a painting, you can lightly gouge the mistake with a razor, remove the blemish with the tip of the blade, then, with the flat side soften the area with feathered strokes. The area surrounding the removed spot should be sanded lightly to even out the surface. When this technique is done correctly, the scraped area will call very little attention to itself when a wash is laid over it.

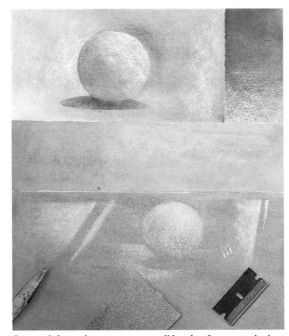

Some of the tools you can use to lift color from a painting are, from left to right, a knife, sandpaper, and a razor blade. Hold the knife or razor blade flat against the paper to gently scrape color off; use the tip to make gouges. For subtle tonal passages or highlights, rub the desired area carefully with sandpaper. These abrading techniques are best done only on heavier papers.

As I painted this sphere, some color bled outside its boundary. Mistakes like this one can be corrected with a razor blade, as long as the paper is completely dry. To do so, I lightly gouged the offending area and removed it with the tip of the blade, then held the blade flat against the paper and gently scraped over the spot with feathering strokes. Finally, I rubbed sandpaper lightly over the problem area to smooth out the surface.

BLOTTING

With this method you lift color by applying absorbent paper or paper towels to paint that is wet to damp, lightening the area as you lift this soft blotter off the surface. This technique is useful for modeling three-dimensional form. Using a rougher blotter adds texture as well.

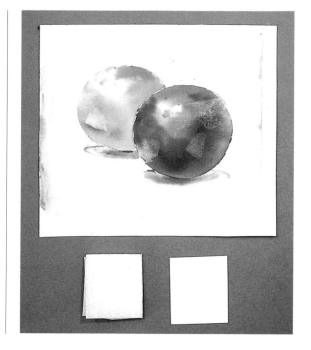

While the paint was still wet, I used paper towels to lift color from the orange sphere and soft, absorbent paper to do the same to the purple sphere. Blotting wet color in this fashion creates soft, textured accents like those you see here.

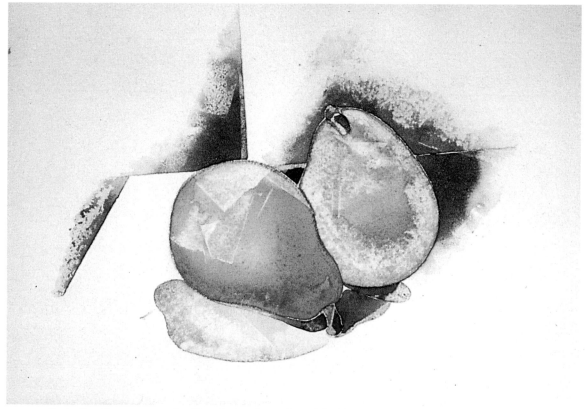

Charles Demuth,
STILL LIFE WITH PEARS.
Watercolor on paper, 10 × 14"
(25.4 × 35.6 cm), 1929.
Private collection.

In this painting, Demuth used the blotting technique almost as a sculptural tool to give the pears and pictorial space a cubistic structure and three-dimensional effect.

WIPING

You can lift or wash off color in a painting by dampening an area with a sponge or brush dipped in water, then wiping it with a dry cloth or paper towel to create soft, lightened effects. This method is very effective for rendering clouds and other sky phenomena, and was traditionally used by 19th-century British watercolorists. Lifting with a sponge works well for depicting puffy white cumulus clouds; a round brush lets you define contrails (streaks of condensed water vapor); and removing color with a flat brush is an excellent way to render wispy cirrus clouds. The more times you repeat the wiping process, the more color you will lift. These techniques can be used with surprising atmospheric effectiveness.

With the wiping technique, you can easily render clouds and other sky effects like those shown here. To create a cumulus cloud, wet the desired area with a sponge and wipe the loosened pigment off the surface with a dry paper towel or rag to reveal the white of the paper beneath the color. To render contrails and other streaks, use a round brush dipped in water to loosen the pigment; for cirrus clouds or the like, use a flat brush for this purpose, again wiping the dampened color with a rag or paper towel.

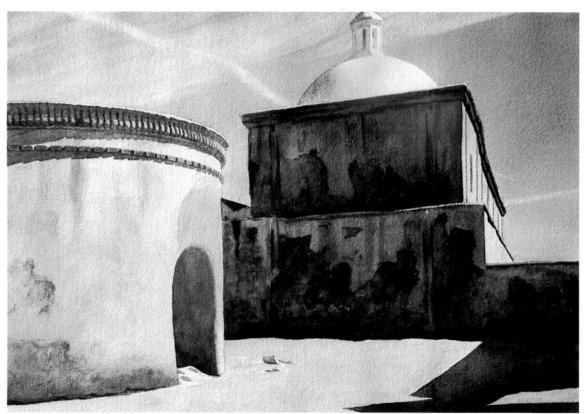

David Dewey,
TUMACACORI SKY.
Watercolor on paper, 13¹/₂ × 19¹/₂"
(34.3 × 49.5 cm), 1989.
Collection of Chris and Marianne Ritter.

The cirrus clouds and vapor trails are rhythmic elements in this painting of a scene at the Tumacacori ruins in Arizona. I wet part of the sky with a flat brush and wiped away the loosened pigment to create a soft cirrus cloud, and then made strokes with a wet round brush, quickly wiping away color to create the contrails.

RESIST TECHNIQUES

Various materials can be applied to watercolor paper to repel paint or otherwise protect areas of a painting where you want to preserve the white of the paper or an underlying color. Masking fluid, or frisket, is one such possibility; another is masking tape, which is especially useful for maintaining sharp edges. Some interesting results can be obtained by drawing on your paper with paraffin wax, which will resist watercolor applied over it and thus preserve the white or colored surface below. Waxed areas can then be scraped and manipulated to create highlights and textural effects.

I masked off the edges of this painting with tape to keep them sharp and applied masking fluid with a brush to areas that are to remain white. (The masking fluid has a yellowish tint so you can see it on the paper, but its color won't stain the fibers.) Don't use one of your good paintbrushes for this, and don't use the one you choose for any other purpose. Wet it often and rub it against a bar of soap to prevent the masking fluid from hardening in the heel of the brush.

Once the tape is in place and the masking fluid has dried, color washes are applied to the desired areas and left to dry completely. The tape is removed by carefully pulling it off the paper. The masking fluid can be rubbed off with a finger or an eraser. Using an eraser will eliminate pencil lines you may need, so be careful. I use my fingers, all of them, and try to build up a few calluses to prevent blistering. Do not leave masking fluid on the paper beyond the recommended time.

Here you can see the clean, sharp edges and preserved white details once the tape and masking fluid have been removed.

Besides using masking fluid and tape, I also covered parts of this large studio painting with sheets of translucent paper to protect them from unwanted splatters of color.

Wax repels wet paint and can be used to create patterns, shapes, and textures on the paper's surface. For this example, I applied paraffin to white areas of the paper and over dry washes to create colored textural effects.

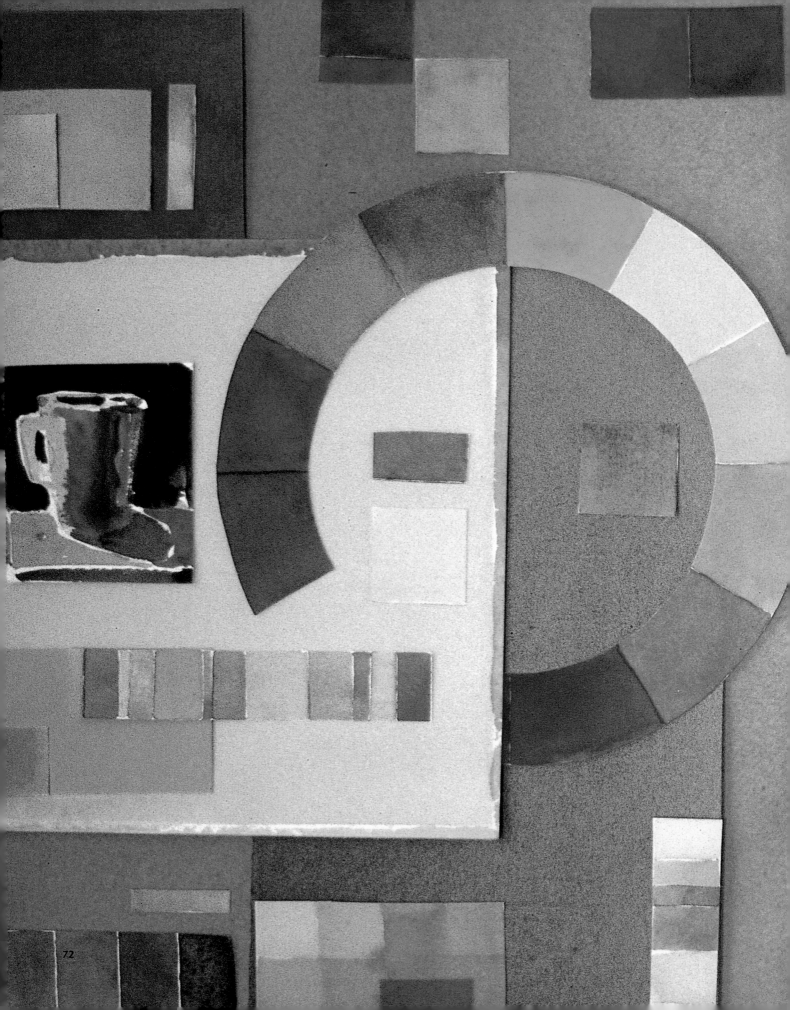

72

COLOR

Color is the heart and soul of watercolor, for it has the capacity to influence our senses and shape our moods. To give color its full voice in a painting, the artist must have an understanding of basic color theories and techniques for color mixing. However, knowledge of theory and technique alone cannot guarantee complete success with color; your natural intuitive response is also essential to using it expressively, because color is innately subjective in nature. Beautiful, meaningful, and sometimes even extraordinary watercolor paintings are achieved by combining technical skill with learned and intuitive responses.

This chapter explores color's many facets: the nature of its physical existence; various theories about how we perceive it; and ways to use it artistically to express specific visual effects.

COLOR IN WATERCOLOR

Light is the source of all color; without it, color would not exist. In watercolor, it is the light generated by the whiteness of the paper that breathes life into the colors painted over its surface, providing this medium with a radiance possessed by no other. An artist with basic technical skills and a knowledge of the theory of color and its harmonies can use color to bring to life visual moments of extraordinary breadth.

You need to understand five basic aspects of color to handle it successfully in watercolor:

1. *Physical.* The laws of nature that govern color's very existence.
2. *Theoretical.* Basic theories about color and design that in practice allow us to shape watercolors into thoughtful images.
3. *Visual.* Recognition of color through optical perception.
4. *Technical.* Practical skills needed for handling watercolors and constructing successful paintings.
5. *Intuitive.* Subjective use of color for artistic expression derived from constant practice of theory, visual observation, and technique.

THE SPECTRUM AND THE RAINBOW

Sir Isaac Newton (1642–1727) provided the basis for our modern knowledge of the physical existence of color and how we perceive it. He directed a beam of white light (daylight) through a narrow slit onto a glass prism in such a way that the light dispersed into the solar spectrum, a series of colored bands progressing in frequency from red (with the longest wavelengths) through orange, yellow, green, blue, indigo, and violet (the shortest wavelengths). These are, of course, the colors of the rainbow, nature's display of the spectrum as formed by the refraction and reflection of the sun's rays in raindrops or mist.

The colors of the spectrum are wavelengths of light made up of electromagnetic energy. These light waves are not color in themselves; rather, their color arises in the human eye and brain through color absorption and reflection. By recombining the separated spectrum rays to again form white light, Newton discovered that objects appear colored in white light because they reflect only a portion of the spectrum. A red object, for example, appears so because its molecular structure absorbs all but red light waves, which the object reflects back to the eye. Thus, we see only the light waves that are not absorbed—in this case, the red segment of the spectrum.

The human eye, however, is limited in the number of wavelengths (measured in millimicrons) it can perceive, and thus we cannot see the entire spectrum; in the rainbow, for example, blue-violet (or indigo) and violet are invisible to us because they are too high in frequency (700–800 millimicrons).

A rainbow exhibits the spectrum's colors in concentric bands. It forms opposite the sun by refracting and reflecting the sun's rays in droplets of water in the atmosphere. In the rainbow, indigo (blue-violet) and violet are invisible to the naked eye because their wavelengths are too short for us to perceive.

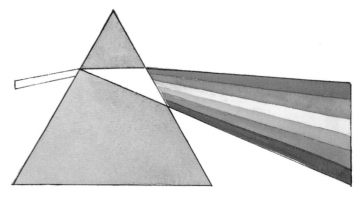

White light passed through a prism breaks into the colors of the spectrum, which are arranged in a progression according to wavelength, from red (the longest) through orange, yellow, green, blue, indigo, and violet (the shortest). An object appears colored in white light because it reflects only a segment of the spectrum while absorbing the remainder.

ATMOSPHERIC AND AMBIENT COLOR

To gain technical and visual mastery of watercolor, it is important to understand that color is both a physical and a perceptual phenomenon. Painting from nature requires especially keen visual observation. We learned that color exists because of daylight, but there's more to it than that. The artist must understand that the color of daylight varies throughout the course of the day, and that this naturally affects the colors of objects in the environment.

The color of the light at a particular time of day depends on where the sun is in relation to the earth and thus the angle at which refracted light comes through the atmosphere. At sunrise and sunset, warm colors pervade the sky because light enters the atmosphere from a very low, oblique angle. Cooler, blue midday skies result from light rays that are relatively perpendicular to the earth. If you are working directly from nature, it is important to know that the color of the atmosphere at a given time of day affects the local (actual) colors of your subject, and that atmospheric color effects supersede local color. Similarly, the local color of any object is optically affected by the colors of objects adjacent to it.

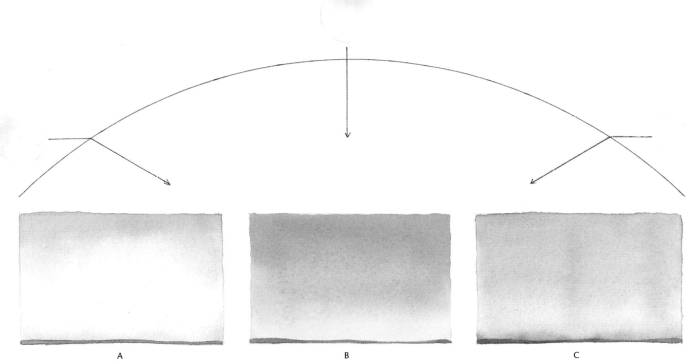

A

B

C

This illustration shows how the color of the atmosphere varies at different times of day. At sunrise (a) and sunset (c), the sun is low in the sky and refracted light enters the atmosphere at an oblique angle, painting the sky with warm colors. At midday (b), when the sun is directly overhead, light rays enter the atmosphere perpendicular to the earth, resulting in cool, blue skies. These atmospheric colors, of course, affect the colors of objects in the environment—a fact that painters must take into account when working directly from nature.

COLOR PIGMENTS

A pigment is a substance that gives color to another material, such as watercolor paints, which are made of pigment bound in a water-soluble solution of gum arabic with (usually) glycerin added as a wetting agent. Pigments are classified as organic or inorganic. Organic pigments are made from carbon compounds derived from vegetable or animal material and are either natural, like indigo, or synthetic, like the phthalocyanines (phthalos, for short). Inorganic pigments are mineral-based and include the earth colors, such as ochre, raw umber, and sienna, which when calcined (changed by the application of heat) result in such colors as burnt umber and burnt sienna. Other inorganic pigments are metals, such as the cadmiums, cobalts, and oxides. The pigments used in making watercolor or any other paints are not themselves soluble but disperse over the painting surface.

Each color pigment has specific physical characteristics—saturation, transparency, opacity, lightfastness, and staining power—that must be understood in order for it to be used with maximum effect in watercolor painting. You need to consider these qualities when deciding which pigments to paint with, because they will have an impact on your results, and you can use them for different purposes. Just choosing the right ones can make all the difference in a painting.

A transparent color is one that allows light to pass through its pigment particles and reflect back to the eye from the surface to which it is applied. Transparent colors mix well with all other colors and are excellent for mixing secondary and tertiary hues from the primaries. Their transparency is important in allowing the paper to "breathe" and makes them especially good for layering and for graying other colors. Added to opaque colors, they supply transparent strength; a good example of such a mixture is phthalo blue (transparent) and cobalt blue (opaque).

Opaque colors allow little or no light to penetrate their pigment particles and are thus best used singly. Mixing two or more opaque colors together results in a loss of color capacity (because of the loss of light), but mixing an opaque with a very saturated transparent color, such as phthalo green, can increase it. Opaque colors can be very effective when placed on a wet surface alongside transparent colors (or semitransparent ones, which are somewhere between the two extremes) and allowed to merge organically. Because of their earthy neutral nature, opaque colors can be stimulated by stronger adjacent pigment activity. Traditional opaques such as yellow ochre can be mixed with cerulean blue or French ultramarine for rich chromatic grays.

Saturated colors are pure—that is, unmixed with white, black, or any other color. To appear transparent on the painting surface, they require a fair amount of dilution with water. Unsaturated colors are those mixed from two or more pigments, resulting in a loss of purity and, consequently, transparency. Staining colors, such as the phthalos and alizarin crimson, are very saturated and intense, and stain the fibers of the paper to which they are applied.

Paints are rated for permanency, which refers to a pigment's lasting quality, particularly its lightfastness, or ability to withstand fading with exposure to light. A fugitive color is one that changes hue over time. Such ratings are usually listed on the paint tubes. Although rating systems vary from one manufacturer to another, in general a numerical scale of 1 to 4 is used, with 4 meaning excellent and 1 unsuitable.

Color	Props	Color	Props	Color	Props	Color	Props
CADMIUM RED LIGHT	O P	WINSOR VIOLET	T P I	BURNT UMBER	P U	OLIVE GREEN	T P
CADMIUM RED DEEP	O P	FRENCH ULTRAMARINE	T P	BURNT SIENNA	P I U	SAP GREEN	T P
WINSOR RED	S P	COBALT BLUE	O P	LIGHT RED	O P U	HOOKER'S GREEN DEEP	S P
SCARLET LAKE	S P	PERMANENT BLUE	S P	INDIAN RED	O P	OXIDE OF CHROMIUM	O P
CARMINE	T P I	MANGANESE BLUE	O P	CADMIUM ORANGE	O P	VIRIDIAN	S P
PERMANENT ROSE	S P	TURQUOISE BLUE	T P I	CADMIUM YELLOW	O P	WINSOR GREEN	T P I
ROSE DORÉ	T P	CERULEAN BLUE	O P U	AUREOLIN	T P I	EMERALD GREEN	O P
BROWN MADDER ALIZARIN	T F I U	PHTHALO BLUE	T P I	NEW GAMBOGE	T P	TERRE VERTE	S P
ALIZARIN CRIMSON	T F I	PRUSSIAN BLUE	T P I	CADMIUM LEMON	O P		
PERMANENT MAGENTA	T P I	INDIGO	T P I	YELLOW OCHRE	P U		
COBALT VIOLET	O P	PAYNE'S GRAY	P I U	RAW SIENNA	P U		
MAUVE	S F	IVORY BLACK	P U	RAW UMBER	P		
ROSE MADDER GENUINE	S F	SEPIA	S P	NAPLES YELLOW	O P		

This chart presents a range of watercolor pigments and their various physical properties. Transparent, semitransparent, and opaque colors are labeled T, S, and O, respectively; an acceptable permanency rating is denoted by P, fugitive colors (those that fade) by F; intensity and/or staining quality is indicated by I; colors labeled U are unsaturated (all others may be considered saturated). The chromatic gray borders are an equal mixture of alizarin crimson and Winsor green. To illustrate opacity, I painted vertical stripes of waterproof black India ink alongside the four color rows and painted each hue over the line. Colors that remain visible over the line are opaque, to varying degrees.

COLOR THEORY

Much has been written proposing why certain combinations of colors work well together and others do not. The eye commonly recognizes in nature and art that colors combined in a pleasing order are "harmonious" and those that appear displeasing are "discordant." Such a response to color is intuitive, based on observation. Color is also subjective; it stirs our feelings and reaches inside us, prompting an emotional response. But neither an intuitive nor an emotional response may be of much help when it comes to selecting and combining colors for a painting, for this is a process that requires you to keep your wits about you. Using color effectively requires a great deal of thought and intelligence. Studying color theories will help you better understand its perceptual aspects, which in turn will sharpen your intuitive skills and give you further insights into color's expressive possibilities.

THE COLOR WHEEL

The color wheel is an ordered arrangement of the colors of the spectrum into a circle. First introduced by Sir Isaac Newton in the 17th century, it is a visual means of measuring the relationships among hues. Studying colors in this context lets you see them in logical terms and helps you better understand why certain relationships are harmonious or discordant.

The wheel comprises 12 colors. Red, yellow, and blue are known as the *primary* colors, since they cannot be mixed from any other colors. The *secondary* colors are produced by combining two primaries—red plus yellow make orange, red plus blue make violet, and blue plus yellow make green. *Tertiary* colors are combinations of a primary plus a secondary, such as blue-green and red-violet.

A color wheel shows primary, secondary, and tertiary colors in a logical relationship. The outer ring of this wheel consists of pure, unmixed colors used straight from the tube. On the inner ring, the secondary and tertiary colors have been mixed from the primary colors Winsor red, Winsor blue, and Winsor yellow. Note how much less vibrant these mixed colors are in comparison with their unmixed counterparts on the outer ring. Color mixing in watercolor is a subtractive process: adding one pigment to another takes light away from the mixture, especially in the darker colors.

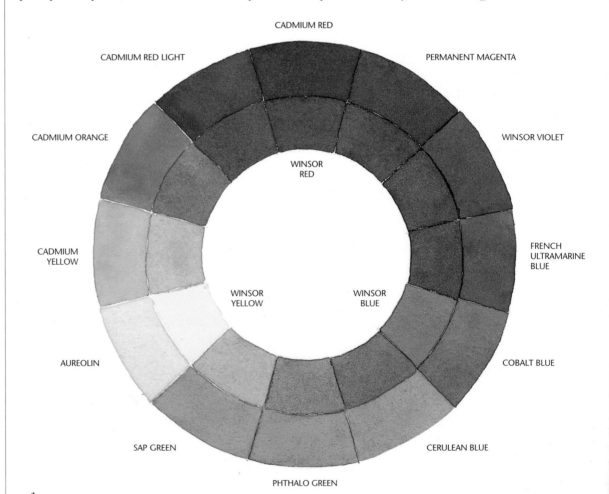

Color Language

It is important to know the meaning of the various terms that are used to describe specific aspects of color. The basic vocabulary includes the word *hue*, which is simply the color's common name, such as viridian green or yellow ochre. The name of the paint color is usually the same as the name of the pigment used in its manufacture, which is why the same names occur in different mediums. Some manufacturers have trademarked their own versions of certain colors; Winsor blue, for example, is Winsor & Newton's name for phthalo blue. *Chroma*, or *intensity*, refers to a color's saturation—its brightness, strength, and purity. *Value* and *tone* are synonymous and refer to a color's relative lightness or darkness.

Color Temperature

Color is often described in terms of temperature—as being warm or cool. Warm colors, like the yellows and oranges associated with sunlight, are light and luminous, while cool colors, like the blues and violets associated with shadows, are darker and heavier. Just as value carries visual weight, so, too, does color temperature. You should also be aware that warm colors advance in the picture plane and cooler ones recede. Both of these factors are important in composition.

Color temperature is relative; that is, a color that usually is considered warm may appear cool when placed next to a hotter hue, and vice versa. Similarly, every color pigment has a warm or cool bias. Red, for instance, is classified as a warm color, but there are cool reds and warm reds. Alizarin crimson is a cool red because it leans toward blue; cadmium red is warm because it leans toward yellow. In your compositions you should constantly be alert to these chameleon effects.

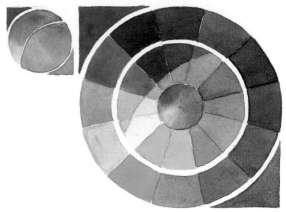

Warm colors—reds, oranges, and yellows—relate to sunlight, while cool colors—greens, blues, and violets— relate to shadow. Here, the red-orange triangles represent the sun illuminating the earth, the blue-green triangles, shadow. In the larger diagram, the outer ring shows each color at full intensity; in the second ring, the colors have been lightened to illustrate how value can affect temperature. Note how the full-intensity warm colors make their lighter counterparts appear relatively cool due to the value contrast.

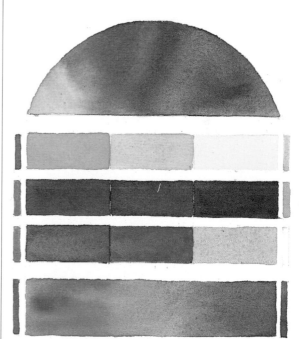

The colors you use as primaries can have a warm or cool bias, depending on which side of the color wheel they lean toward. The primaries at left appear warm: cadmium yellow and French ultramarine blue contain some red, and vermilion contains some yellow. The primaries at right appear cool, cadmium lemon and alizarin crimson containing some blue and cerulean containing some yellow. The primaries aureolin, Grumbacher red, and cobalt blue in the center row can lean either way, depending on the context in which they are seen.

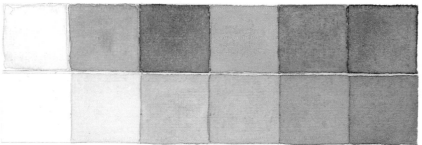

Every hue has an inherent value, or relative degree of lightness or darkness. This becomes especially clear when colors are juxtaposed with a gray scale, in which tone is measured in increments from white to black. Of the basic spectrum hues, yellow is the lightest in value, violet the darkest, with red and green about equal in value in the middle of the scale. A color's assigned value must be taken into consideration when you are balancing color weights in a composition.

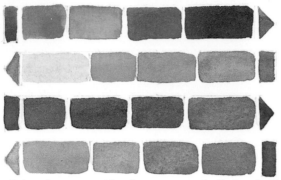

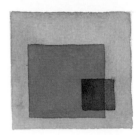

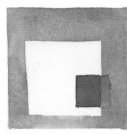

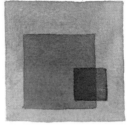

Colors that are considered warm are optically "pushed" by hotter colors adjacent to them to appear cool, and vice versa. In the top horizontal row, for example, placing the oranges, which are warmer because they contain more yellow, next to the red makes the red look cooler, pushing it toward violet. Likewise, in the next row, placing cool blue-greens next to yellow-green pushes the latter toward its warm component, yellow.

The three monochrome primary examples show that a given color appears cooler and recedes in space when light in value, and warmer and closer to the viewer when more intense. In the three-color combination, the cool, light-value blue square recedes; the warmer, middle-value yellow square serves as a middle ground; and the red-orange rectangle advances in space because it is the warmest color in the illustration.

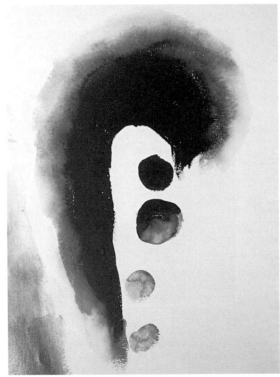

Georgia O'Keeffe, RED LINE WITH CIRCLE.
Watercolor on paper, 29¹/₂ × 22"
(74.9 × 55.9 cm), 1977. Private collection.

O'Keeffe's painting is a perfect example of the relativity of color temperature. The primary red of the composition is pushed warm in some areas by the addition of yellow (particularly along the outer edge of the large form), and in other areas is pushed cool by the addition of blue, as in the two lower circles.

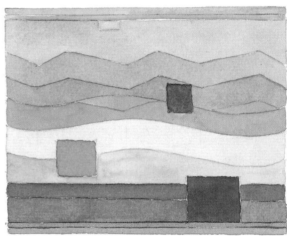

To create the illusion of three-dimensional space, objects or areas that are meant to come toward the viewer are depicted with warmer colors, and cooler colors are used for elements that are meant to appear more distant. Similarly, things that are meant to recede in space are depicted with values that become progressively lighter toward the background. The gradual cooling and lightening of colors to make objects appear more and more distant is known as atmospheric perspective. This spatial illusion can be skewed by unexpected contrasts: here, the cool blue stripe in the immediate foreground recedes in spite of its position, and the warm orange stripe in the background pops forward.

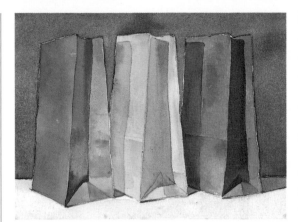

I painted these paper bags with a range of warm to cool primary colors, using their temperature contrasts and inherent values to give the objects three-dimensional structure. I made the background at left a warm gray to set off the cool blue bag, while at right I made the gray cool to contrast with the warm red bag.

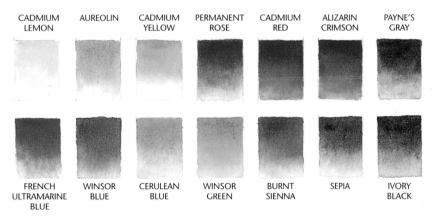

CADMIUM LEMON	AUREOLIN	CADMIUM YELLOW	PERMANENT ROSE	CADMIUM RED	ALIZARIN CRIMSON	PAYNE'S GRAY

FRENCH ULTRAMARINE BLUE	WINSOR BLUE	CERULEAN BLUE	WINSOR GREEN	BURNT SIENNA	SEPIA	IVORY BLACK

This is my basic working palette; it represents a balance of warm, cool, transparent, opaque, and staining colors. There is only one green here because I usually mix my own from a blue and a yellow.

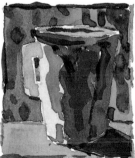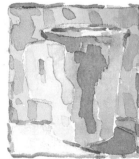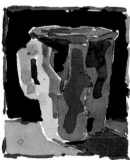

Here, color is used three different ways to establish spatial structure. The example at left is in a high key, with all colors used full strength. A sense of depth and three-dimensional form results from warm/cool and light/dark contrasts. The center example is rendered in a low key, with diluted colors; the softer, more intimate spatial effect is the result of very little contrast. At right, warm and cool colors are set against a black background, which has little or no depth itself but pushes the colored shapes forward and makes them appear larger and weightier.

Emily Dewey, COLOR CHAIR.
1992. Courtesy the artist.

Although we've seen several examples supporting the concept that warm colors advance and cool ones recede, it's important to note that color can also be ambiguous. My daughter's chair is a case in point: the way color has been used is out of sync with the object's three-dimensional form, contradicting our normal expectations. For example, blue-violet, a cool color that normally would recede, is used on a forward plane (the chair's front left leg); and yellows, reds, and blues shift the eye back and forth, skewing natural visual spatial relationships.

COLOR HARMONIES AND CHORDS

The term *harmony* implies order and balance. The eye reacts to the arrangement of colors much the same way the ear responds to the sounds of musical notes. When chords of musical notes or colors are arranged in a rhythmic order, we are moved by their harmony. The harmonic color compositions of Paul Klee come to mind when music and color are mentioned together. In music, each composition is keyed to a chord of notes that serves as the basis for a melody. The visual artist's chord is an arpeggio of colors made up of hues from certain related positions on the color wheel. These chords consist of color groupings that go by such names as primary triads, complements, split complements, tetrads, and analogous colors, all of which are systematic arrangements of color commonly used to develop compositional relationships, or harmonies. Such groupings are most easily seen in geometric terms on the color wheel, as in the illustration shown here.

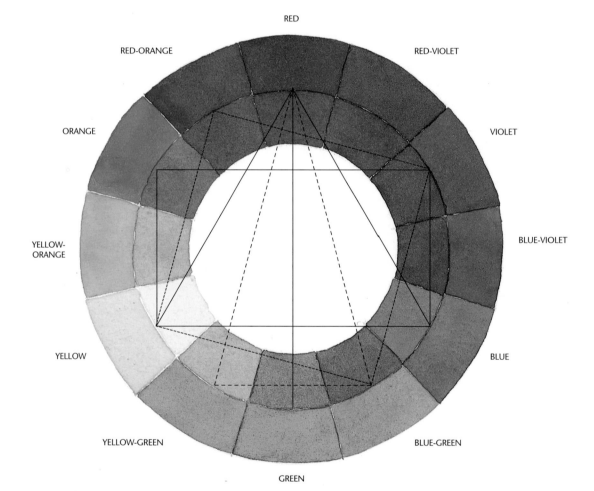

RED

RED-ORANGE

RED-VIOLET

ORANGE

VIOLET

YELLOW-ORANGE

BLUE-VIOLET

YELLOW

BLUE

YELLOW-GREEN

BLUE-GREEN

GREEN

A complementary harmony is based on two colors that lie directly across from each other on the color wheel, such as red and green, which are connected by a line dividing the wheel in half. A triad harmony consists of three colors located at the angles of an equilateral triangle superimposed on the wheel, in this case, red, blue, and yellow. Superimposing an isosceles triangle (one with two equal sides) on the wheel indicates the colors that form a split complementary harmony—here, red, yellow-green, and blue-green. Tetrad harmonies consist of four colors located at the angles of a square or rectangle superimposed on the wheel.

PRIMARY TRIADS

If you were to superimpose an equilateral triangle on the color wheel, its endpoints would land on three equidistant colors, forming a chord known as a triad. A primary triad is one based on a red, a yellow, and a blue, from which all secondary and tertiary colors are mixed. The idea behind working with such a triad is to use these "root" colors as a foundation for achieving color harmony—in other words, to try to do more with less. Several variations on the primary triad are possible; shown here are five that demonstrate a range of options for different effects.

The first triad is made up of semitransparent primaries, in this case cadmium red deep, French ultramarine blue, and new gamboge. The second is composed of transparent primaries, here permanent rose, cobalt blue, and aureolin. The third is an intense triad of Winsor red, Winsor yellow, and Winsor blue. The fourth is triad of the opaque earth colors Indian red, cerulean blue, and yellow ochre; the fifth, also opaque and based on earth hues, is composed of burnt sienna, indigo, and yellow ochre and was traditionally used by early masters of watercolor.

The gray triangle at the center of each triad is a neutral created by mixing the corresponding primaries in equal amounts. In watercolor, color mixing is subtractive, meaning that in the process of adding one color to another, you are taking light away from the mixture. The color bars below the triangles represent the chords you can achieve by mixing the secondary and tertiary colors from the given primaries.

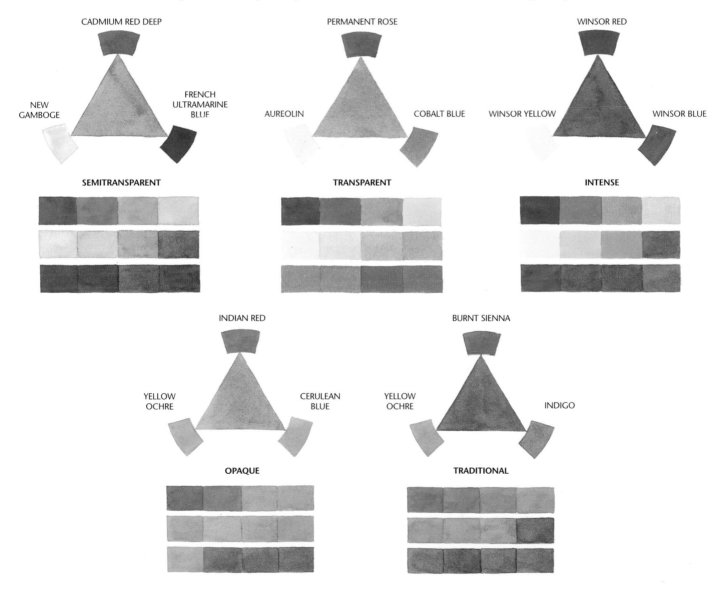

COMPLEMENTS

Two colors that lie directly across from each other on the color wheel are considered *complements*, or opposites. Complementary pairs consist of one primary plus one secondary color, such as red and green, or of two tertiary colors, such as yellow-green and red-violet. One color in a complementary pair is warm, the other cool; value contrast may be strong, as with yellow and violet, or nearly nonexistent, as with red and green. Because of their equal strength, complements intensify each other when placed close together in a composition. Mixing two complements together results in a neutral color; when the complements are "pure," meaning they don't lean toward one primary or another on the color wheel, the neutral is a true gray.

The illustration below shows the basic complementary pairs of yellow and violet, red and green, and orange and blue. Each of the wheels pairs "pure" complements and shows the neutrals that can be obtained by mixing

them in various proportions, while the swatches below them show alternative pairings of less pure complements and their neutral mixtures. Note in particular what happens when the yellow/violet complements new gamboge and permanent magenta are combined. The resulting mixtures reflect the fact that permanent magenta contains a fair amount of red.

Grays mixed from complements can be modulated for temperature by varying the proportion of one color to the other in the mixture. In each of the wheels shown here, the band that joins the complements is formed of three rectangles. The central rectangle is a 50:50 mixture of the complements; the rectangles on either side of it are 75:25 mixtures, with the higher proportion belonging to the adjacent complement and determining whether the gray is cool or warm. Thus, in the yellow/violet example, the gray rectangle next to the yellow complement is a warm neutral composed of 75 percent yellow and 25 percent violet.

WINSOR
VIOLET

CADMIUM
LEMON

CADMIUM RED

WINSOR GREEN

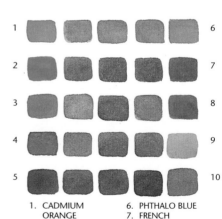

CADMIUM
ORANGE

PERMANENT
BLUE

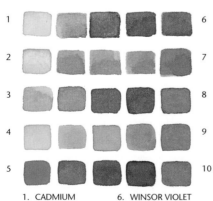

1. CADMIUM YELLOW
2. NEW GAMBOGE
3. YELLOW OCHRE
4. NAPLES YELLOW
5. RAW SIENNA
6. WINSOR VIOLET
7. PERMANENT MAGENTA
8. MAUVE
9. MAUVE
10. MAUVE

1. CADMIUM RED
2. ALIZARIN CRIMSON
3. PERMANENT ROSE
4. INDIAN RED
5. LIGHT RED
6. VIRIDIAN
7. WINSOR GREEN
8. HOOKER'S GREEN DARK
9. OXIDE OF CHROMIUM
10. COBALT TURQUOISE

1. CADMIUM ORANGE
2. CADMIUM ORANGE
3. RAW SIENNA
4. BURNT SIENNA
5. BURNT SIENNA
6. PHTHALO BLUE
7. FRENCH ULTRAMARINE BLUE
8. COBALT BLUE
9. CERULEAN BLUE
10. CYANINE BLUE

The complements have been allowed to mingle organically in the inner circle of each wheel; in the outer ring I created value gradations, juxtaposing the cool gray with the warm complement and vice versa.

In any complementary pair, the visual weight of each color when seen side by side is proportionate to its value. In high-key (full-intensity) pairs, the lighter-value color has greater optical weight than its partner and is balanced visually by a higher proportion of the darker-value color, as you can see on the right side of the diagram above at right. Note that at full intensity, red and green are about the same in value and thus equal in weight. In low-key (light-value) conditions, the reverse is true: the darker color has greater weight and is balanced by a higher proportion of its lighter, warmer counterpart, as in the left side of the diagram. In composition, balancing the visual weight of complements is a matter of adjusting the value and proportion of one color in relation to the other.

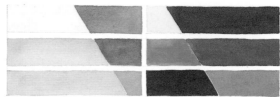

This diagram shows the comparative visual weights of complementary colors in high- and low-key conditions. In a pair of high-key (full-intensity) complements as shown at right, the lighter-value color has greater optical weight than its partner and is balanced by a higher proportion of the darker-value color. (Note that at full intensity, red and green are equal in weight.) In low-key (light-value) conditions as shown at left, the reverse is true: the darker, cooler color has greater weight and is balanced by a higher proportion of its lighter, warmer counterpart.

Wayne Thiebaud, HYDRANGEA. Watercolor on paper, 10¹/₂ × 12" (26.7 × 30.5 cm), 1980. Courtesy Allan Stone Gallery, New York City.

Here is a fine example of using a complementary harmony to great effect. In this painting, Wayne Thiebaud pairs orange and blue, setting up color as well as temperature contrasts for some surprising effects. In a reversal of visual convention, he has used a cool, normally recessive blue in the foreground and a warm, usually advancing orange in the background, against which the cool blue flower stands out due to the modifying contrast of the two complements.

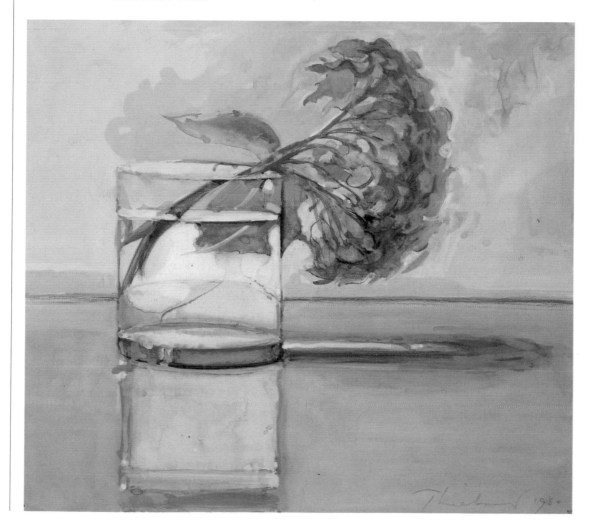

SPLIT COMPLEMENTS

If you were to superimpose an isosceles triangle on the color wheel with the narrowest angle pointing to a primary color, the other two angles would touch the two colors adjacent to the complement of the given primary, forming a split-complementary harmony. Thus, red unites with yellow-green and blue-green; yellow joins red-violet and blue-violet; and blue joins with yellow-orange and red-orange. Split complements allow a more pleasing harmony than true complements because they have a broader color capacity, since the two "split" colors each contain some of the other primaries. This extends the range of neutrals possible, as well as warm and cool combinations.

Split-complementary schemes join a primary with two colors on the wheel that are adjacent to its true complement. One split complement leans warm, the other cool. In these examples, the true complement is shown directly opposite the primary in a band at the base of the triangle; inside the triangle is an organic mixture of the scheme's three colors, while on either side are the warm and cool neutrals achieved by mixing the primary with an equal amount of one or the other of the split complements. For example, red's true complement is green, so its split complements are yellow-green (warm) and blue-green (cool). Red mixed with yellow-green yields a warm neutral, red plus blue-green, a cool one.

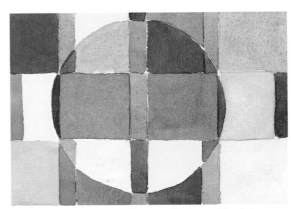

These two illustrations use the yellow/red-violet/blue-violet scheme. At left, the three colors are dominated by their neutrals, which are larger in compositional proportions; at right the opposite occurs, with the yellow, red-violet, and blue-violet dominating.

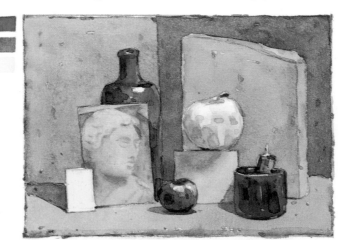

David Dewey, HERAKLES RECEIVING THE GOLDEN APPLES.
Watercolor on paper, 5¼ × 7¼" (13.3 × 18.4 cm).

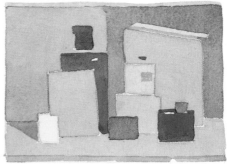

The painting at left uses a split-complementary scheme of blue-violet, red-violet, and yellow. To understand how it works, study the abstract version above, where you can easily see that the dominant neutrals are balanced by the colors' visual weight.

TETRADS

A tetrad is a four-color scheme consisting of either two pairs of complements (colors at the endpoints of a rectangle superimposed on the color wheel) or a pair of complements plus a pair of split complements (colors at the endpoints of a square superimposed on the color wheel). Obviously, extending the number of colors in a scheme widens the range of neutrals and warm-versus-cool possibilities in the chord.

At left in the diagram shown below, the four corners of the rectangle point toward the complementary pairs yellow and violet and orange and blue. At right, the square's four corners fall on the complements yellow and violet, and on the split complements red-orange and yellow-green.

A tetrad *is arrived at by superimposing a rectangle or square on the color wheel and choosing the colors located at its four endpoints. As you can see in the illustration at right, a rectangle yields two pairs of complements, while a square yields a pair of complements plus a pair of split complements.*

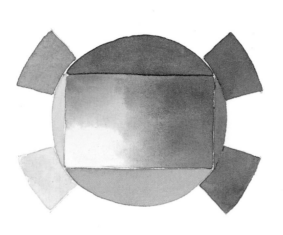

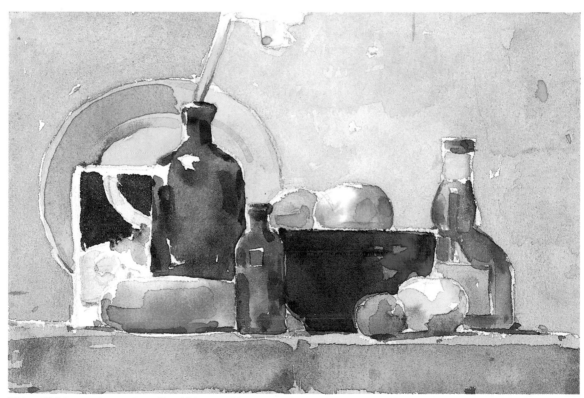

This still life was done primarily with a tetrad harmony of complements and split complements. The neutrals are chromatic mixtures made from colors in my chosen tetrad.

ANALOGOUS COLORS

Colors in an analogous harmony are contiguous on the color wheel and have in common one of the primaries. Typically, an analogous range consists of one-third of the color wheel; any more colors than that and you would lose the analogous effect of the harmony.

Analogous harmonies can become monotonous, so to use them effectively, it's best to choose a dominant hue and introduce complementary accents to stimulate color activity. Interestingly, this is the color scheme used in Scottish tartans, in which the overall plaid pattern is based on an analogous harmony that is then accented with touches of the dominant hue's complement, like thin red stripes running through a pattern based mainly on greens and blues. Adding an element of contrast can bring an analogous scheme to life.

The color wheel at right is divided into thirds to illustrate the common analogous color harmonies, which are based on a shared primary and typically consist of no more than four contiguous colors. The analogous colors on the outer ring are paired with their complements on the inner ring.

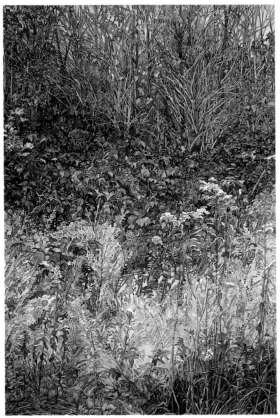

**George Harkins, AUTUMN PAUSE
(left panel of diptych).**
Watercolor on paper, each panel 60 × 40"
(152.4 × 101.6 cm), 1983.
Courtesy Tatistcheff Gallery, New York City.

I created these "analogous tartans" to point out how analogous color schemes are brought to life by the introduction of complementary accents. Weaving strands of violet, blue-violet, and blue through the predominantly yellow "tartan" activates the pattern; the same is true of the violet example, which gains visual interest from touches of green, yellow-green, and yellow, and the green example, which is livened up by accents of yellow-orange, violet, and red-violet.

George Harkins takes an optical approach in his use of color. In this painting he has used a red analogous color scheme, making it work beautifully by introducing complementary accents of green and blue-green.

THE COLOR OF GRAY

Gray colors are neutrals that generally dominate watercolor painting. They can make or break a watercolor if not viewed and mixed with an understanding of their nature. Gray is subordinate color; it depends on combinations of hues to be brought to life and on its adjacent hues for recognition. Placed thoughtfully in the right context, its subtle modesty can become as fresh and radiant as colors of greater intensity.

Neutrals are either achromatic, meaning without color (grays and blacks), or chromatic, created from mixing two or three hues. Achromatic blacks and grays—unmixed tube colors such as ivory black and Payne's gray—are used to shade other hues and are dull in comparison to chromatic neutrals, which have a lively quality because of the color particles suspended in their mixtures. Using neutral colors you have mixed yourself will help your paintings radiate more light and your compositions work more harmoniously.

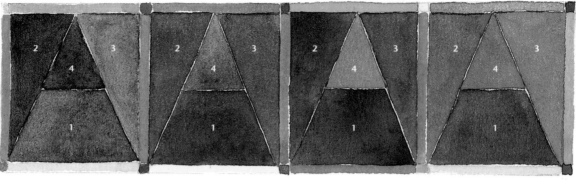

SQUARE 1
1. EQUAL PARTS NEW GAMBOGE, WINSOR RED, WINSOR BLUE
2. + RED
3. + BLUE
4. IVORY BLACK

SQUARE 2
1. CADMIUM LEMON, ALIZARIN CRIMSON, PHTHALO BLUE
2. NEW GAMBOGE, WINSOR RED, WINSOR BLUE
3. CADMIUM YELLOW, CARMINE, FRENCH ULTRAMARINE BLUE
4. IVORY BLACK

SQUARE 3
1. EQUAL PARTS WINSOR RED, WINSOR GREEN
2. CADMIUM ORANGE, FRENCH ULTRAMARINE BLUE
3. CADMIUM YELLOW, WINSOR VIOLET
4. PAYNE'S GRAY

SQUARE 4
1. EQUAL PARTS NEW GAMBOGE, WINSOR RED, WINSOR BLUE
2. + RED
3. + BLUE
4. PAYNE'S GRAY

This chart shows a variety of warm and cool chromatic grays mixed from two or three colors. The triangle at the center of each "A" shape is an achromatic tube gray— ivory black in the two left-hand examples, Payne's gray in the two at right. The contrast between these grays and the chromatic ones surrounding them reveals their warm or cool bias. The colored bands around each square represent the hues used to mix the various grays and serve to stimulate the neutrals. In square 1, all of the chromatic grays are mixed from the same primary triad. Shape 1 is an equal mix of the three colors; 2 contains more red and is thus warm; 3 contains more blue and is cool. In square 2, each shape is mixed from a different set of primary colors. In square 3, grays are mixed from complementary pairs. In square 4, grays are mixed from the same colors as in square 1, but in different values.

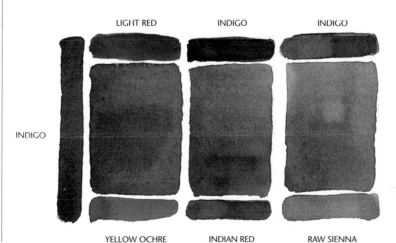

LIGHT RED INDIGO INDIGO

INDIGO

YELLOW OCHRE INDIAN RED RAW SIENNA

To identify the middle neutral of a mixed gray, you must see it next to its separate components, which will help you determine its relative temperature. (This is true for any color mixture.) When creating a chromatic gray, mix two or three colors and physically move the puddle in one direction, then stop it and tint it with one color or another to push it warm or cool.

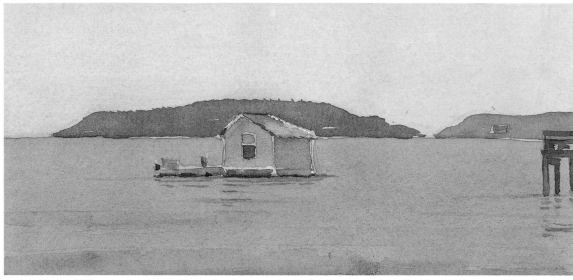

**David Dewey, CAPE
PORPOISE HARBOR, ME.
(sketchbook study).**
Watercolor on paper,
4 × 10" (10.7 × 25.4 cm).
Courtesy the artist.

I painted this study using a neutral color harmony created with cadmium red, French ultramarine blue, cerulean blue, and yellow ochre. The graying effects of the blues are set off by the warmth of the cadmium red. Warm and cool relationships can be seen in the neutrals throughout the painting. Note, for instance, the contrast between the predominantly blue island on the right with the water adjacent to it, which appears more red or violet. In neutral harmonies, the pigments used to create the warm and cool effects need to be used in an active way, as in the red lobster shack in this composition.

**Paul Rickert, WINTER
WINDOW MIST.**
Watercolor on paper,
20 × 14" (50.8 × 35.6 cm).
Courtesy the artist.

The subtle neutral harmony in Paul Rickert's painting was created with cerulean blue mixed with yellow ochre and some cadmium red. The key to this painting is the blue plate; it is the active element the surrounding neutrals and reds play against.

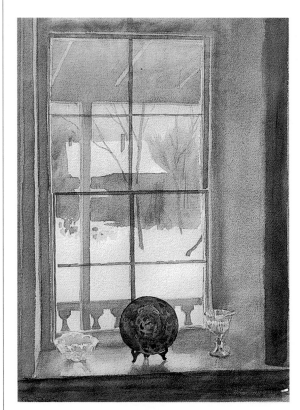

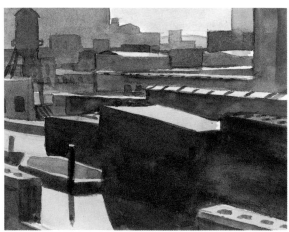

**David Dewey, GRAY VARIATION,
NEW YORK ROOFTOPS.**
Watercolor on paper, 8 × 10"
(20.3 × 25.4 cm). Courtesy the artist.

Here I used a primary triad of French ultramarine blue, Indian red, and yellow ochre. The darkest values were achieved with a combination of the red and the blue. Note the varying proportions of cool to warm grays in the composition; the warmer grays contain more red, the cooler ones more blue.

COLOR MIXING

Essentially, mixing color in watercolor is either a physical or optical process. Optical color mixtures rely on the viewer's eye rather than the medium itself to do the work of blending one hue with another. Physical color mixtures are made by combining pigments in various ways; the most obvious is to stir two or more colors together into a puddle on your palette, like mixing a yellow and a blue to create a green. Other physical color mixing options include layering, organic mingling, and variegated bleeds.

ON THE PALETTE

In watercolor, mixing color on the palette is vital to the painting process and should always be a part of your preparation for starting work. You need to have enough of the right color mixtures ready so that your paintings can progress smoothly through every stage of development.

Two kinds of color mixtures are prepared on the palette. The first consists of the large, homogenized washes you will use the most in a painting; these belong in the concave or slanted compartments on the side of a typical palette (or otherwise in separate small saucers or cups). The second consists of mingled puddles created by dragging individual colors out of their wells onto the flat part of the palette with the brush. Bring warmer colors out first, then the cooler darks. Use a separate brush for the warm and cool colors you want to mingle so as to keep the colors in your mixtures clear and the paints in the wells clean.

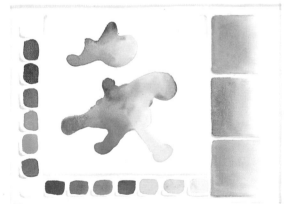

A typical palette has concave or slanted compartments where you premix the washes you will use for larger areas in a painting. These washes can be tinted with other colors as needed, either on the paper or on the palette. To create organically mingled mixtures, drag individual colors out of their wells and onto the flat part of the palette.

Many options are possible when you mix secondary colors from two primaries. In the chart shown below, I mixed green, orange, and violet from yellow, blue, and red using three different approaches: layering, organic mingling, and in variegated bleeds. On either end of each color bar are the two primaries used for the secondaries that lie between them. To mix the center square in each bar, I loaded the shape with the warm primary first, then dropped in the cool color, letting them mingle organically on the paper. I created the square to the left by laying down the warm primary first, then overlapping it with a layer of the cool primary; for the right-hand square I layered warm over cool. The strip below each bar is a variegated warm-to-cool bleed. Compare the results of the different mixing methods, and note especially what happens when the order in which the colors are combined is reversed. Applying cool over warm gives more luminous results, while applying warm over cool produces darker, more opaque effects.

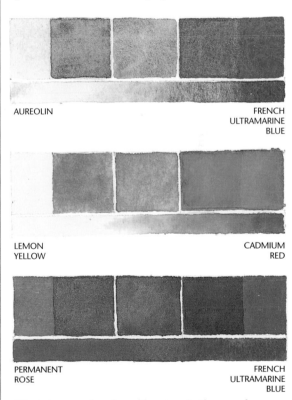

AUREOLIN FRENCH ULTRAMARINE BLUE

LEMON YELLOW CADMIUM RED

PERMANENT ROSE FRENCH ULTRAMARINE BLUE

The primary colors I used here to mix the secondary colors are just a few of the possible pairings. Try mixing other reds, blues, and yellows in various combinations and compare the results.

OPTICAL COLOR MIXING

Optical mixtures depend on the placement of individual colors adjacent to each other so that the eye combines them, as with the two examples at right. Secondary and tertiary colors, as well as various harmonies, can be created by juxtaposing the appropriate hues. Optical mixtures can provide lively visual texture to a painting; Maurice Prendergast's *Beach, Saint-Malo, France,* shown below, is a vivid example of this.

Optical color mixing. *In each of these examples, individual colors are placed close enough to one another that the eye tends to blend them.*

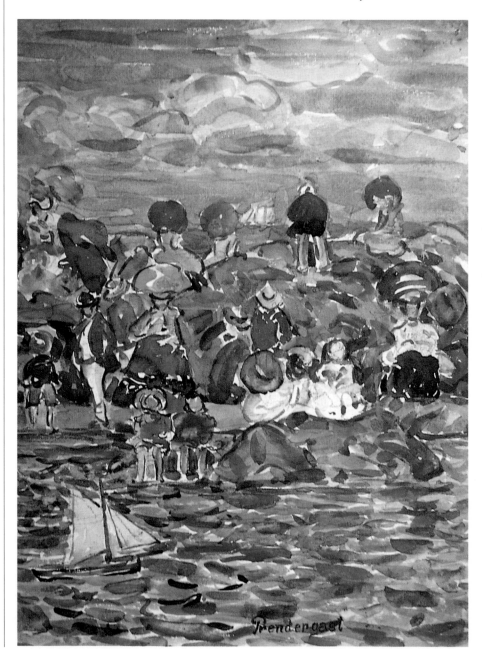

Maurice Prendergast, BEACH, SAINT-MALO, FRANCE. Watercolor on paper, 15 × 10³/₄" (38.1 × 27.3 cm), 1907. Private collection.

Prendergast, influenced by the Post-Impressionists' use of color in the early 20th century, created vibrant harmonies with patches of color that sometimes overlap and sometimes are juxtaposed so they mix optically. Here, in his mosaic style, brilliant transparent hues are woven together into a tapestry of color and sunlight. The subjects almost dissolve because the strokes of color used to render them are so active.

PHYSICAL COLOR MIXTURES

An interesting approach to color mixing in watercolor is to let two or more colors mingle together organically, as in the example shown at right and in Andra Gabrielle's study of lilacs below. This is done by wetting an area of the paper and placing the desired colors side by side on the wet shape or dropping one color onto the other and allowing them to mix together on their own. The resulting color effects are more unpredictable than those you can achieve with other mixing methods, but are very expressive and full of unimaginable variations. In a painting, passages created with organically mingled, or modulated, color appear to have a stronger physical presence or form than those rendered in another type of wash.

Organic color mixing. *I created this green by wetting the paper and dropping in yellow and blue, letting them mingle naturally. Colors mixed this way are visually exciting.*

Andra Gabrielle, LILACS.
Watercolor on hot-pressed paper, 12 × 16" (30.5 × 40.6 cm). Courtesy the artist.

This study of lilacs was done with a loaded brush on hot-pressed paper, a very slick surface. Forms were defined lightly at first using paint diluted with lots of water; then richer colors were added to the still-wet passages and allowed to mingle, or modulate, naturally on the surface of the paper. The touches of color—the blue spots—that hold their shape were painted on using less water so they would not spread and mingle.

You can also mix color physically by layering one transparent color over another—creating a green, say, by overlapping a yellow wash with a blue one. This transparent painting process is the most commonly used technique in watercolor and the very essence of the medium. Colors that are mixed in transparent layers have great depth and visual richness because the eye recognizes not only the mixed color but also the two or three individual colors used to create it. This approach to color mixing is a *subtractive* process, because with each new layer of pigment you add, you subtract light. In other words, the more pigment particles there are, the less light can penetrate through them to reflect off the paper. Thus, you should limit the number of overlapped colors to just two or three for the most successful transparent effects, and use transparent to semitransparent pigments for best results. Each layer or stroke must be dry before you paint another one over it.

Transparent color mixing. *Beautifully resonant color mixtures are created by layering one transparent color over another, as here. For maximum effect, it's best to limit the number of layers in such mixtures to just two or three.*

A textural approach can also be used in color mixing. Basically a transparent technique, though some optical mixing takes place as well, this method employs the texture of rough, well-sized paper in color expression. One color is brushed onto the surface quickly so it doesn't settle too deeply in the paper's little "valleys" and so bits of white will show through. When this is dry, the second color is layered over the first in the same manner, so that it sits on the paper's "peaks" and leaves bits of the first color and white to show through. This results in a sparkling, jewel-like effect. Watercolor paintings with textural color elements have a more tactile look and an edge or spark that paintings done on smoother papers don't.

Textural color mixing. *Brilliant color mixing effects can be created on heavily sized rough paper. To do so, apply the first color over the surface quickly, leaving white "pinpricks" showing through. When the paper is dry, brush on a second color in the same way, allowing the first layer to show through the texture of the second. In the top example, I applied cerulean blue over cadmium yellow; in the one below it, I used the yellow over the blue.*

COLOR PERCEPTION AND ILLUSION

According to Isaac Newton, we perceive color through the absorption and reflection of wavelengths of light, as stated at the beginning of this chapter. Experience, though, teaches us that things are not always what they first appear to be, and in this case, that colors do not always appear to be what they really are. Beyond Newton's discoveries are some other perceptual phenomena, including simultaneous contrast, extended contrast, and irradiation, that have a profound effect on how we see color and how artists use it to attain specific results. To take full advantage of color's potential, you must first develop the ability to analyze it, which can be done only through practiced observation. By understanding the various ways color is perceived, you can improve your use of color harmony.

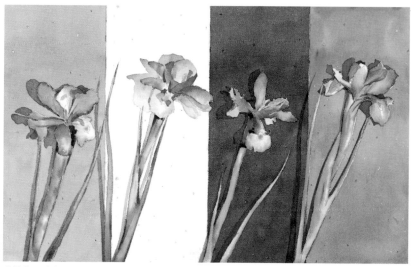

All four irises were painted with the same combination of colors, yet to the eye they appear to differ in hue because the background panel behind each was painted a different color. This demonstrates how adjacent colors influence each other in ways that affect our perception of them. The background in the first panel (reading left to right) is a chromatic gray mixed from mauve and cadmium lemon. Because of simultaneous contrast, the violet iris makes the gray appear yellowish. In the second panel, against the white background the flower appears darker and more concentrated—just the opposite of what happens in the next panel, where the dark background, a warm, neutral, chromatic gray-black mixed from Winsor green and cadmium red, seems to amplify the flower, especially the yellow on the forward petal (think of how a lit candle looks in the dark). The fourth panel shows the chromatic activity of juxtaposed warm and cool colors. At the top, the cool blue-violet petals rest against a warm orange-yellow space; this background color is gradually cooled to a blue-violet toward the bottom, offsetting the warm yellow-green stem.

SIMULTANEOUS CONTRAST

In the 19th century, the French scientist Michel-Eugène Chevreul observed that shadows appear to be complementary to their light source, such that warm light produces cool shadows and cool light, warm shadows. Chevreul called this phenomenon *simultaneous contrast*, which describes the mutually intensifying effect a color has on its complement. It also describes what happens when a strong color is juxtaposed with a neutral gray: the gray appears to take on the hue of the color's complement.

Thanks to simultaneous contrast, the gray surrounding the yellow square looks violet (yellow's complement), while the gray square surrounded by violet looks yellow. The same phenomenon applies to the red-orange and blue-green examples. In the bars shown at center, the simultaneous effect is that one complement projects its adjacent complement optically. Each influences the surrounding gray, but the effect is more ambiguous because, for example, the violet on one side makes the gray look yellow, but the adjacent red-orange tries to push the gray toward green.

The neutrals in this illustration were mixed from equal amounts of the complements. However, should a gray contain more of the complement to which it's adjacent, simultaneous contrast won't be apparent.

In the manufacture of tweed fabric, bits of colored wool are sprinkled into piles of neutral-hued wool. In that same spirit I created this illustration of three different grays using, from left to right, the complementary pairs red and green, yellow and violet, and blue and orange. Each of these grays is "sprinkled" with flecks of the warm complement it contains, resulting in simultaneous contrast and stimulating the neutral mixture.

EXTENDED CONTRAST

Extended contrast refers to a color relationship in which complements are used in unequal proportions. For example, a relatively large area of one color in a composition will be stimulated by the presence of a small, very intense touch of its complement. Winslow Homer used extended contrast to great effect in his Caribbean paintings, which are dominated by gray and turquoise colors that are stimulated by the strategic placement of little red elements in the compositions. In good painting, the judicious placement of the right color accent has a great visual effect on the image.

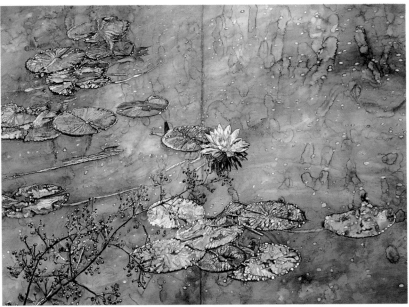

**Joseph Raffael, LILY
POND, LANNIS,
RESTORATION.**
Watercolor on paper,
64^1/$_2$ × 88^3/$_4$"
(163.8 × 225.43 cm),
1993. Courtesy Nancy
Hoffman Gallery,
New York City.

Joseph Raffael's painting is a perfect example of using the "tweed" effect in a composition. The tiny colored petals floating on the water's surface stimulate their neutral surroundings, and their color in turn is stimulated even more by the yellow water lily in the middle of the painting. The touch of red in the upper left not only contrasts with the green lily pads, but also stimulates the violet activity in the water, heightening the complementary effect of the yellow petals strewn across the pond.

In extended contrast, a large area of one color is stimulated by the introduction of a harmoniously small touch of its complement. Note here how the brightness of the small red-orange triangle is magnified by the surrounding darker-value blue-green complement, and how the tiny blue-green triangle makes the larger red-orange field appear to glow more brightly.

In this abstraction blues and greens are stimulated by warm and cool red accents. Altering the reds in tone and temperature activates the surrounding colors and creates depth in the painting.

IRRADIATION

Black and white influence color in specific optical ways too, causing an effect called irradiation. A color surrounded by white appears denser, darker, and smaller, while a color surrounded by black or another dark appears lighter and larger. This apparent change in a color's value is caused by the contrasting effects of black and white.

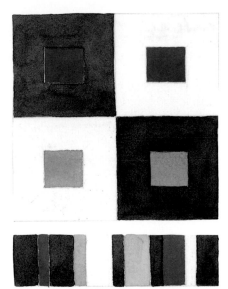

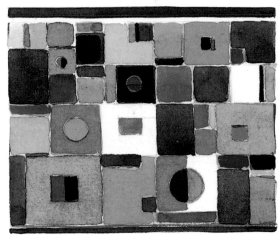

Like semaphore flags, this "nautical" abstraction uses the effects of simultaneous contrast and irradiation to stimulate color activity.

In this illustration the top two red squares are the same value, but the one surrounded by black appears brighter and larger, while the one surrounded by white appears darker and smaller, thanks to irradiation. The same is true for the light-value red squares below. In the striped band, a vibrating effect results from the way the white and black stripes alter the appearance of the light and intense reds and from the fact that the weights and proportions of the colors vary.

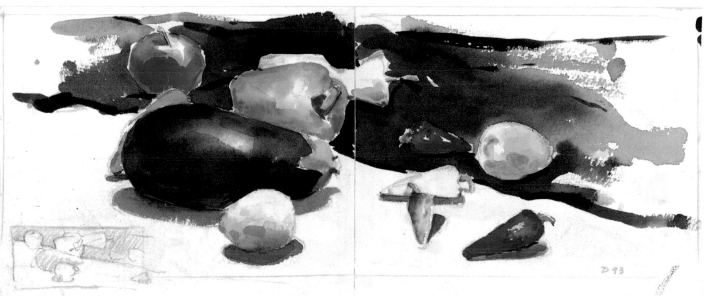

David Dewey, STILL LIFE STUDY WITH BLACK.
Watercolor on paper,
8¹/₂ × 20¹/₂"
(21.6 × 52.1 cm), 1993.

Here is an example of how irradiation can be used strategically in composition. The black background in the top half of this still life gives the organic shapes set against it a weight and intensity that balances them with the shapes in the white foreground, which makes the objects placed there appear smaller and darker by contrast. (The pencil sketch at lower left shows this in simple graphic terms.) The strong diagonal element acts as a pivot between dark versus white and white plus color versus dark, playing up the natural adjustment of weights to create a visual balance.

COLOR PROGRESSION IN COMPOSITION

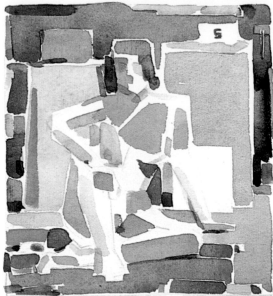

Composing with color requires an ordered progression of events that must be carefully choreographed from the beginning to reach a satisfying climax. As you approach your subject, the first step is to paint in neutral colors that are close in value to indicate the color harmony of the composition. Soft, less intense colors come next, creating a simultaneous effect on the neutrals. With this, the composition's color harmony is firmly established. Stronger hues are added in progression until the painting nears its conclusion, at which point the most vibrant colors are applied; these add depth.

The various color relationships in a composition modify one another. This activity is important not only in constructing compositional balance but also in creating movement, for it draws the eye from place to place in the picture plane. Colors and neutrals should be mixed and placed throughout a composition based on this phenomenon.

Gradually I aim toward stronger, mid-level color effects with additions of yellow-orange and violet; this begins to build greater visual depth. Note how the whites in the composition are affected by the surrounding colors.

DEMONSTRATION: FIGURE COMPOSITION

In creating the figural abstraction shown here, I start in a lower key, working mainly with neutrals; I add complementary touches gradually in stages, building slowly toward a climax. It's important not to overstimulate colors too quickly; otherwise you risk losing the visual direction the painting is moving toward. Save your big guns, like intense color, for last. Being steady in your design approach will guide a painting's technical progression. Read from the painting as it moves forward so you can make design choices that will lead to a satisfying conclusion.

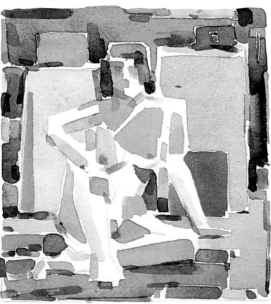

The red square brings the composition to a climax, making the pieces of the image snap together into a visually satisfying whole.

I begin to establish the composition with mostly light-value warm and cool neutrals and minor color effects using a split-complementary scheme of violets, yellows, and orange.

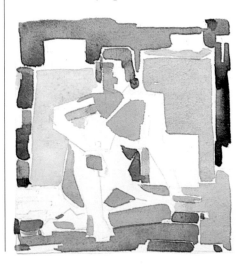

DEMONSTRATION: STILL LIFE COMPOSITION

In this still life I achieve simultaneous and extended contrast using a color scheme based on two pairs of complements: orange/blue and red/green. In determining the color scheme for a painting, it helps to let pigments mingle on the white palette so you can preview their optical and physical mixtures before bringing them to the paper. This makes it easier to choose colors for descriptive purposes as well as for visual effects.

Letting colors mingle on your palette helps you think about them more abstractly and influences your visual response to a subject.

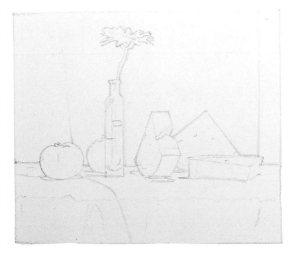

The color chord approximates the proportions of the colors to be used in the composition and the various effects they have on one another.

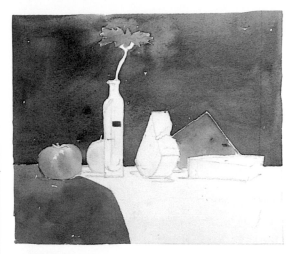

I established some of the main elements of my color scheme, notably the complementary contrast between orange and blue at left, and the cool gray background mixed from the complements red and green.

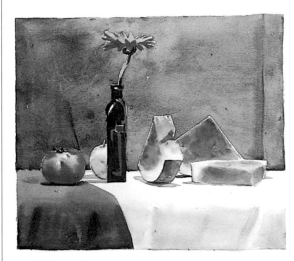

By working with a range of warm to cool colors, I achieve richer color effects in the painting, and greater depth and structure in the various forms. For instance, I accented the cool red of the watermelon slices with a warm red and used a cool red to render the shadows on the basically warm red tomato. The same is true for other forms throughout the composition; modeling with warm and cool colors creates form and a sense of depth.

Two-Color Paintings

Painting with two colors can be a valuable transition into understanding color harmonies based on a full palette. The two colors chosen should represent one of the two qualities inherent in all color: value (light and dark) and temperature (warm and cool). Complementary color harmonies represent these characteristics because they contrast warm lights and cool darks, and they never lose their value-temperature identity.

A rule of thumb when composing with two (or for that matter, more) colors is, "Never place the same value or color side by side." This represents the commonality that exists between value and color and will ease you into dealing with the complexities of color harmony. To use this rule requires that you first identify the values and weights of the two colors you have chosen. Then you must be totally conscious of the ways you mix and juxtapose them in your design. The color-temperature contrasts will become visually apparent as your design develops.

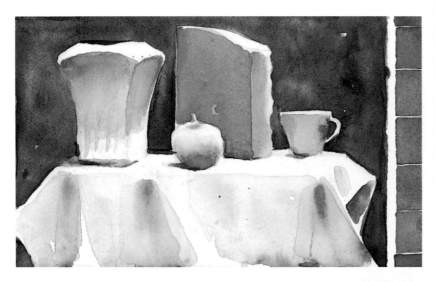

Arbitrarily, I chose one warm and one cool color with which to produce a full tonal range for this composition. I achieved a variety of warm versus cool and light versus dark contrasts, adjusting my use of color and value throughout to create balance; the color bar to the right of the finished painting illustrates the possibilities for this. The negative space at left is cool, setting off the warm, positive object (the vase) against it; conversely, the negative space to the right is warm, contrasting with the teacup, which is cool. In the black-and-white photocopy, you can more easily see the light-to-dark contrasts and intermediate values.

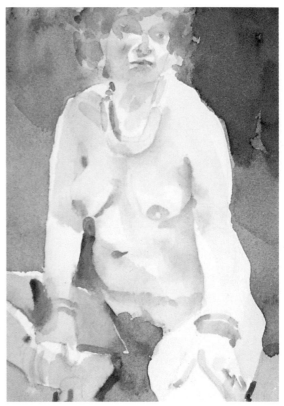

Christy Gallagher, FIGURE.
Watercolor on paper, 6 × 4¹/₂" (15.2 × 11.4 cm), 1993.
Courtesy the artist.

Christy Gallagher's figure painting, executed with French ultramarine blue and burnt sienna, is a fine example of the use of just two colors to create a full range of light and dark and warm and cool effects.

TRIAD PAINTINGS

Composing with color may be compared to juggling. You must focus your attention on all, not just one, of the suspended objects in motion. Each color has its own uniqueness but depends on its neighboring colors to have a voice in the composition.

A primary triad contains the building blocks of color harmony. Though only three colors are involved, they offer nearly limitless possibilities. Because the goal in composing with color is to do much with very little, working within the limits of a triad is an effective way to learn. The triadic colors you choose must have the essential traits of the primaries and turn gray when mixed in equal amounts. The colors used in the next two demonstrations are mauve (red), burnt sienna (yellow), and French ultramarine blue (blue).

To be harmonious, colors must have a commonness of purpose. By starting with a group of colors such as a triad or other complementary chord, then bringing in subtractive mixtures, you will find that the colors in your composition form a harmonious union. Each color mixture may retain its individuality, but it must also conform to the overall harmony.

DEMONSTRATION

All four of the thematic abstractions shown here were painted with the same triad of mauve, burnt sienna, and French ultramarine blue. I used the three colors in various combinations to create overall analogous harmonies, giving each composition a unique rhythm and a different warm or cool emphasis. In developing these four harmonies, while aiming for a close thematic feeling, I followed the basic rule of never juxtaposing color mixtures of the same value or temperature.

Here, temperatures are in balance; I mixed warm and cool colors in equal proportions to achieve this effect.

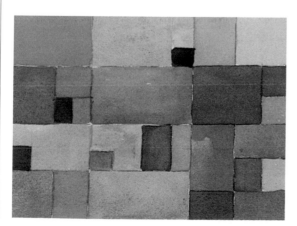

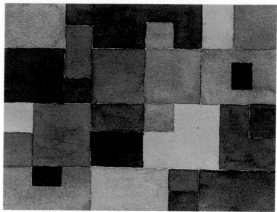

This composition emphasizes cool colors, but warm notes of burnt sienna were added for relief.

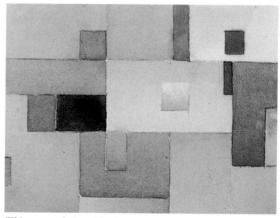

This example is cold; the color mixtures contain a higher proportion of the coolest of the triad, French ultramarine blue, and were diluted with water to give a cooler, lighter feeling. Still, some areas appear warm because of the presence of burnt sienna in neutral mixtures.

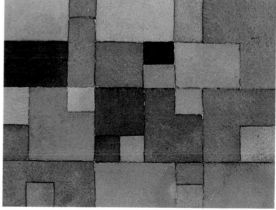

The warm harmony emphasized here resulted from using a higher proportion of warm to cool color. A few shapes, however, were painted in cool tones, relying on the harmony's support color, French ultramarine, to give the composition greater depth.

DEMONSTRATION

Night Porch is simply a representational example that combines the effects illustrated by the abstractions on the preceding page. Here, I am able to create the tonal and temperature variety my subject calls for using the same triad of burnt sienna, mauve, and French ultramarine. In the drawing, I lay out the overall patterns of the composition, which I consider according to how color and value effects will be weighted in the design. I develop the painting's evening mood using dark, cool color mixtures. The lighted windows are color effects that stimulate the nocturnal harmony and give the painting greater depth.

The compositional drawing anticipates what my painting will be about.

**David Dewey,
NIGHT PORCH.**
Watercolor on paper,
7 × 6" (17.8 × 15.2 cm).

This painting is a primarily cool composition relieved by warm tones, notably those of the lighted windows; these visual weights are in turn stimulated by the contrasting cool and dark areas. This general compositional rule applies: always set up contrasts of tone and temperature that will create a visually active design; the eye is continually moved about by these conditions.

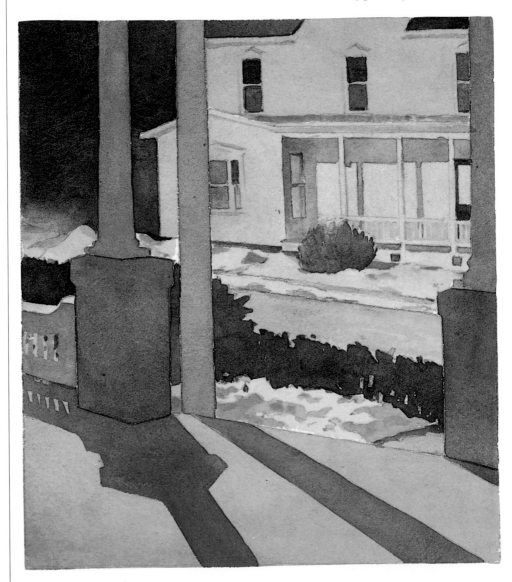

BURNT SIENNA

MAUVE

FRENCH
ULTRAMARINE BLUE

INTERPRETING THE COLORS YOU SEE

To execute a watercolor painting, you must begin by observing your subject and take from it the information that pertains to painting, not to the details of the subject itself. This process is called color perception, and it is the most difficult part of painting. In color perception, your eye is stimulated by perceived color—the subject's natural color—but your color choices must be based on the abstract principles of painting with color; they may have very little to do with the natural colors you see. You have to learn to let go of the subject, to give in to the needs of your painting, and interpret with color, not describe!

In this process, you reinvent the subject through color. For example, if you are looking at a tree you want to paint, you start with a drawing of its shape, then paint the tree with colors that don't look exactly like the tree. If the tree is brown, you choose colors that might not just suggest brown but improve on its visual character.

DEMONSTRATION

In painting, it's not *what* you see, but *how* you see. The following demonstration presents techniques to assist you in visual observation and color selection.

When you are looking at a landscape, a viewfinder is a useful device in color observation; it helps you see your subject in terms of pigments and values. In this case I am using one to identify the three bands of color in the scene. The dots to the right of the main opening allow me to isolate individual colors as if they were spots of pigment on the paper.

Here I superimpose a viewfinder on a painting I did on site to show the relationship between my subject and the image I created of it.

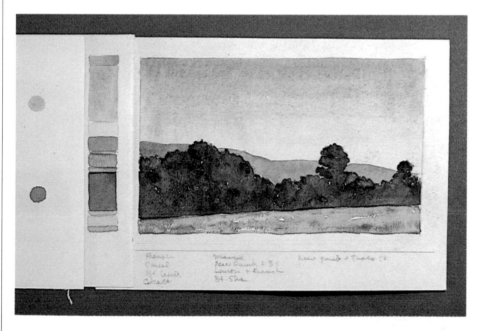

The color bar, or chord, to the left of the finished painting shows the colors I used in the foreground, middle ground, and background of the composition. The two dots to its left are the contrasting blues isolated for use in the background and middle ground of the landscape.

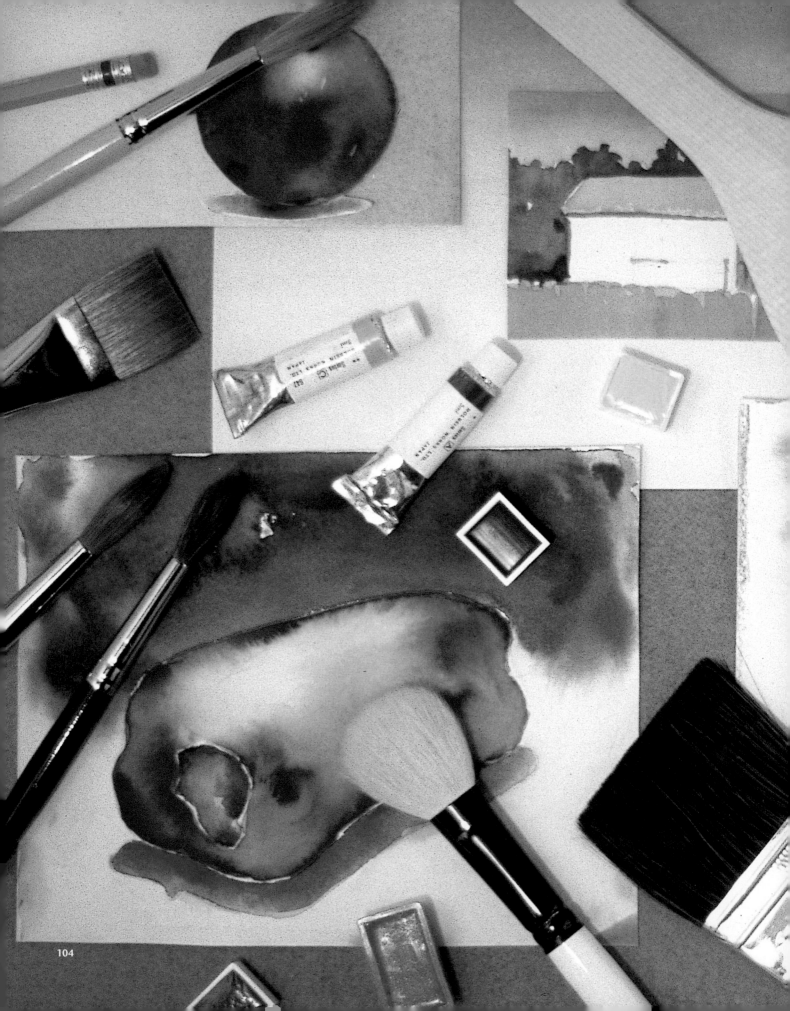

PAINTING SUBJECTS

Imperative to rendering subjects successfully in watercolor is a synthesis of three skills: vision, design, and technique. Technical proficiency can yield impressive results, but without vision or design, such results lack heart and are merely superficial. On the other hand, vision and design rely on your ability to handle the medium well enough to give ideas clear visual form. Each skill is dependent on the other in the effort to achieve total visual coherence. I have found in my own journey with watercolor that as my vision gained conviction, my ideas stimulated a constant appreciation for the interpretive force that skill in handling the medium brought to my work. As my ideas grew in ambition, my painting skills were in turn stimulated by their energy and grew also.

Encompassing all the traditional genres of still life, figure, and landscape, this chapter places the skills of technique, design, and vision at the feet of painting subjects that are suited to the unique interpretive effects of the watercolor medium. By applying all three skills, you can bring the subjects you choose to life.

Still Life

Like a window opening onto an intimate view, a still life painting can reveal much about the life and times of the artist who created it. The objects in such pictures are usually items of personal significance from the artist's surroundings, and their arrangement in a composition generally suggests a place of refuge the artist finds satisfying.

This section explores the genre of still life through a variety of subjects based on common, everyday items ranging from reflective and transparent objects to organic and botanical forms.

DEMONSTRATION: TRANSPARENT AND REFLECTIVE OBJECTS

Objects made of glass, metal, or other transparent and reflective materials place demands on the artist because of the complex maze of patterns on their surfaces. However, the physical nature of watercolor lends itself to depicting these very qualities. Such subjects provide an opportunity to explore how chromatic neutral color mixtures, adjusted for temperature as needed and optically stimulated by strong touches of their pure component colors, can be used to create the illusion of three-dimensional form.

To the left of each step in this demonstration is the color chord to which the painting is keyed; it consists of cadmium orange, cerulean blue, Winsor green, indigo, permanent rose, phthalo blue, and French ultramarine blue, plus the warm and cool neutral mixtures that dominate the composition.

I established the composition's major shapes, including the reflection patterns. I laid in the first washes using warm and cool neutrals mixed from cadmium orange, permanent rose, and indigo, allowing the colors to mingle and leaving some areas white for contrast and light.

Here, I used the same tones but with a warmer emphasis, painting around the candle holder. Next, I painted the candle with cerulean and a touch of phthalo blue. This blue element establishes a strong visual relationship with the predominantly yellow neutrals behind it.

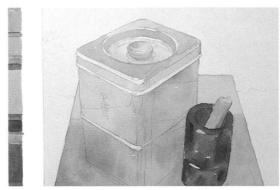

I wet the shape of the candle holder with water and applied a wash of cerulean and phthalo blue warmed with permanent rose, leaving bits of white to convey the reflective brilliance of the glass. I continued with its reflection in the mirror.

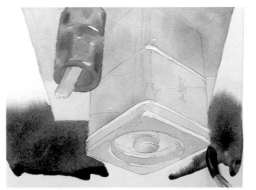

Next, I added the dark, negative background space. I turned the painting upside-down, wet the area with water, and applied a wash of indigo warmed with permanent rose, depositing color on the surface and letting gravity pull it down and across the paper. The contrast between the soft edge of the background and the hard edges of the mirror and canister gives the painting depth.

I added the blue reflection to the edge of the canister, as well as darker blue and blue-violet touches to the candle holder to further describe its form and function as a counterweight to the dark background. The warm, light tones of the canister and mirror contrast with the cool, dark background and candle holder.

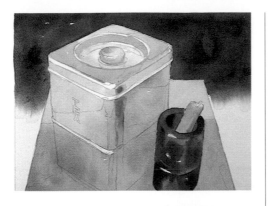

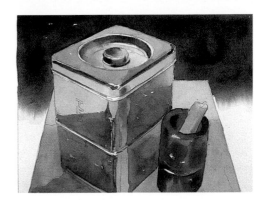

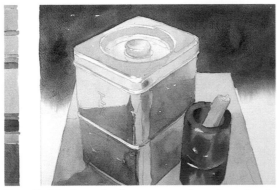

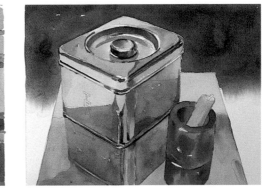

I applied darker-valued warm neutrals to the canister's side planes to further define its form and reflective surface, using cooler versions of these neutral tones for the corresponding reflection in the mirror. I also placed bright orange accents on the edges of the canister and its reflection to strengthen form and compositional depth. This was done both wet-on-wet, resulting in softened edges, and wet-on-dry, resulting in much sharper edges.

Strong light and dark spots and vivid touches of blue and other colors have started to bring the forms and reflective effects to life. These are most apparent on the lid, front corner, and right-hand plane of the canister. Note the pieces of white I left in the background and on the canister; these add sparkle. For light and brilliance, some white must always be preserved in a watercolor painting.

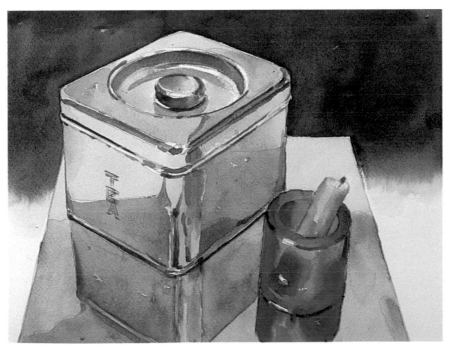

Finally, I placed touches of blue and orange on the insides and outsides of the objects, taking care to preserve small bits of white for the color activity they prompt.

DEMONSTRATION: ORGANIC OBJECTS

An organic still life is one composed of objects from nature, like fruits and vegetables. Their colors and unique, often irregular shapes lend themselves to being depicted in watercolor that itself is handled in an organic way, in which pigments are allowed to mingle naturally on the palette or on paper wet-on-wet to describe three-dimensional form. This demonstration and the next focus on the use of secondary and analogous color harmonies in painting organic still lifes.

The spheres at right look three-dimensional because I used the lightest, warmest colors of each range to depict the illuminated areas and the coolest, darkest ones for the shadows on the forms. The illusion is underscored by the contrast between the forms and their darker, cooler blue cast shadows.

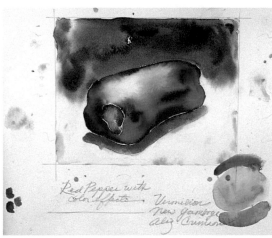

I painted this red pepper as a study of form in space, defining my subject with an organic mingling of the warm and cool hues that describe its local (actual) color— vermilion, new gamboge, and alizarin crimson—and offsetting it with darker colors to describe its surroundings. Note the heightening effect the vibrant cast shadow, composed of cerulean and phthalo blue, gives to the red-orange pepper; complementary colors used this way emphasize and modify each other.

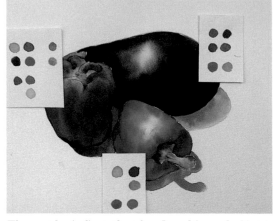

The swatches indicate the colors I used for each object in the still life. The top horizontal row shows the objects' local colors; the second row shows the colors used for the shadows on the objects' forms; and the bottom two or three colors are those used for the cast shadows.

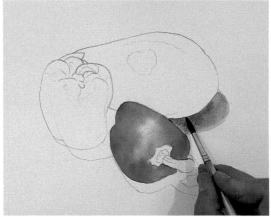

I began with a contour drawing; the marks in the middle of each shape indicate areas that are to be left white. In watercolor, you should paint the brighter, lighter, warmer shapes first; doing so will help keep their colors clean. First, I wet the entire surface and applied aureolin and cadmium yellow to the foreground pepper, avoiding the small outlined area that's to stay white, since the color can easily spread over it. Without this bit of white, the form would look flat. I followed with progressively darker, cooler colors to give the orange pepper some weight. Once it was finished and completely dry, I painted the eggplant's cast shadow behind it. I wet the desired area with water, then applied paint starting from the inside of the shadow shape and allowing the color to bleed outward. I began with cerulean, warming it with French ultramarine on the inside of the shape. I followed with the pepper's cast shadow, this time using French ultramarine blue and permanent rose. Note how the dark, cool blue cast shadows push the bright, warm orange pepper forward.

When the shadow was dry, I wet the eggplant shape and painted in the warm and cool colors of its skin, avoiding the area that is to stay white and working from light to dark values to articulate the form's weight and volume. In this organic approach, use the brush simply to transfer paint from the palette to the paper. Let the colors mingle naturally, and tilt your board to move paint where you want it to go. Note how the finished eggplant's dark color makes the white highlight radiate.

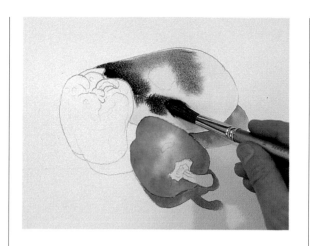

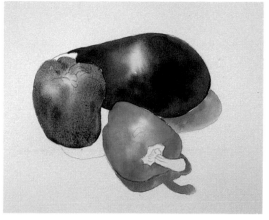

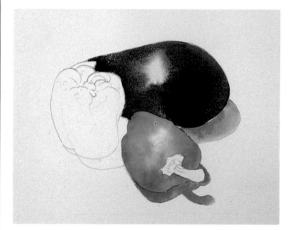

I painted the green pepper using colors that were pretty well mingled on the palette. It's important that you see how colors behave together on the palette so you can anticipate how they will work with your subject. Again working from light to dark on a wet surface, I tried not to overmix the colors as I applied them so as to retain evidence of the individual pigments. Note the variety of greens in the finished pepper: warm yellow-greens, earth greens, and cool blue-greens. Used in combination, these colors define the object's character and heighten the sense of its three-dimensional form.

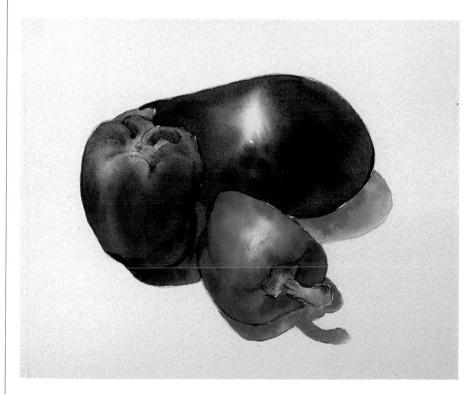

I painted the stem of the orange pepper using cooler greens for the inner parts and progressing with lighter, warmer greens as I worked outward. The last glazes firm up the objects' volume and form. When the green pepper was dry, I rewet it and applied the same colors I used in the first wash but diluted them less, following suit with the orange pepper. I finished by adding the cast shadow between the two peppers.

DEMONSTRATION: ORGANIC OBJECTS IN SPACE

For this organic still life I set several different fruits and vegetables against a patterned cloth. The cloth's flat, low-key colors contrast with the high-key colors of the fruits and vegetables, enhancing the sense of the objects' three-dimensional form.

I began with a drawing, then applied the first layers of color to the background. I also painted in a few of the objects as color weights, along with their cast shadows to anchor them in space and give them volume.

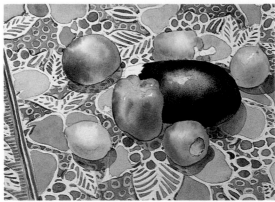

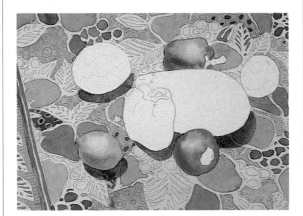

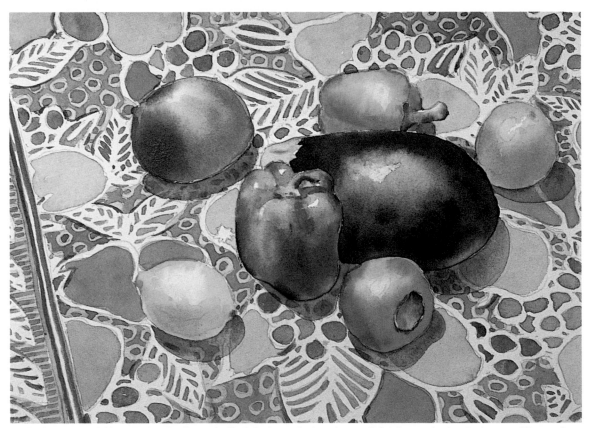

I added color to the rest of the fruits and vegetables using the organic, wet-on-wet method, as well as completed the background pattern. I also painted in the remaining cool cast shadows; note how transparent these blues are, a quality I achieved by diluting their color with water.

In the last stage of this painting I enhanced all of the forms by layering on light glazes of color. Before applying a glaze, be sure the surface of your painting is completely dry.

**Charles Demuth,
RED APPLES.**
Watercolor on paper,
10 × 14" (25.4 × 35.6 cm),
1929. Private collection.

*The American
watercolorist Charles
Demuth (1883–1935)
painted these apples
in an organic
manner using warm
and cool reds, which
he countered with
complementary green
passages. He used
the blotting technique
to lift color, creating
highlights that
heighten the apples'
three-dimensional
quality.*

**Marianne Barcellona,
STILL LIFE WITH GOURDS.**
Watercolor on paper,
12 × 16" (30.5 × 40.6).
Courtesy the artist.

*This painting is
a fine example of
the effective use
of complementary
contrasts in an
organic still life.
The orange and
red-orange objects
appear more
brilliant because of
their juxtaposition
with the blues
and greens in the
composition; note
especially the effect
the blue background
pattern has on the
red-orange objects.*

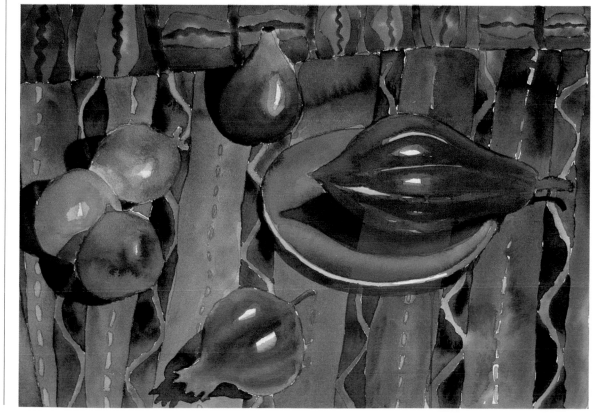

DEMONSTRATION: A BOTANICAL STILL LIFE

Plants and flowers, with their delicate organic structures and beautiful colors, are expressions of nature that give our lives great pleasure. However, painting botanical subjects must be approached soberly, for their attractiveness makes it all too easy to depict them with sloppy sentimentality. Don't ignore the design and color principles you would apply to other subjects; when painting flowers and plants, keep your head on your shoulders.

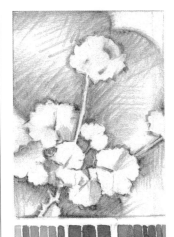

I created tones in the negative spaces to see how these dark areas affect the positive geranium shapes. Below are the colors and a few mixtures I consider using; based on cadmium yellow, carmine, and French ultramarine blue, this palette includes other colors for a greater temperature range.

This page from my sketchbook shows thumbnail compositional and color studies of my subject and some notes; the gray tones at the bottom are experiments involving the use of soap. All of this sketchbook activity helps me get a feel for the subject so I can think of it visually rather than in physical or literal terms.

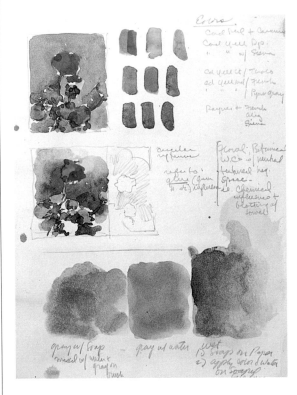

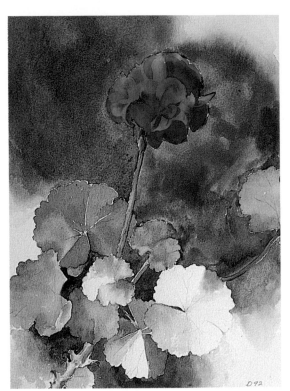

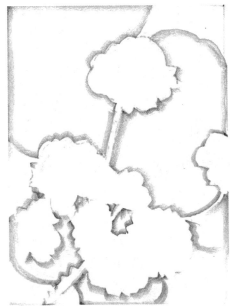

With a contour drawing I established the positive and negative shapes of the composition. The rhythm of the geranium leaves and blossoms is echoed in the curves of the surrounding space. I call this approach the "outer" drawing method because I define the outside contour of my subject rather than the inside.

I painted the flower with both warm and cool reds using the wet-on-wet approach, defining structure and form with glazed layers of color. For the background I combined alizarin crimson, Winsor green, and Payne's gray, sometimes mixing the paint with Ivory soap and water to get an organic textural effect that relates the background to the subject. I left a fair amount of white in both the inner and outer parts of the composition, which at first glance makes the geranium seem unfinished. However, the subject actually has a completeness that is due to the balancing effect of the white areas, and to the way the space around the unpainted leaves has been constructed to imply the plant's three-dimensional form.

**Charles Demuth,
KISS ME OVER
THE FENCE.**
Watercolor on paper,
11⅝ × 17½"
(29.5 × 44.5 cm),
1929. Private collection.

*Demuth used
mixtures of yellow
and blue to create
soft, earthy greens,
which are offset by the
pinks and reds of
the flowers in a low-
key complementary
harmony. The
subtlety seen here
is typical of his
work; in this case
he achieved both
delicacy of color and
three-dimensional
depth, as well as a
luminous quality lent
by the large amount
of white space.*

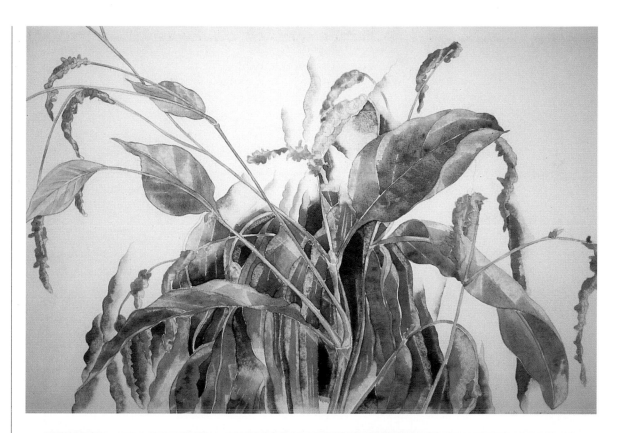

**Fran Hardy,
BISLET CABBAGE.**
Watercolor on paper,
30 × 42½"
(76.2 × 108 cm).
Private collection.

*This painting uses
a red and green
complementary
harmony in a high
key. Fran Hardy
attained great depth
and luminosity by
working with layers
of warm and cool
red and green glazes,
as well as by leaving
white areas that add
brilliance. Color
effects are heightened
by the extended
contrast between the
large expanses of icy-
cold blue-greens and
the proportionately
smaller but equally
weighty warm,
advancing reds.*

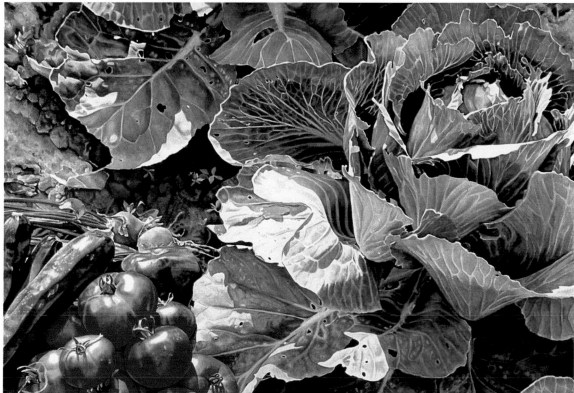

DEMONSTRATION: A MORE COMPLEX STILL LIFE

This still life is based on a fairly complicated setup that incorporates more objects and a more complex spatial arrangement than the previous demonstrations did. The emphasis here is on structuring a design whose elements are placed in a visually pleasing context.

I picked out the spatially pertinent verticals, diagonals, and curves of my subject, then made this sketch of their rhythmic relationships as they connect and divide areas.

I rendered the positive and negative, "inner and outer" shapes of my still life to show how the various objects relate to one another and to the space they occupy.

In this value and temperature study, the reddish-brown ink served as my warm, dark value, while the gray wash served as my cool, middle values. Areas left white represent daylight and its reflection in the setup's shiny surfaces.

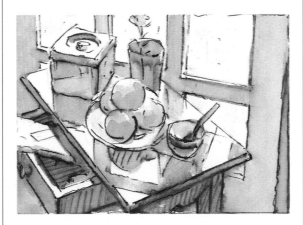

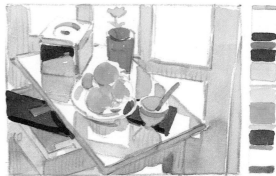

Here, I studied ways to move the eye around the composition: the red napkin and turquoise card at left, plus their reflection in the canister, are counterbalanced by the green-rimmed teacup and red napkin at right; orange and blue were arranged for similar effects.

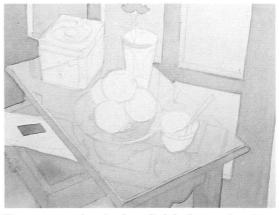

To my contour drawing I applied the first wash to the tabletop and windowpanes for the basic light and dark patterns. I then painted the wooden parts of the table with reds and burnt sienna, and the windowframe with a neutral grayish yellow. Next came the blue card at left for visual weight, and the yellow flower to bring out the light of the initial washes.

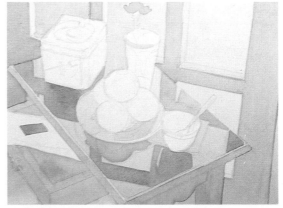

I added cerulean at right and on the table's front edge, then painted the cast shadows and reflections on the tabletop with French ultramarine and burnt sienna.

I painted the teacup with yellow and French ultramarine, adding the stripe with Winsor green. I used cerulean and ultramarine for the glass and left white on the rim to suggest transparency. The red napkins were then laid in; their color stimulates the blue and green notes.

The oranges were painted with aureolin, cadmium orange, and permanent rose. They, plus the flower and napkins, now contrast vibrantly with the cool blues and greens. Using French ultramarine, cadmium yellow, and permanent rose, I then began to render the canister's reflective surface.

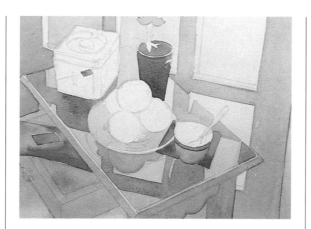

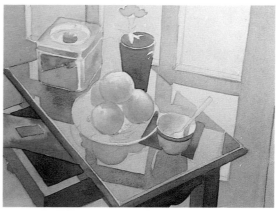

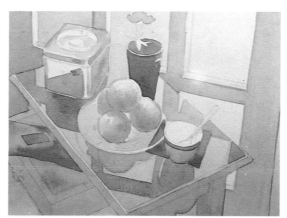

I painted the reflection of the red napkin and blue card on the front plane of the canister and added some darker values to further define the object's form. Then, using a soft flat brush and working wet-on-dry, I layered darker values on the table to indicate depth and three-dimensional structure.

The final color tones were layered on with consideration given to the overall harmony. These last details are meant to add interest and focus to what is already in the picture; they should never be unrelated afterthoughts.

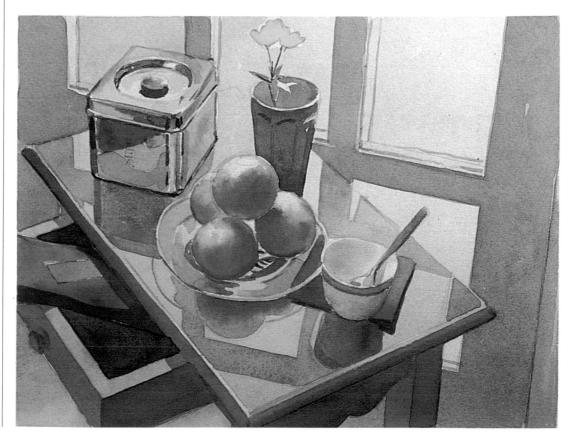

STILL LIFE

**Nancy Hagin,
SAWTEETH, 1989.**
Watercolor on paper,
42 × 50" (106.7 × 127 cm),
1989. Collection of Stroock,
Stroock and Lavan,
New York City.

*This beautiful
arrangement has a
red and green color
harmony. Note how
the very cool blue-
greens and very warm
yellow-greens work
in conjunction with
the red-violets and
brilliant blue-violets.
The geometric patterns
that dominate create
a strong abstract
effect, and the
composition's linear
rhythms, as well as
its color and value
contrasts, guide the
eye around the picture.*

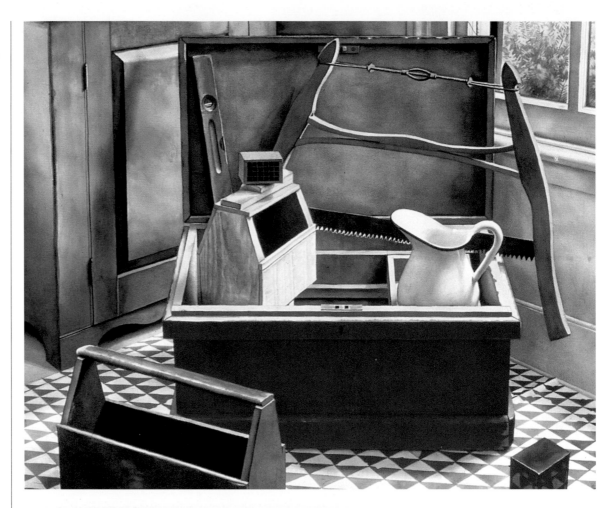

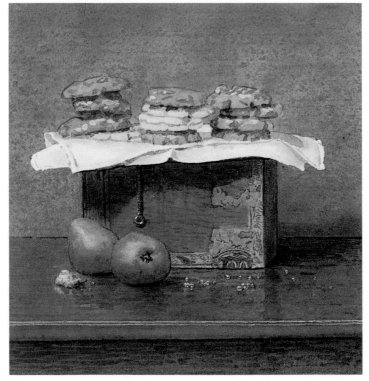

**John Stuart Ingle, STILL LIFE WITH
BOSC PEARS AND COOKIES.**
Watercolor on paper, 1986.
Courtesy Tatistcheff Gallery, New York City.

*Ingle painted this watercolor study, which
he refers to as a "cartoon," on a letter
sent to his New York art dealer. The letter
contains the artist's thoughts on various
aspects of this particular painting and
other small ones like it. The composition
is geometrically ordered, centering on the
box, whose well-placed note of green in
the lower right-hand corner offsets the soft
reds and earth tones of the cookies and
pears. This green note, responding to the
reddish background, is key to the painting's
beautiful overall color harmony.*

The Figure

Since our Paleolithic ancestors first painted and carved images on cave walls, artists have been compelled to depict the form of the human body. In Western culture, the human figure has even been revered as a manifestation of a higher and more perfect order. Such assumptions, in conjunction with the revival of classical Greek and Roman aesthetics during the Renaissance, ultimately led to the addition of the study of human anatomy to art education. The figure teaches fundamental lessons in form, proportion, space, and design—the essential tools required to create art.

In this section, we review a number of techniques that will improve your skills in handling watercolor and increase your understanding of the human figure.

David Dewey, FIGURE STUDY.
Watercolor on paper (sketchbook), 1994.

In this figure study I used reds, yellows, and blues and left a great deal of white on the paper, which produced a luminous effect. The colors I chose draw the eye progressively through the composition.

Ruth Lurie Kozodoy, FIGURE.
Conté crayon and ink wash on paper, 24 × 18"
(61 × 45.7 cm), 1994. Courtesy the artist.

This artist first used Conté crayon to define the figure within the composition, then added warm ink washes in a range of values to create the illusion of form. The contrast between hard and soft edges produces depth, and the contrasting densities of light and dark passages lead the eye through the composition, establishing a visual order and balance.

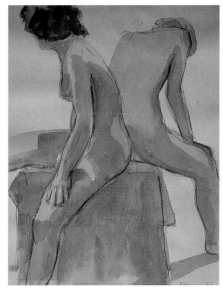

David Dewey, FIGURE STUDY.
Watercolor on paper (sketchbook), 1976.

These two figures are visually linked by similar contrasts of warm and cool color. The arrangements of light and color also emphasize their relationship to the surrounding space.

DEMONSTRATION: THE MODEL

The nude figure's surface effects and anatomical details are simultaneously fascinating and disconcerting. Most representational artists either focus on the body's external features or emphasize the underlying structure that gives it its form. However, the figure cannot be fully understood without a thorough examination of its structural dynamics. When working from a model, the artist must first define its structure, then conform its surface to the underlying contours without obscuring or distorting them.

As is true of any subject, light plays an important role in interpreting the figure's structure and surface. When the light is diffuse, surface tones are stressed, but when the light's source and direction are more defined, structure is accentuated. Understanding how light clarifies structure can be very useful in learning to see the "inner figure," or the framework beneath its immediately discernible form. The sketches shown here illustrate how pencil and monochromatic washes can be used to capture, in terms of light, the structure of the figure and its relationship to the surrounding space. In the demonstration that follows, I used a primary triad of Indian red, yellow ochre, and cerulean blue to compose a more precise figure study.

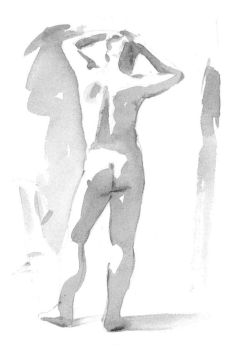

This male nude shows how staggered contrasts of light and dark, both within and outside the figure, create form and depth and propel the eye through the composition.

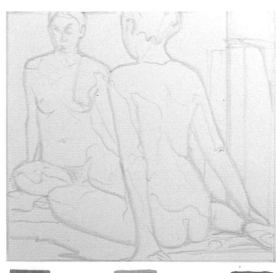

This contour pencil drawing of a figure and its mirror image reveals the dominant patterns of both back and front views. Below it is a primary triad of Indian red, yellow ochre, and cerulean blue.

I drew the figure at near right quickly in pencil, then added a one-color wash, allowing natural variations in value to suggest form. For the example at far right, I used three values of the same color to locate the figure in space, first developing the form's basic light and shadow patterns with midtones, then adding a low-value wash to convey depth and increase the structural effects of the whites. I also used darker tones to define the figure's edges, which advance the form within the pictorial space.

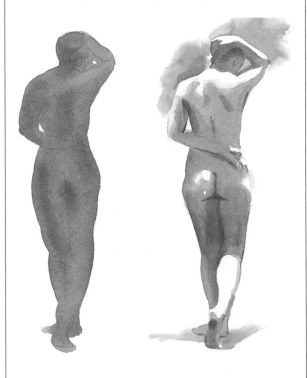

Mingling yellow ochre and a touch of Indian red directly on the paper with a clean, moistened brush, I established my subject's basic light and dark value patterns.

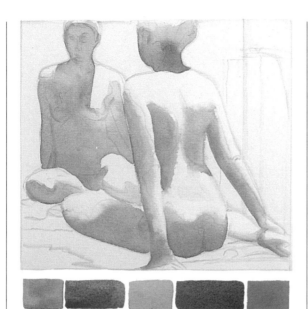

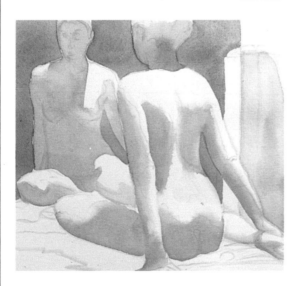

To paint the negative background, I wet the paper and dropped in equal amounts of my triad colors, letting them mingle for a textural, granular effect. This made the warm areas of the figure seem more luminous. I then added more yellow and red to the figure's neck, creating a strong contrast with the background.

The dark space at top right is blue plus red blended with a touch of darkened yellow, I used a thinned wash of this mixture at lower left. The addition of slightly grayed Indian red in the lower right foreground completed the first set of washes and created a balance of light values and warm and cool colors.

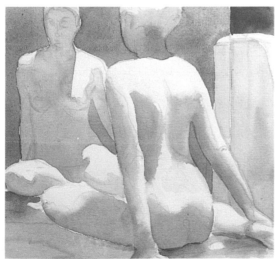

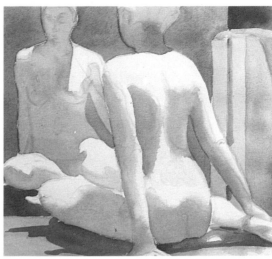

At this stage I added the dark blue and red shadows and the draped blue fabric at right. These darker values suggest depth and provide contrast for the warm and cool mid-value colors that dominate the composition.

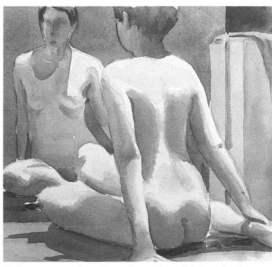

Subsequent touches of cerulean blue added to the drapery and the head create volume without becoming too descriptive, which would lessen the impact of the color relationships that stimulate visual movement throughout the composition.

DEMONSTRATION: THE PORTRAIT

Because of its direct emotional and psychological link to the sitter, the human head can be a more challenging and problematic subject than the complete figure. The very qualities that inspire an artist to draw or paint a portrait—the personality and character evident on a subject's face—can become obstacles to an accurate and sensitive rendering. In spite of the complexities of the head's form, structure, and proportion and the emotional component of the relationship between sitter and artist, the methods used for drawing and painting the figure can also be applied to the portrait. The structure of the head and face can be clarified through color, which can be used to build form through contrasts of temperature; of equal importance is value, which is used to express the interplay between light and shape. In both cases the effects of light on the head also play a vital role in understanding its structure.

In this demonstration, we review the structural effects of light on the human head and interpret both its external and underlying forms in pencil, monochromatic wash, and color.

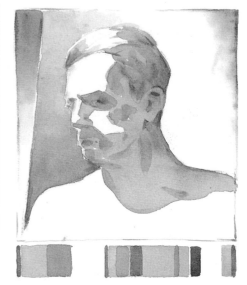

This watercolor sketch illustrates how a monochromatic chord of color (in this example, burnt sienna) can be used to express structural depth and form. As can be seen repeatedly in this demonstration, form is suggested by positioning high values within or immediately adjacent to low ones, which also results in strong, vibrant contrasts of positive and negative space.

At the bottom of this illustration, the schematic diagram at near right shows the structural use of light within a superimposed geometric framework. This kind of sketch is the essential first step in executing a portrait. The sketch at far right simply suggests the head's basic structure and foreshortened proportions. In the pencil drawing above, I used hatching to relate the head to the surrounding space by creating contrasts of value that move the eye through the picture plane. I then layered the hatching to suggest form.

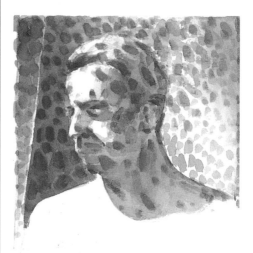

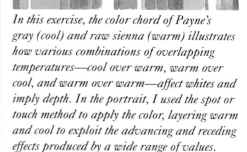

In this exercise, the color chord of Payne's gray (cool) and raw sienna (warm) illustrates how various combinations of overlapping temperatures—cool over warm, warm over cool, and warm over warm—affect whites and imply depth. In the portrait, I used the spot or touch method to apply the color, layering warm and cool to exploit the advancing and receding effects produced by a wide range of values.

I defined my subject's light and dark patterns in pencil, then applied warm, luminous mixtures of new gamboge, permanent rose, and ultramarine blue. Letting the colors mingle on the wet paper resulted in an organic brilliance that intensified the white front plane of the head.

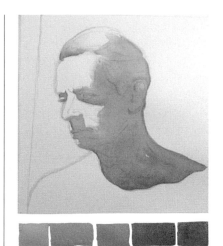

I painted the area to the figure's left with a dark value that advanced the white areas within the head and established an equilibrium of value in the composition. The adjacent lighter violet staggers the warm and cool relationships, and the weight of the background balances the shadow at right within the figure.

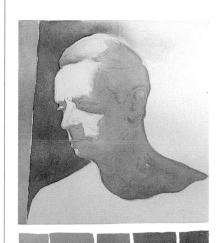

Shadow and form within the hair and face are further defined at this point. Color is layered on softly so that specific detail does not interfere with the overall development of the image.

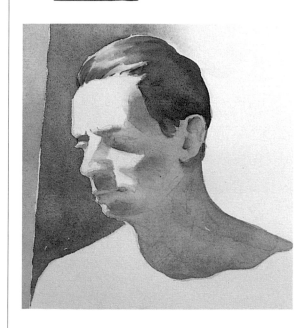

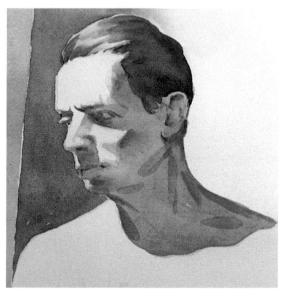

I applied transparent strokes of yellow and red over the first washes and to the white of the forehead to enhance its form, allowing the radiance of the colors beneath to show through and the identity of the figure to evolve without sacrificing the structure.

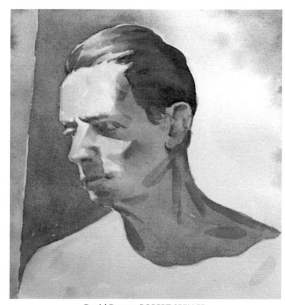

David Dewey, ROBERT SPELLER.
Watercolor on paper,
6 × 5¹/₂" (15.2 × 14 cm).

In the final step, I stained the right-hand corner of the image with touches of violet, blue, yellow, and their neutral mixture to resolve the balance of the composition and the overall harmonious effect of the triad.

DEMONSTRATION: COLOR, COMPOSITION, AND THE FIGURE

Creating a fully developed composition in which a figure is the primary subject requires an understanding of the relationship between color and design, whose successful alliance can produce remarkable figurative watercolors. In preparation for your painting, you must detach yourself personally from the figure, locate it in a secure visual context, and portray it in colors that are harmonious, balanced, and dynamic.

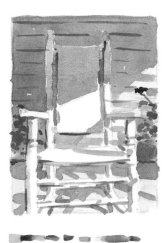

I made this study to get a feeling for the color relationships and light effects in my subject. I added color notes for capturing the essence of the location. Note how the red geraniums and whites in the chair serve as both focal points and connections to other compositional areas.

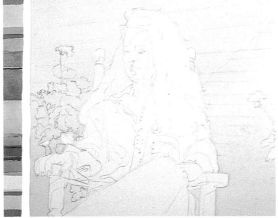

In arranging the figure and establishing the composition's basic patterns, I repeated the strong diagonal shape of the background shadow in the position of the model's arm, leg, and head. The geraniums will also draw the eye toward the figure, as their color echoes that of her hair. Using my notes from the color study, I devised the chord at left by taking into account the compositional context of the colors as well as their simultaneous and extended complementary effects. To establish the highest value for the figure, I laid in a warm, creamy mixture of yellow ochre tinted with permanent rose over most of the rest of the composition, working from top to bottom.

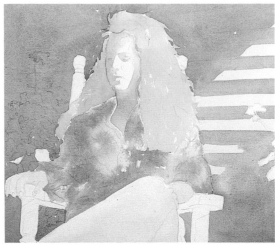

I painted in the hair and the shadows on the skin. When these areas were dry, I added the blue of the shirt by wetting the paper and dropping in color, letting white show through to suggest form. I then laid in a diluted wash of the yellow ochre and permanent rose mixture on the figure's knee, softening it with a moistened brush. Next, I wet the background with water and dropped in French ultramarine and permanent rose, letting the colors mingle to produce a flowing, granular texture. I quickly painted in the shadows on the clapboard while the paint was still wet, then added warm and cool touches throughout the background for variety.

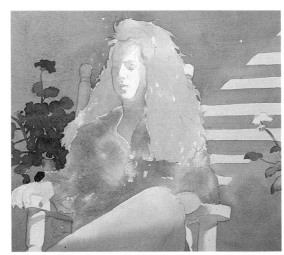

The warm shadow on the knee connects the figure to the background, giving an abstract quality. The cadmium red in the geranium at left stimulates the eye to detect various color relationships throughout the image. I used new gamboge and a mixture of permanent rose and French ultramarine for the warm and cool shadows on the arms of the chair, then softened and filled out the shapes with thin washes of ultramarine. Mixtures of Winsor green and new gamboge (warm) or permanent magenta (cool) were used to give form to the geraniums.

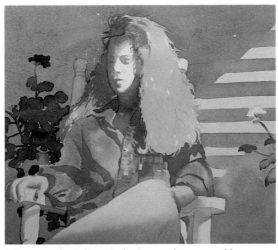

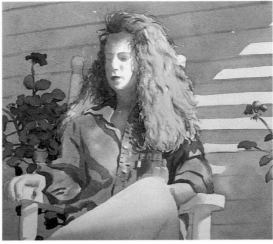

The strength of the painting's complementary blue and orange color strategy is now more apparent. The luminous orange shadows on the figure's hair and neck vibrate against the blues in the shirt. I painted in the shadows of its folds with touches of cobalt blue that are keyed to match the brilliance of its complement. I then added warm shadows to the hands, arms, and forehead with thin washes of new gamboge and permanent rose.

Using the drybrush technique, I added texture—rather than detail—to the hair, then added a touch of red to the lips. I painted in the geranium flower at right, which draws the eye to that area of the painting. These color effects work as signposts to move the eye across the composition. I then added my cool green mixture (Winsor green and permanent rose) to further define the geranium leaves without disturbing the color balance.

**David Dewey,
AMANDA.**
Watercolor on paper,
9¹/₂ × 10¹/₂"
(24 × 26.7 cm), 1994.

To finish the work, I added touches of low value throughout the figure, then placed the last stroke of color—the red label on the shirt pocket. This contrasts greatly with the surrounding ultramarine blue, creating a vibrant effect that completes the visual linkage throughout the painting.

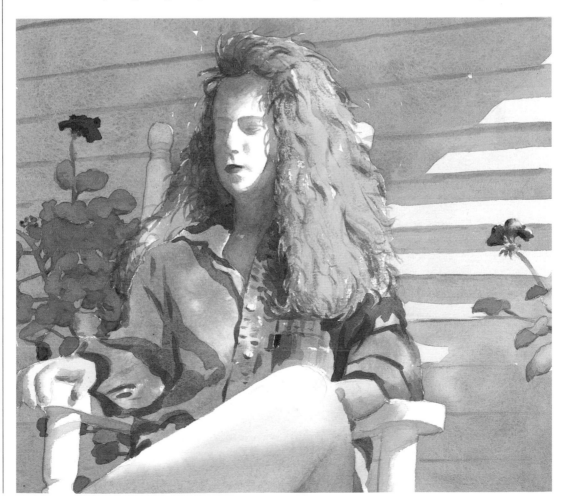

LANDSCAPE

Watercolor has long shared in the tradition of landscape painting. This is due, in part at least, to the medium's portability and fast-drying quality, two characteristics that readily suit it to capturing, quickly and spontaneously, nature's constant state of flux and fleeting atmospheric conditions. Painting the landscape involves careful observation of its physical appearance as it is affected by changes of season, weather, and especially light. Light, as we know, is the wellspring of color, and thus of our visual perception of the landscape's topographical structures. It is the most important influence on anyone choosing to paint the colored tapestries of landscape with watercolor, a medium uniquely suited to the task.

This section is devoted to studying and interpreting the vibrant effects of light and color on the various natural and man-made structures that comprise landscape compositions, all in the context of color observation, color theory, color mixing, and design.

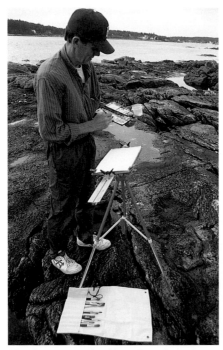

Here's an example of how I work on site. Painting landscapes outdoors requires that you have the right equipment and organize it so you can work comfortably and efficiently in the field.

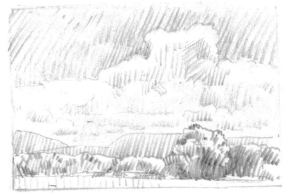

This drawing shows how I used hatching to establish the design characteristics of the sky's rhythms as they are reflected in the land's contours. It also shows the composition's overall structural development, including the tonal harmonies of the various elements.

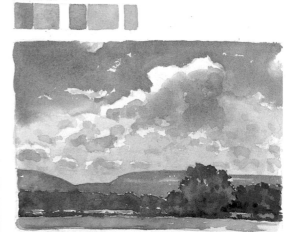

The painting demonstrates the use of color for compositional structure and spatial illusion. Working with the dynamic of advancing warm colors and receding cool ones helps me create visual depth and a feeling of light. The light reddish touch of plowed-up earth to the lower right is placed in that part of the composition to contrast with the analogous yellow-greens and blue-greens. This note plays against the very vibrant blues of the background hills, increasing the sense of depth in the painting.

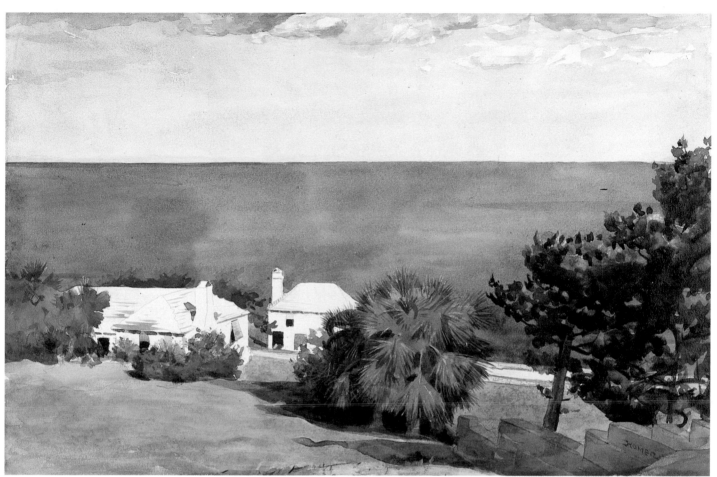

**Winslow Homer,
SHORE AT BERMUDA.**
Watercolor over pencil on paper,
14 × 21" (35.5 × 53.4 cm),
c. 1899. Courtesy The Brooklyn
Museum, 11.539, Museum Collection
Fund and Special Subscription.

In this powerful watercolor, Winslow Homer demonstrates his skillful use of a very limited but vibrant analogous color palette. Here, the harmony of the greens, blue-greens, and turquoise is empowered by a note of extended contrast, the tiny, brilliant red rectangle in the lower middle of the painting. Homer often used variations of this scheme throughout his work. In this painting, the architecture and landscape are equal partners. The rhythm of the horizontal elements is offset by the verticals of the chimney and rooftop, and this creates a sense of stability. The careful placement of the tree at a slight diagonal is a dynamic design feature that adds visual tension, thus preventing the painting from becoming static. The white house is a powerful weight that affects the entire composition.

SKIES

Whether seen at sunrise, midday, sunset, twilight, or in moonlight, the sky can be visually breathtaking, stirring our thoughts and influencing our moods, as well as the appearance of all other elements in the landscape. The sky is a great atmospheric prism that transforms light moving through it into constantly changing color. These changes of colored light, along with the variety of cloud shapes and formations and the continual shifts in their patterns, will keep you on your toes as you try to capture them in watercolor. You need to understand the light, look for the rhythmic sequences that govern cloud patterns so you can predict their behavior, and generally anticipate changes in atmospheric conditions. All of this also requires that you work quickly.

This drawing shows cumulus clouds, which have a flat base topped by a high, rounded mass. The schematic below it at left shows the rhythmic curves of the billowing clouds as they relate to the land's shapes. The schematic at right illustrates the use of perspective in sky compositions. As clouds move toward the horizon, they overlap and diminish in size, giving the illusion of spatial depth.

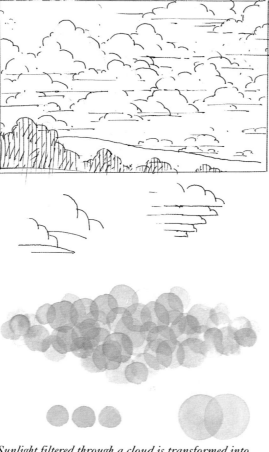

Sunlight filtered through a cloud is transformed into attractive warm and cool neutrals resulting from subtractive mixtures of the spectrum colors yellow, red, blue, and violet. Overlapping these colors in varying proportions makes it possible to capture the many nuances of tone and temperature that are present in clouds. Clouds painted with subtractive color mixtures achieved in this manner are especially luminous.

DEMONSTRATION: CAPTURING RHYTHMS

Discerning rhythmic sequences is an important function of design. In landscape painting, it is a means for making the sky relate to the land below, for the rhythms and patterns of these two key elements should appear to sing a similar tune. Here, I emphasize structural development through the use of color.

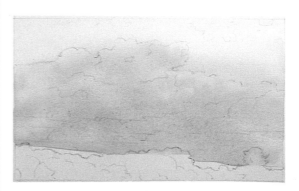

I established the cloud and landscape patterns with a drawing and added my color chord below. The chord includes a warm and a cool blue, cobalt and cerulean, respectively, as well as a primary triad of French ultramarine blue, burnt umber (which serves as my yellow), and permanent rose. Mixing these triad colors in various proportions gives me the warm and cool chromatic neutrals for the clouds. The first light, warm wash is an organic mixture of my chosen triad.

I painted in the upper part of the sky with blue along the tops of the clouds to establish their shapes, simultaneously initiating the luminous effect these cool notes will have on the subsequent warm, chromatic neutrals of the sky. First I wet the chosen area, then I applied cerulean blue lightly near the edge of the clouds, following with cobalt blue along the top to create visual depth and increase luminosity. I let the cobalt blue bleed down into the cerulean for a somewhat graded, atmospheric effect.

I began to add violet middle tones to the clouds, working in layers to achieve visual depth and to suggest form.

The mountains just below the clouds are painted with French ultramarine and a touch of violet. Their placement against the clouds sets up a contrast between light and dark that increases the sky's luminosity and enhances the illusion of spatial depth in the painting.

Continuing with the same colors and allowing the warms and cools to mingle as I layered them on, I finished defining the cloud forms, leaving light areas around their shapes to show the structural effects of light. Note how visual depth is expressed by the way the cloud forms overlap.

In this stage I added the final, darker layers of color that give the clouds their full volume and visual weight. I applied them directly with a round brush, using touches of water here and there to soften edges where needed.

To complete the painting I added the landscape, its dark values setting off the luminosity and brilliant light effects throughout the composition.

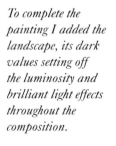

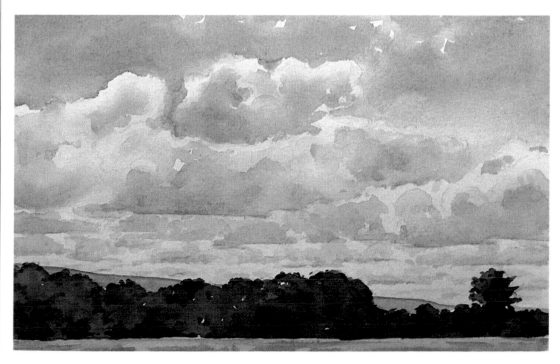

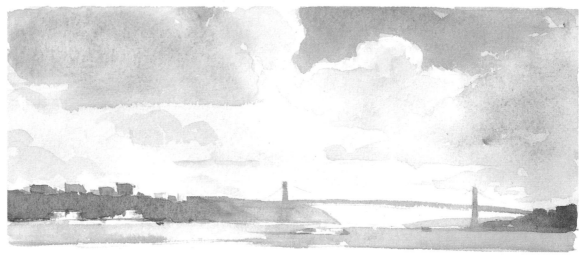

**David Dewey,
CLOUDS OVER GEORGE
WASHINGTON BRIDGE.**
Watercolor on paper,
8 × 12³/₄" (20.3 × 32.4 cm).

The sky, with its light effects, dominates the design of this composition. The cool blue shape in the upper right part of the sky has a powerful, luminous effect on the clouds hovering over the landscape below.

**David Dewey,
NEW MEXICO CLOUDS.**
Watercolor on paper,
12 × 17" (30.5 × 43.2 cm).

In this composition, the sky is linked to the landscape in two ways—through geometry, and through color. First, the horizontal contrail and cloud shapes rhythmically repeat the horizontal rooftops in the structures below; second, the blue of the sky is repeated in the blue door frame at right, and the neutral colors of the clouds are echoed in parts of the land and its structures. These kinds of connections have an overall harmonious effect.

Here, note how the clouds' rhythms are echoed by the shapes of the foreground rocks. Rickert achieved the painting's luminous quality by using chromatic neutral blue, gray, and pink tones. The illusion of spatial depth is strengthened by the contrast between the dark, intense color of the foreground cloud and the lighter, more diluted color of those in the background. The rocks come forward because of their texture and intense light and shadow patterns.

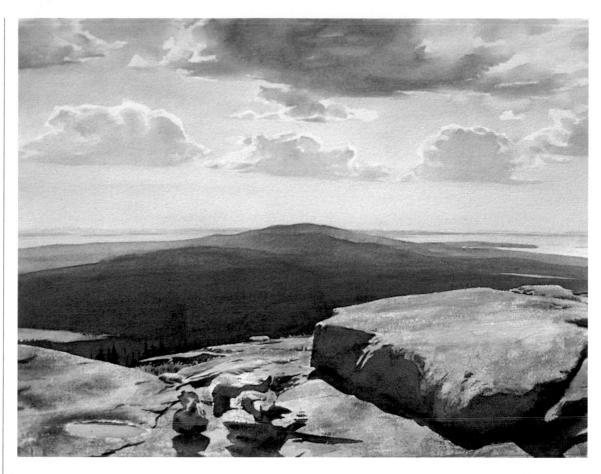

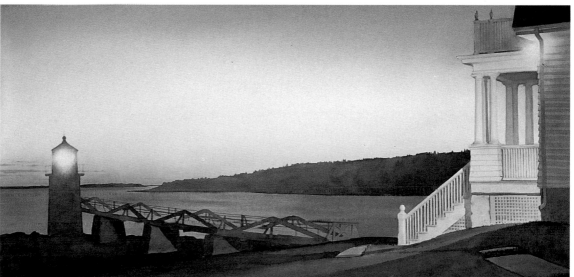

This is an example of light's influence on the color of the landscape. I painted the sky with a wet-on-wet variegated wash in which warm and cool colors were allowed to bleed together for a luminous effect. Cool and warm violets are reflected in the water; note the complementary contrast between the red-violet reflection and the yellow-orange area and the increased color intensity this juxtaposition provokes. The reflection of the cool part of the sky in the water, and the contrast between the cool landscape and warm artificial light on the porch, create a heightened sense of luminosity. The contrasts between artificial and natural light are used as color effects to illuminate the entire painting and to move the eye through the composition.

FOLIAGE

Foliage blankets the land with analogous color harmonies that mark the seasons: think of spring's bright yellows and greens, summer's lush deep greens and blues, and fall's brilliant reds, oranges, and warm browns. The colors of grass, leaves, and flowers are all subject to constant transformations by light and shadow that affect our visual perceptions. The strong light of late afternoon, for example, induces high-key contrasts, whereas dawn's softer light provides a quiet tonal richness; midday sun brings everything into clear focus, heightening complex optical color mixtures.

To the inexperienced eye, each of these lighting conditions can be problematic in interpreting the "correct" colors of foliage in the landscape.

Painting summer's greens or fall's yellows and oranges requires keen observation, an understanding of light's alchemical effects, and good judgment in interpreting the perceptual aspects of color. You must also comprehend color in terms of harmonic relationships and know how it can be used to establish spatial illusions. The next step is to bring all of these elements to bear on your use of color in establishing a sensible visual order in landscape subjects.

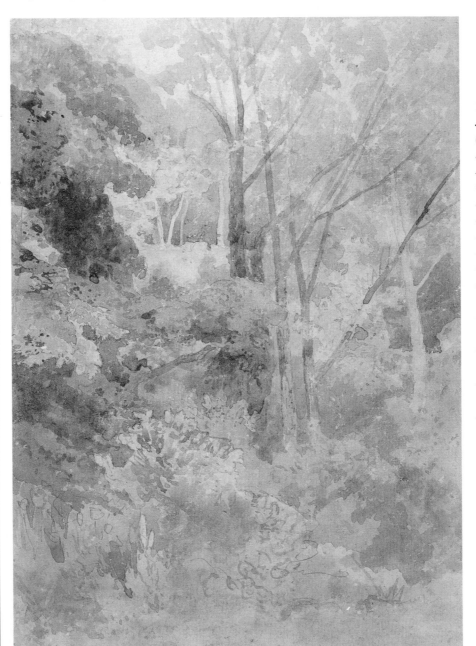

**John Sell Cotman,
IN ROKEBY PARK.**
Watercolor over pencil,
13 × 9" (33 × 22.9 cm),
B1977.14.4671. Courtesy
Yale Center for British Art,
Paul Mellon Collection.

The British artist John Sell Cotman (1782–1842) built this landscape with subtle layers of washes, structuring the painting in an almost architectural manner. The soft, tonal approach to color used here is typical of all his watercolors, which are also marked by an extraordinary sense of design characterized by great stability and inner strength. This painting is essentially monochromatic, dominated by the cool blues of the foliage with touches of umber that provide warmth and depth.

COLOR STRUCTURE

Landscape subjects demand not only that you attempt to describe the colors you see in them, but also that you put those colors in an order that suggests spatial depth. Doing so, of course, depends on the subject itself and on the light conditions that prevail according to the time of day you are trying to capture. The diagrams shown here illustrate different ways of handling such concerns.

With hatched lines, I suggested the dominant organic patterns and structural, spatial dynamics of a landscape view of New York City's Central Park. The deeper, heavier darks in the lower part of the buildings pushes against the lights at the top of the trees, allowing the trees to come forward and thus, through contrast, producing the illusion of spatial depth. The drawing helps me understand how in a painting of the same subject I will use warm and cool color not just to describe but also to convey the landscape's organic quality.

Greens dominate this diagram; I mixed all of them from French ultramarine blue and cadmium lemon yellow. I used more yellow in the foreground mixture to make it warm and thus advance in space. The bank of trees in the middle ground is a "medium" green that represents the general perceived color of landscape; I got it by mixing my blue and yellow in equal proportion. As I moved into the background, I worked with a cooler green created by increasing the proportion of blue in the mixture to make the area recede in space. The cool blue sky enhances the effect of visual depth and completes the definition of the composition's spatial structure.

This painting is an example of the warm and cool effects you can achieve by working with one color plus one or two others that contrast not only in hue but also in value. In this case, I used French ultramarine blue as my dark and aureolin, a very luminous yellow, as my light. Their value contrast helps enhance the composition's subtle structure, and their temperature contrast also allows the buildings to recede in space. To describe the natural forms of the trees in front of the buildings, I let my yellow and blue mingle organically, resulting in modulated greens that, in their alternation of warm and cool effects, push the foliage forward in space and produce the illusion of depth. Allowing the yellow-greens to bleed toward the top and the blues toward the bottom helped created the feeling of light in the landscape. Note the touches of yellow and yellow-green throughout the painting, especially the yellow shape in the middle of the blue building at right; this strong contrast causes a visual color modification that stimulates the landscape's overall harmony.

Here I used an expanded palette of the spectrum colors to establish spatial structure. I placed the warm (and thus advancing) colors red and red-orange in the foreground, the somewhat cooler yellow-green in the middle ground, and the cool (and thus receding) greenish blue in the hills beyond to create the illusion of depth. The even cooler, atmospheric blue and violet sky completes the illusion.

GREENS

Often the dominant colors in landscape painting, greens can be problematic. To have any success with this genre, an artist must have a good understanding of color mixtures and the chromatic effects of green. Greens for landscapes are best mixed from triads and complements, as shown in the illustrations below.

The green mixtures in the top two rows on this page were produced using three different primary triads. The first row shows the warm mixtures, the second row, the cool ones. To attain these warm and cool variations, I used what I call the "two-plus-one" mixing method. As you know, when you mix all three colors of a triad in equal proportion, the result is a neutral gray. But for landscape greens, you need to adjust the proportions of the colors in your mixtures to create the necessary warm and cool range. To produce the warm greens shown here, I mixed the two warm members of my chosen primary triad,

yellow and red, and added a smaller proportion of the cool member, blue. The cool greens were produced by combining yellow and blue, then adding red in a smaller proportion, which has a graying effect on the blue in the mixture.

In the chart at bottom I mixed landscape colors from complementary pairs, using Winsor green in combination with three different reds for a variety of warm and cool results. The warm green at left results from cadmium red, a much-used and important color in landscape painting. The middle mixture was created with phthalo red, and the one at right was created with permanent magenta, which contains some blue and thus results in cool green mixtures.

On the opposite page are numerous other possible warm and cool green mixtures that you will find useful in painting landscapes. Practice mixing greens using different proportions of their component colors to find combinations that suit your subjects.

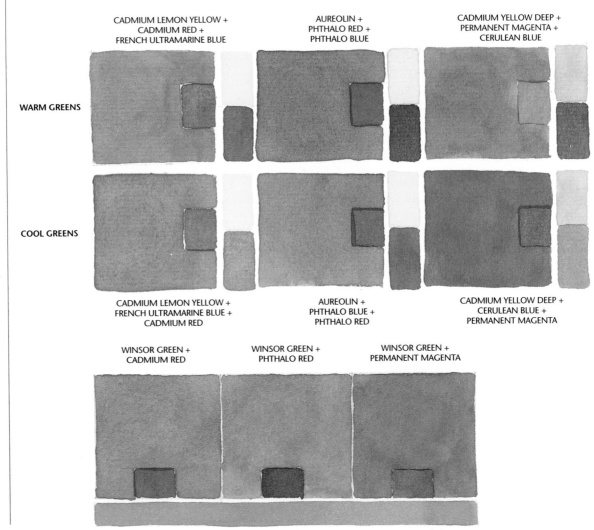

CADMIUM LEMON YELLOW +
CADMIUM RED +
FRENCH ULTRAMARINE BLUE

AUREOLIN +
PHTHALO RED +
PHTHALO BLUE

CADMIUM YELLOW DEEP +
PERMANENT MAGENTA +
CERULEAN BLUE

WARM GREENS

COOL GREENS

CADMIUM LEMON YELLOW +
FRENCH ULTRAMARINE BLUE +
CADMIUM RED

AUREOLIN +
PHTHALO BLUE +
PHTHALO RED

CADMIUM YELLOW DEEP +
CERULEAN BLUE +
PERMANENT MAGENTA

WINSOR GREEN +
CADMIUM RED

WINSOR GREEN +
PHTHALO RED

WINSOR GREEN +
PERMANENT MAGENTA

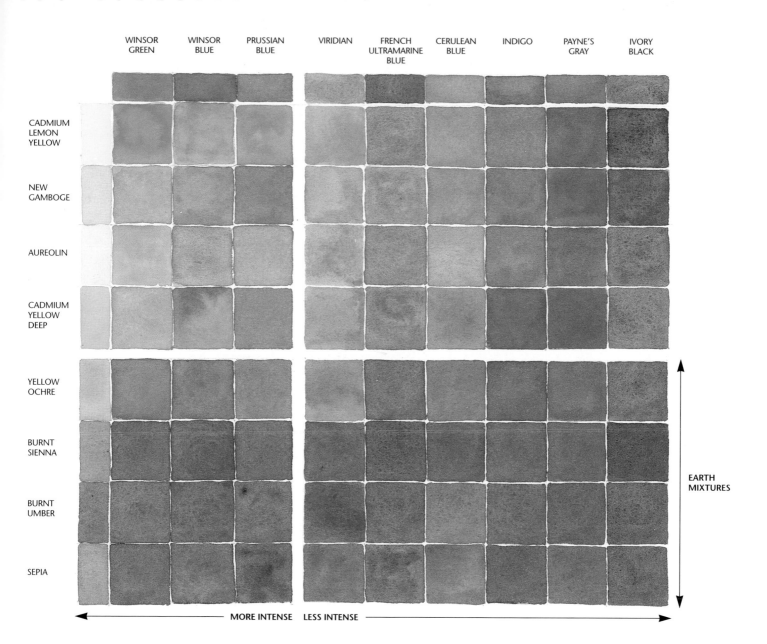

WINSOR GREEN · WINSOR BLUE · PRUSSIAN BLUE · VIRIDIAN · FRENCH ULTRAMARINE BLUE · CERULEAN BLUE · INDIGO · PAYNE'S GRAY · IVORY BLACK

CADMIUM LEMON YELLOW

NEW GAMBOGE

AUREOLIN

CADMIUM YELLOW DEEP

YELLOW OCHRE

BURNT SIENNA

BURNT UMBER

SEPIA

MORE INTENSE · LESS INTENSE

EARTH MIXTURES

DEMONSTRATION

The painting for this demonstration is based on a color harmony that can be used with great effect in landscape paintings: a dominant analogous scheme stimulated and modified by complementary accents that help loop the eye into key areas of interest. In this case, a summer scene, I used a dominant yellow-green to blue-green scheme with complementary warm and cool red accents; for a fall painting, you might use a dominant yellow-orange to red-orange harmony with complementary accents of blue and blue-green, and for a spring scene, yellow-greens with complementary accents of violet and blue-violet. For examples of these types of harmonies, refer to the "analogous tartans" in the chapter on color.

Working wet-on-wet, I washed in the sky colors using cerulean first, followed by French ultramarine, letting them bleed downward to create luminosity. I followed with the background trees, using French ultramarine blue tinted with yellow, and with the fields and road, for which I used burnt umber with a touch of yellow.

In preparation for painting, I made a pencil sketch of my subject to study the relationships between land and sky. Subsequently, I did this wash sketch; in it you can see the distinct diagonal rhythm that begins in the lower left and moves across the horizon line up into the clouds.

The greens are mingled mixtures of warm and cool yellows and blues plus neutralizing touches of red. Flecks of white paper left as textural notes excite the eye.

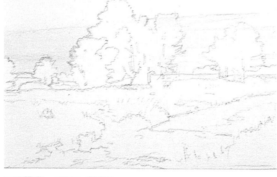

Here you can see the linear contours of the landscape— the road, field, trees, and sky—along with the color chord below. I painted in the cirrus clouds with very light, diluted washes of permanent rose and French ultramarine to give the sky a pale violet tint.

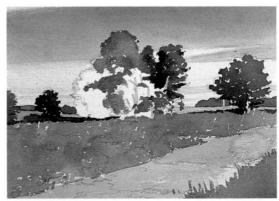

Starting with the tree at right, I suggested the warmth of sunlight with warm greens, which I then juxtaposed with cool greens to suggest shadows and give the tree its form. The trees behind the large middle-ground mass employ the same color effects.

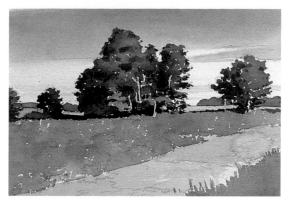

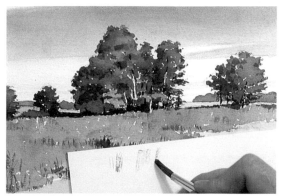

I painted in the remaining warm greens of the trees and, while they were still wet, added dark, cool greens mixed from Winsor green, Winsor violet, and touches of yellow. Note how the white flecks on the tree trunks add brilliance to the painting.

I used the drybrush technique to bring out the texture and character of the tall grass in the field.

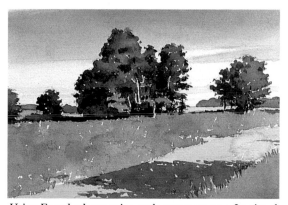

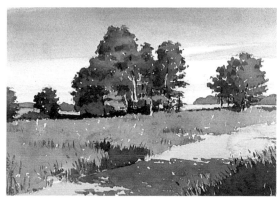

Using French ultramarine and permanent rose, I painted the cool shadow on the road, a detail that links the diagonal elements of the composition and sets up a vivid contrast between advancing warm and receding cool light.

At this point the brushwork in the field has been completed. Note the effect the darks have on the organic warm and cool green mixtures in describing the grass. Flecks of white amid blades of tall grass create the feeling of light on the landscape.

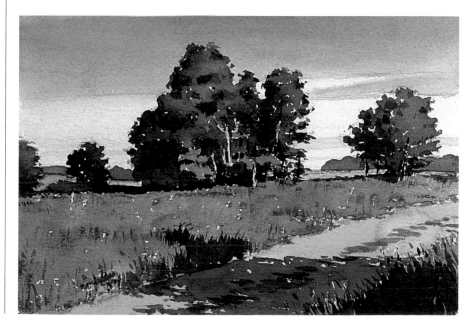

I added the final dark touches of color, chiefly the brown tones running down the middle of the dirt road; they consist of burnt sienna with permanent rose and other red accents. I placed the same color in other parts of the painting, emphasizing red for its complementary modification of the analogous greens.

ATMOSPHERIC EFFECTS

Fog, mist, haze, vapor, smoke, and the like are atmospheric conditions that can transform the landscape into a soft, ephemeral place. Light diffuses as it passes through tiny particles of moisture or soot, causing forms to dissolve into mere nuances of shape that seem to float in space. Whistler's stainy, bluish-green nocturne paintings of the 19th century are excellent examples of the way watercolor can be used to capture such enigmatic effects.

DEMONSTRATION

The granular quality of many watercolor pigments uniquely suits this medium to interpreting fog and similar atmospheric phenomena, in that the particles of color in the paints can physically mimic vapor or soot particles. The texture and sizing of the paper you use in attempting to capture such effects also contribute to the results you will achieve. The subject of this demonstration, Niagara Falls, is a challenge in that it involves painting multiple aspects of water's place in the landscape.

With a drawing I established my composition's spatial divisions and linear dynamics. Note especially how the rainbow extends toward the horizon so that the overall movement is constantly active.

After setting up the painting's major shapes and color chord, I wet the paper and, beginning at left in the sky, dropped in French ultramarine blue tinted with permanent rose, softening color at the edge to set up the contrast between the sky and atmospheric mist of the falls. I left the paper white for the clouds at right.

After wetting the area near the falls, I dropped in cerulean blue with just a touch of yellow to create a turquoise that would describe the feeling of the cascading water, softening any hard edges to enhance the scene's atmospheric effects. Using a stronger mixture of cerulean touched with yellow, I depicted the rim of the falls, quickly rushing in with clear water to soften the right edge.

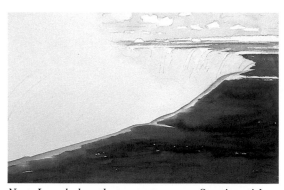

Next, I worked on the two water areas. Starting with the background, I used somewhat diluted French ultramarine to suggest spatial depth. In the foreground, for strong color effects I used phthalo blue with a touch of Winsor green and cadmium lemon yellow, leaving flecks of white here and there to suggest brilliant highlights on the water.

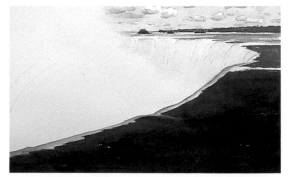

At this stage I added mixtures of phthalo blue, burnt umber, and burnt sienna to give warm and cool green effects to the landscape's shapes; then I painted in the clouds with mixtures of French ultramarine blue plus red or green.

To paint the falls, I lightly wet the surface of the paper, then, to get a stainlike effect, gently stroked in color with a small round brush.

Next, I painted in the rainbow. First I lightly wet the paper's surface, keeping it flat, then I applied the spectrum colors, beginning with the yellow in the middle and moving to orange, red, and violet on the left side and greens and blues on the lower right. I worked quickly so that the colors would spread somewhat, but not so much that they would move too far away from the rainbow's shape.

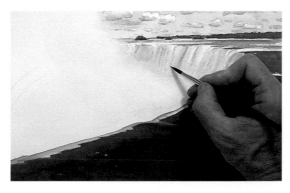

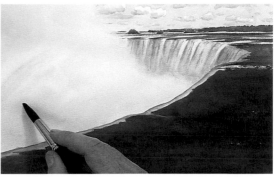

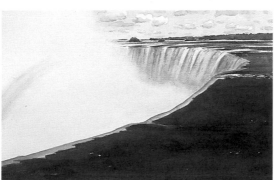

To evoke the atmospheric effects that define the nature of the composition, I wet the paper thoroughly where I needed to express the feeling of mist, then dropped in blue and yellow plus a touch of red and allowed the colors to mingle. The result is a luminous, stainlike quality.

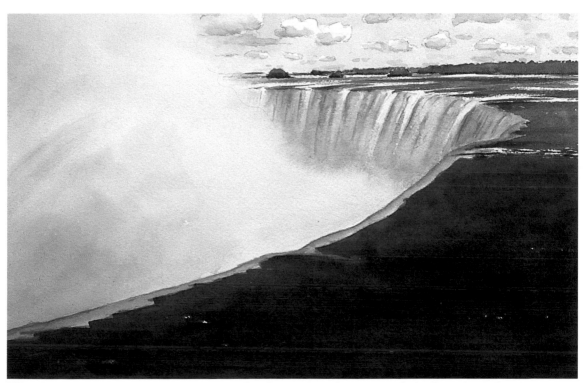

When the paper was dry, I rewet it in the areas where I wanted to enhance atmospheric effects, then I glazed on layers of neutral colors to increase the luminosity of the mist adjacent to the falls. In the process, I tried to avoid any distracting hard edges. This resulted in a very strong compositional dynamic.

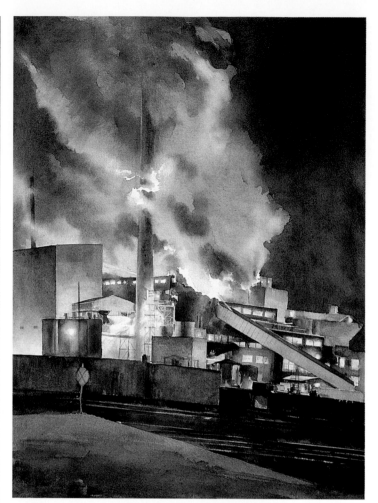

**Paul Rickert,
PURIFY THE NIGHT.**
Watercolor on paper,
30 × 22¹/₂" (76.2 × 57.2 cm), 1988.
Commerce Bancshares Collection.

In this painting of a refinery, Paul Rickert explores the dramatic atmospheric effects of an industrial site, where billowing clouds of steam and smoke seem to dissolve solid forms. To capture the scene's luminous, nocturnal quality, Rickert worked largely wet-on-wet, creating stainlike passages of rich, chromatic neutrals sparked by yellow, blue, and touches of red. The painting is visually exciting for its organic, accidental effects, which could only have been brought about by an artist who handles his medium with great skill.

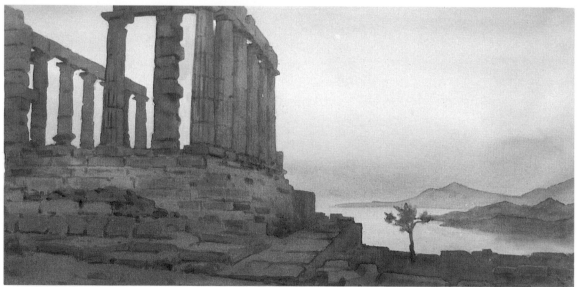

**David Dewey,
POSEIDON AT SUNSET.**
Watercolor on paper,
11 × 17¹/₂"
(27.9 × 44.5 cm), 1993.
Courtesy Tatistcheff Gallery,
New York City.

I began this sunset sky by wetting the paper's surface and washing on warm, then cool color. Once the surface was dry, I built the atmospheric effects in the foreground with layers of glazes. Note in the background how the mountains appear to float; to achieve this, I wet the mountains with clear water first and then, with a round brush, applied color to the top of each shape and allowed it to stain downward.

WATER

Who among us has not enjoyed the pacifying experience of watching the ocean's waves roll in, one after another, and splash onto shore? With their varied rhythms and color activity, bodies of water, whether stream, pond, lake, or sea, make almost purely abstract subjects. Though transparent and essentially colorless itself, water reflects the colors and shapes of its environment, behaving as a mirror when calm and, when stirred into motion, transforming reflections into graphically expressive ripples and faceted fragments. Interpreting and capturing water in paint requires an understanding of its physical nature. When its surface is smooth and glasslike it can be relatively easy to depict, but ripples and waves make things more challenging; such conditions call for a good eye and the ability to identify rhythmic patterns, much the way you would when listening to a piece of music for the first time. Painting water involves ordering the colors and shapes of these patterns according to an overall harmonic chord.

This drawing illustrates some linear rhythmic patterns. Note how the staggered, broken shapes echo one another, forming long and short sequences that give a sense of lively, continuous movement.

Here, I've depicted a rock and its reflection; I simply repeated and inverted the rock's shape, "folding" it over the water's surface. The broken horizontal lines represent the water's rhythmic ripple pattern.

DEMONSTRATION: LINEAR WATER RHYTHMS

This demonstration, the first of three devoted to water subjects, focuses on depicting linear ripple patterns on the water's surface.

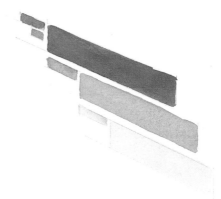

In this diagram, I staggered the colors I intended to use in the composition to form a rhythmic sequence of light and dark and warm and cool.

I drew the water's rhythms in pencil, wet the paper's surface, and laid in the first wash, a diluted mixture of French ultramarine blue with just a touch of cerulean blue, achieving a stainy, shimmering quality.

Once the paper was dry, I began to establish the rhythmic pattern using cerulean blue with touches of permanent magenta for a lively warm and cool effect. I applied color quickly in a sequence of long and short strokes.

When the paper was again dry, starting from the top of the composition, with a round brush I painted in the reflected landscape color using the same sequence of long and short strokes. This dark, earthy green is a mixture of Winsor blue and burnt sienna.

In this stage I completed the linear pattern, defining the water's reflective rhythm.

In the finished piece you can see the chromatic activity of the burnt sienna and the touches of permanent magenta that give the water its lively, luminous, reflective quality.

DEMONSTRATION: CONCENTRIC RIPPLES

As we all know, dropping a stone into a still pond sets off a ripple pattern of concentric rings that appear to reverberate into infinity. Here, I illustrate one way of depicting this natural phenomenon.

This water abstraction from my sketchbook shows the rhythmic dynamics of my subject in terms of color and tonal effects.

Working on a wet surface that contributed to the paint's shimmering quality, I laid in a first wash of diluted French ultramarine blue and permanent rose, letting the colors mingle organically.

Using dark greens mixed from phthalo blue and burnt umber to represent the color of the surrounding environment as seen in reflection, I painted rounded curves to define concentric ripple shapes in the water. I left some areas white and let the darks move into them as well as into areas covered with the previous blue wash; this strengthens the illusion of the water's reflective surface.

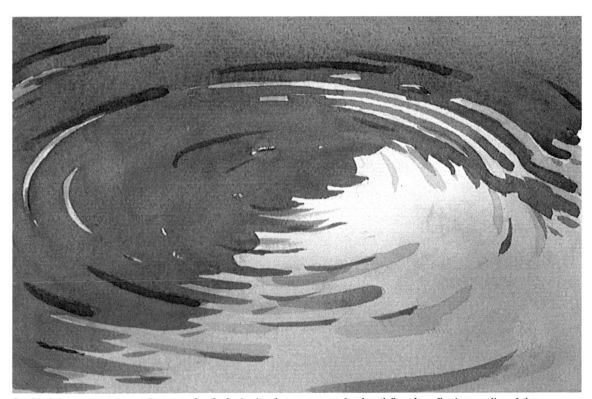

I added darks in a staggered way to the rhythmic circular pattern to further define the reflective quality of the water.

DEMONSTRATION: A MORE COMPLEX WATER COMPOSITION

This time my subject is a scene from the Japanese garden at New York's Brooklyn Botanic Garden; here, the added challenge is to depict the reflection of a structure in the water in a visually convincing way. The composition relies on a red and green complementary harmony.

This abstraction expresses the design and complementary color harmony to be used in my painting: a red Japanese shrine reflected in dark green water. Below the sketch are the pigments used—new gamboge, cadmium red, burnt umber, permanent rose, French ultramarine blue, ivory black, and Winsor green— along with various mixtures made from these colors.

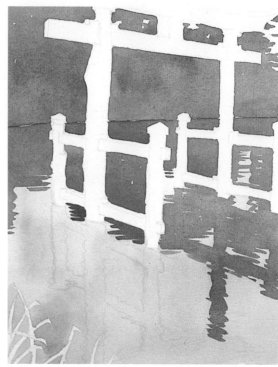

I painted the land using gray, yellow, and gray-green mixtures, then painted its reflection and part of the shrine's on the surface of the pond using an olive green mixed from new gamboge tinted with red and blue.

I washed in the color of the water, wetting the paper in that area first and then applying a diluted mixture of French ultramarine with a touch of red to create a mirrorlike effect. I left the grass area at lower left white, as it will be painted in later.

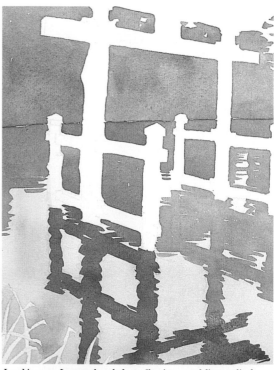

In this step I completed the reflections, adding a little more red to the olive color to depict that of the shrine; note how I made its shape wavy to convey the distortion caused by ripples on the water's surface.

To paint the shrine itself, I used a luminous red-orange mixed from new gamboge and cadmium red, thus strengthening the composition's overall color scheme. I added touches of permanent rose and blue to the caps on the shrine's vertical posts for a very light violet contrast.

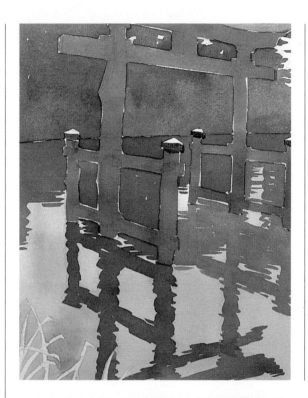

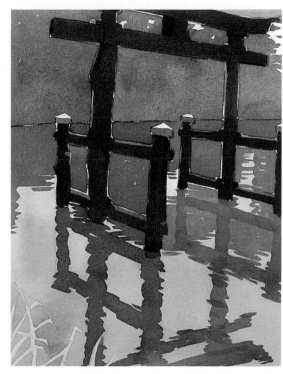

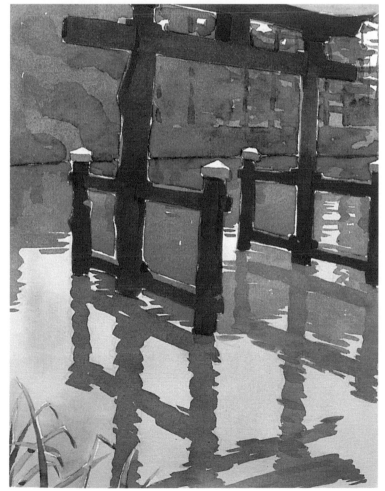

When the red structure was dry, I rewet it with clear water and glazed over it with yellows and reds to strengthen the color and increase the feeling of depth and luminosity in the painting. Note the areas I left white, which enliven the color. Next, I added rhythmic strokes of darker color to the water to enhance its appearance as a reflective surface.

To enhance the illusion of spatial depth in the landscape and increase the red/green complementary contrast, I layered on touches of yellow and gray-green. I also painted the tall grass in the foreground with a light green, leaving a little bit of white between the blades to give the feeling of light. Last, I added dark green to further define the grass's form.

ARCHITECTURAL SUBJECTS

Architecture is a subject whose physical character is in constant flux as the light of day changes and reshapes its visual appearance. Architectural forms have prescribed functions to perform, but it is the salient effects of daylight on their surfaces that elevate them to their true significance. Architecture is a monument to light! Light is the energy that transfigures architecture into an evocative subject. Light does not discriminate; it shows no partiality with regard to design. All structures are transformed as they are bathed in sunlight. Watercolor, and color, as we have learned, like architecture, is at the mercy of sunlight, and so becomes an exciting vehicle for expression. In this section we will explore ways of observing architecture as it is affected by light, discovering its abstract character and learning methods for capturing and portraying structures in paint as powerful visual ideas.

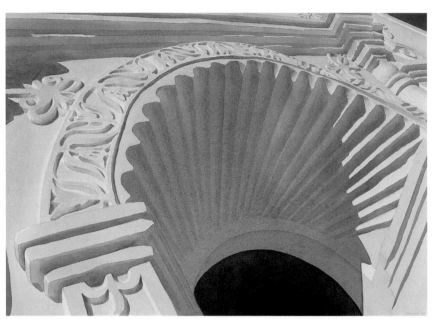

David Dewey,
TUBATAMA.
Watercolor on paper,
17 × 23$^{1}/_{4}$"
(43.2 × 59 cm), 1988.
Courtesy John W. Waller III.

Sun and shadow reveal the lush sculptural decoration of this stonework archway. Expressing the details and the varying depths of the carving called for a very subtle handling of the blues, violets, and yellows used for the shadows that define them.

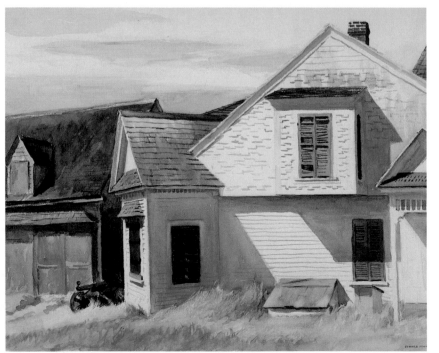

Edward Hopper,
HOUSE ON PAMET RIVER.
21$^{13}/_{16}$ × 26 $^{13}/_{16}$"
(55.4 × 68.1 cm), 1934.
Collection of Whitney Museum of American Art, New York.
Photo by Geoffrey Clements.

Hopper was a master designer, capturing and shaping light to endow humble dwellings like this one with symbolic meaning. Windows, doors, and other details are carefully placed so that their colors and shapes rhythmically direct the eye around the painting.

DEMONSTRATION: THE POWER OF WHITE

The white of the paper can be used with great impact in watercolor painting, but warrants a keen eye for recognizing abstract patterns of light in your subject and an ability to discern what role such patterns will play in your design. Light striking the planes of an architectural subject, for example, may result in a pattern of geometric shapes that can be viewed abstractly and then arranged on the picture plane to represent the subject's three-dimensional form, as with the white house in this demonstration.

Warm, light colors like yellow and orange absorb white, gaining radiance from it and conveying luminosity, while dark, cool colors like blue and violet excite white, projecting it forward and endowing it with weight. Keep these effects in mind when balancing the shapes in a composition.

In this abstraction the white shapes pinned between the cool colors are weighty and appear to pop forward, while those near the warm, lighter colors absorb the eye into a luminous space. Notice how the darker colors give the whites more force.

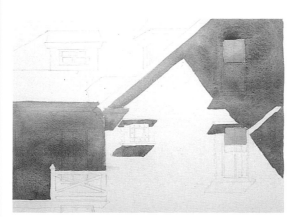

The pigments used for this demonstration are cadmium red, alizarin crimson, Indian red, French ultramarine blue, phthalo blue, aureolin, and raw sienna. To give the subject an abstract quality, I used an "open" composition, cropping the image around the edges. I began by painting in the shadows, working wet-on-wet to keep the color moving across the paper. These first warm and cool tones should establish the abstract presence of the whites and their place in the overall design. Don't be afraid to make this initial value darker, as doing so will push the whites more for a stronger effect.

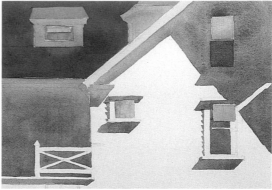

I painted in the warm dormer colors first using blues tinted with red (which reflects off the red roof). When these shapes were dry, I added the red around them. I also established the first darks of the windows at right, allowing the yellows to become more brilliant so as to push the white. When all was again dry, I layered another fluid light red glaze on the roof for a luminous quality.

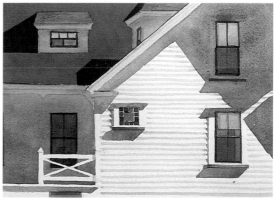

Next, I painted in the deep red shadow patterns to establish depth and weight. Only at this stage was it time to add the details. Be patient; try not to get ahead of things by moving too soon into the details, which will fall in your path if you prepare their way. Still following my design, I painted in the sills, windows, and clapboards to enhance the overall effect of the white. Don't drop your guard! Bringing a painting to a successful conclusion requires technical facility, but design is the key.

DEMONSTRATION: PAINTING THE LIGHT

When painting an architectural subject, give first attention not to its concrete, physical presence but to the patterns of light you see on it. Paint the light! The architecture will always be there, but the light will not. Don't let details distract you, but don't completely ignore them either; eventually they will be included as color effects in the painting.

Presented here is a three-part analysis of my painting of a lovely Victorian house shown opposite, a work I completed on location after spending much time observing the effects of sunlight on the subject. The stages shown here typify my basic method of development. I began by establishing my design using a viewfinder. Then I prepared my first washes of aureolin, permanent magenta, and ultramarine blue (the colors shown below), making sure I had enough to carry me through the entire composition.

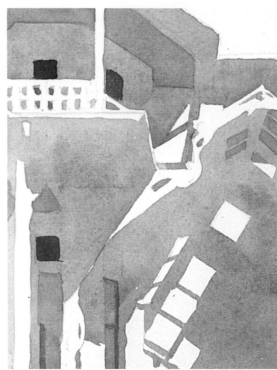

Next, I painted in the first warm-to-cool washes, which as you can see start to define the colors of light. In this context, the white of the paper begins to "pop."

Warm colors applied to bright white paper will appear very dark at first, but become luminous when juxtaposed with truly dark values, as you can see at right. Here, note how the white space pushes the adjacent wash dark while the blue to the left pushes it light.

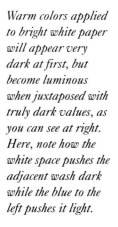

To begin, I painted in the abstract patterns of the shadows, working from warm to cool, top to bottom; this approach gives me greater luminosity and helps keep my colors clear.

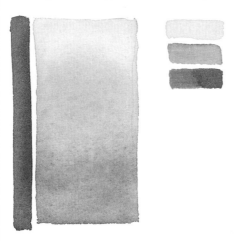

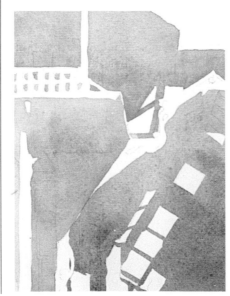

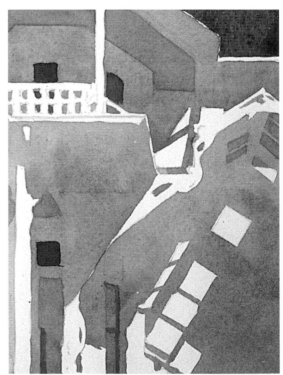

I added the most dramatic effects in this stage: the final dark values and intense colors. Note in particular the powerful effect of the blue sky on the white; this element is used as an abstract shape in the overall design.

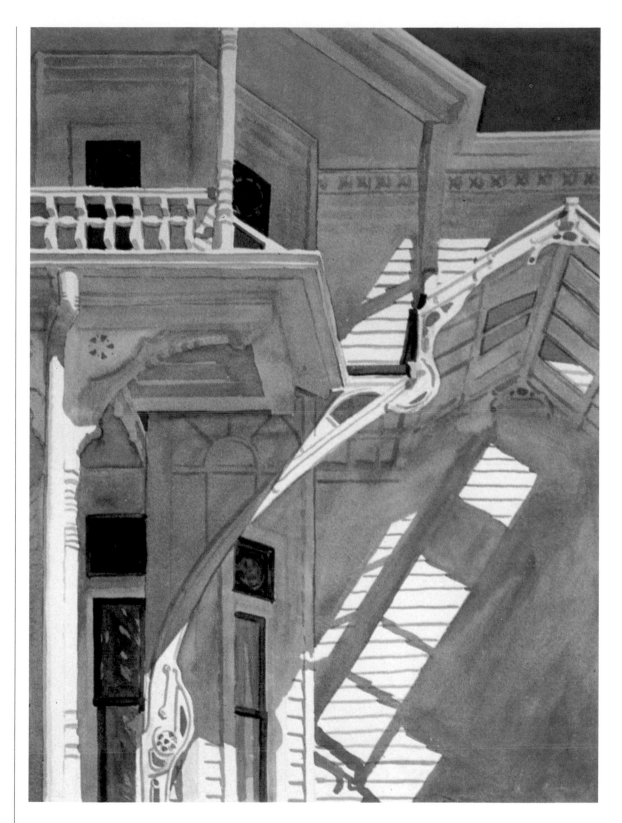

**David Dewey,
BROKEN SHADOWS.**
Watercolor on paper,
31 × 22" (78.7 × 55.9 cm),
1981. Private collection.

*Obviously the
finished watercolor
is more detailed than
the three re-created
steps. Throughout
the middle stages of
work, I layered my
washes to bring out
the subtle effects of the
architectural details
without disrupting
the overall abstract
design.*

DEMONSTRATION: INTEGRATING STRUCTURES IN A LANDSCAPE

Buildings, houses, barns, bridges, and other man-made structures dot the landscape, their geometric shapes and patterns complementing the topography's linear and curved rhythms. A structure that exists in aesthetic harmony with its environment depends on good architectural design, which takes into consideration the shape and feeling of the surrounding terrain. I was most struck by this during my first visit to Tuscany, where every building seemed to fall naturally into the arms of the land's graceful contours, the structures' vertical lines echoing those of the native cypress trees.

Beyond thoughtful building design is the crucial role light plays in uniting structures with their surroundings, which serves as the focus of this demonstration.

I drew my subject with a water-soluble pen, establishing its linear patterns first and adding the vertical hatchings for tone. I then brushed over the drawing with water to create the pattern of light and shadow that ties the landscape and structure together.

Here is a study of my subject done in a low-key color scheme, which lends a soft, balanced feeling and reduces the weight white carries in the painting.

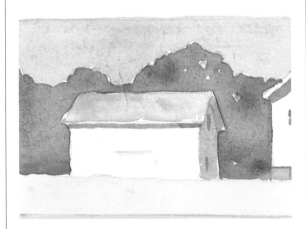

This abstraction demonstrates the advancing and receding effects of warm and cool colors, as well as the use of an analogous harmony of blues, blue-greens, and yellow-greens accented with touches of violet and red.

For this study I used the same colors but diluted them less to keep them in a high key. The result is a heightening of color and value contrasts, and thus of visual activity in the painting; note especially the powerful contrast between the white lower barn and the one at right.

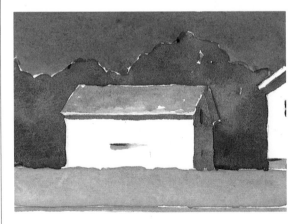

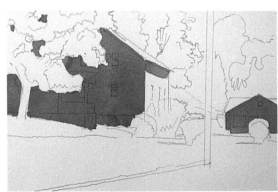

I made a contour drawing to establish the overall pattern of the landscape and the architectural shapes within it, uniting all the elements with line. With a loaded brush, I then applied the first washes to the structures; at left I used French ultramarine blue and alizarin crimson, while at right I used cerulean blue with touches of yellow and rose for greater color activity.

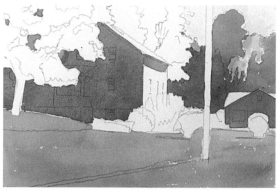

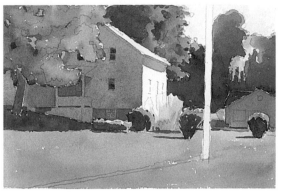

I painted in the foreground with a luminous mixture of aureolin and Winsor green, leaving flecks of white to stimulate the color and convey the feeling of sunlight. I used aureolin for the willow trees at upper right, then applied cool blue-greens using a two-plus-one mixture in which phthalo blue dominates, giving a cooling effect.

Next, I added the darks, further defining the shrubs and establishing the shadows. These dark elements stimulate the light and create a feeling of brilliance. To enhance the form of the tree to the right of the house, I wet parts of it and dropped in some blue-green. The porch was developed with layers of blue-gray; the house's foundation is burnt umber plus red.

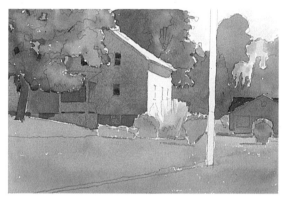

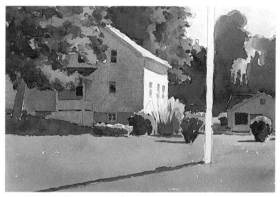

The trees surrounding the building on the left were painted in with a warm green mixture of cadmium yellow plus green and red. I used touches of red in the windows and tree trunk to counter the effect of the dominant analogous green harmony.

I added dark greens and blue-greens to the tree at left. I lightly applied red with a touch of blue to the roof using the drybrush technique to convey the feeling of light. The windows at right were painted in directly.

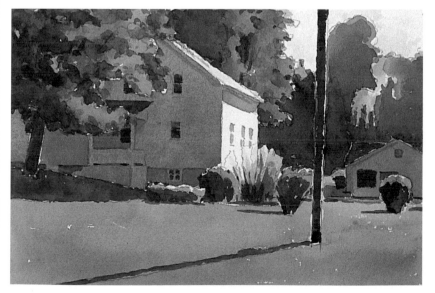

The final touches increase the feeling of depth and luminosity. As I painted the telephone pole, I made sure to leave white on its edges for highlights. Note how its cast shadow, established in the previous step with phthalo blue and aureolin, pushes the pole forward in space. The striking contrast of this cool, dark element with the warm yellow grass gives a dramatic effect.

ARCHITECTURAL SUBJECTS

Matthew Daub,
ROW HOMES IN THE
SHADOW OF INDUSTRY.
Watercolor on paper,
22 × 30" (55.9 × 76.2 cm),
1992. Private collection,
Tulsa, Okla. Photo courtesy
the artist.

The warmth of this neighborhood street scene is expressed by the artist's use of a warm color scheme. The compositional space is organized by the color effects of the windows and doors, echoing the way Edward Hopper used such elements in his work.

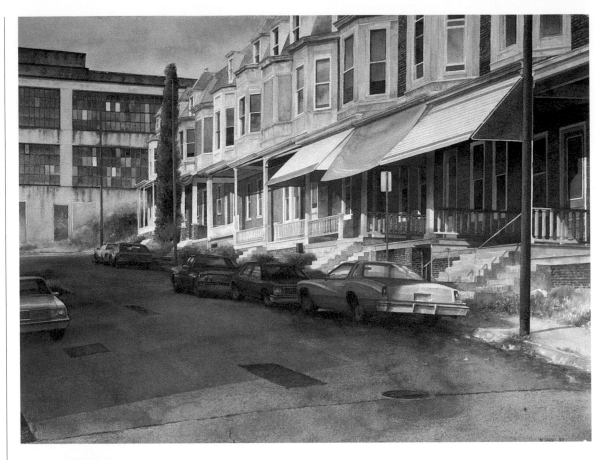

William Christine,
SUMMER SHADOWS.
Watercolor on paper, 15 × 11" (38.1 × 27.9 cm),
1992. Collection of Dale and Bobbie Bowen.

Windows, doors, clapboards, rooftops, and chimneys are all common architectural features that artists have used to good end as abstract color elements. Placed strategically as color weights in a design, like the curtained windows in William Christine's painting, such details become very powerful accents. To fully appreciate their use, you need to develop a critical eye for abstraction and must have a good handle on the optical effects of color and value in design. But as a general guiding principle, keep everything simple at first; cut to the bare minimum.

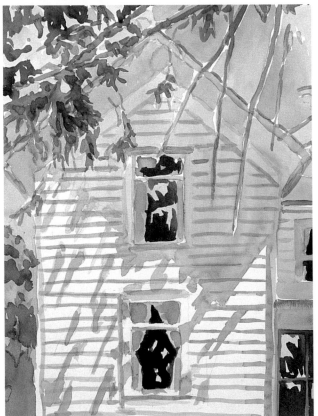

WORKING ON A LARGE SCALE

Until relatively recently, watercolor was only rarely used to produce large-scale works. In the last two decades, however, spurred by their expanding ideas, a desire to push the limits of the medium, and perhaps also partly by the rise of corporate art collections—which tend to favor artworks of grander dimensions—watercolorists have been steadily increasing the size of their compositions. The forebears of this trend are the Prix de Rome competitions of the 19th century and, more recently, artists such as the American master Charles Burchfield (1893–1967).

In terms of paper size, "large" today generally means elephant and double-elephant sheets measuring 29¹/₂ × 40" and 40 × 60", respectively. As paper technology has advanced to support the growing demand for large-format watercolor paintings, artists have been breaking down barriers between watercolor and the mediums traditionally used for big works, oil and acrylic. While bringing watercolor's technical possibilities to new heights, such artists have simultaneously continued to propagate a long-standing appreciation of this medium's unique qualities, thereby increasing its popularity.

Working on large scale is not for the fainthearted. To succeed, you must be secure in your skill level and have a pretty good grasp of your subject. Don't start a painting without a clue as to the technical approach you are going to take; experience should be the basis for your ambitions. By the time I first took up the challenge of painting in a large format, I had developed a strong urge to expand my visual ideas on a physically bigger surface. Only when I was convinced that my technical understanding of the medium was sufficient and I was equipped with the right materials for the task did I set out to paint a large watercolor. I work in washes that call for large brushes and substantial amounts of premixed colors to cover big areas; other artists construct their paintings using smaller layers and touches of color. Whatever your approach, select materials that will meet its demands.

Painting big in watercolor for the first time is a terrifying yet exciting entry into the unknown, an experience in which you are literally learning on the job as you cover new ground. Keep confident in your ability to handle the medium and hold on to your vision of the outcome as you progress through the often lengthy stages of developing a large watercolor painting. Don't panic; stay within the limits of what you need to accomplish in each step along the way. Make preliminary studies of your subject to keep your mind's eye on the finished image.

DEMONSTRATION

The main reason for working in a large format is that your idea for a painting is visually compelling enough to warrant the space. Before starting, map out your ideas with drawings and color studies to fuel your enthusiasm and generate the courage you'll need to sustain the interest and energy level big-scale pieces demand. This is the most important stage. Be careful, though, not to overwork your idea to the point where you lose interest in the main event, which should be to move the painting to a satisfying climax.

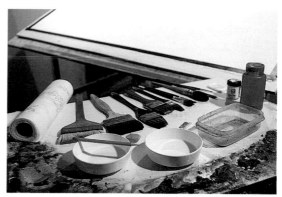

Arrange all of your painting equipment so that you know where everything is and can work comfortably and efficiently. Here you can see my basic setup. For large works I generally use Arches 555-lb., 40 × 60" paper cut to the size I need for a given composition. Because my technique employs a lot of wet-on-wet washes, I stretch the paper first according to the method described on page 28.

WORKING ON A LARGE SCALE

Preparatory studies help me work through the long, complex process of painting a large-scale composition; here, I've affixed one to the top of my stretched paper. The technical difficulty of producing expansive compositions makes it hard for the artist to keep a sense of the completed image in mind; thus, I use such sketches as visual references. At right you can see where I've masked off the edges of the porch where they meet the sky using liquid frisket and tape. I also laid thick, heavy tracing paper over the area at right to completely seal it off; these precautions enable me to apply the first wash freely and fluidly, without worrying about paint going where it doesn't belong.

Alongside the work in process is my palette and the large brushes I use to wet the paper and apply washes. The bottles contain premixed blues; when painting large washes, you must always have a generous supply of the necessary colors on hand, because there's not enough time to mix paint as you go along. I pour these mixtures out onto the palette and tint them with other colors as needed.

To apply the second glaze to the sky, I very quickly wet the area top to bottom with a large brush, allowing the water to just drench down. Then, with a back and forth motion, I rapidly applied my wash across the top third of the sky, allowing the color to bleed downward for a graded effect. This layering is done several times. Each glaze has to be applied very quickly and carefully; the paper must be wet with a soft touch so you don't saturate it and thereby disturb the previous layer of color, which would result in an opaque rather than a transparent effect.

I wet the paper heavily in the appropriate area and then, with my board tilted at a steep angle, washed in the first layer of sky color. I started at the top, brushing back and forth across the paper and allowing the paint to run downward to create an even, graded bleed. I waited until this was bone-dry before going on to the next stage. The sky has to be completely finished in advance of everything else because the quality of light it conveys is an important visual key to the entire painting. (It's also because of all the careful masking that was done.)

At this stage the third and final glaze has been applied. I use a small brush or paper towel to pick up the excess water at the bottom of the painting. When working with glazes you must allow the paint to run freely. Once a wash has been laid in, you cannot go back over it, so it must be applied very carefully in the beginning to ensure evenness of color.

Again I apply masking fluid to cover areas of my painting I don't want paint to cover when I lay in a free-flowing wash. I also tape tracing paper to areas I want to protect from possible paint splatters.

I painted the shadows on the porch steps, setting up contrasts that, together with the brilliant blue sky and its evocation of sunlight, begin to establish the composition's spatial depth. This is a stage where you begin to transcend the technical process and get your first real visual feel for the direction the painting will take.

At this point I've completed the sky. Note the paper towels surrounding the painting; when you're working with large, fluid washes, you need them to mop up, remove excess moisture from your brush, and prevent unnecessary drips. Here, I am painting in the water using the free-flowing colors you see on my very large palette. As with the sky, I wet the surface with water first, then apply the colors across the top of the shape and allow them to run downward. In this case I'm using a combination of cerulean blue, as you can see in the foreground, and a light tint of turquoise in the rear.

Here you can see the colors I've mingled on the palette to get a feel for the effects I want to use in painting the land. I covered the background with tracing paper to protect it from splatters, tilted my board at a lower angle, and wet the lawn area with water. Then, working from light to dark and warm to cool, I applied the paint to this shape and allowed it to mingle there.

I covered the lower portion of the painting to protect it while transferring paint from palette to paper. Using the colors shown here, I painted the foliage and trees behind the porch and across the top of the water to the left. I worked directly, laying in the warm colors first and then touching them with dark blue-greens to create an organic mingled effect.

Here you can see the layering process I used to develop the structure of the porch, building form with a series of washes. The cool blues seek out the warm colors that were flooded in with the first wash. As I painted the columns at left, I softened color where needed to subtly model their forms. When all was completely dry, I carefully wet the surface and washed in warm yellow layers to increase the luminous effect in the porch.

**David Dewey,
FRONT STEPS,
MARSHALL'S POINT.**
Watercolor on paper,
31 × 58" (78.7 × 147.3 cm),
1994. Collection of
Don Handal.

In the finished painting, the vast expanse of blue sky and strong turquoise notes are countered by the weight of the yellow flowers against the brilliant white, resulting in a dynamic compositional tension that gives this painting its power.

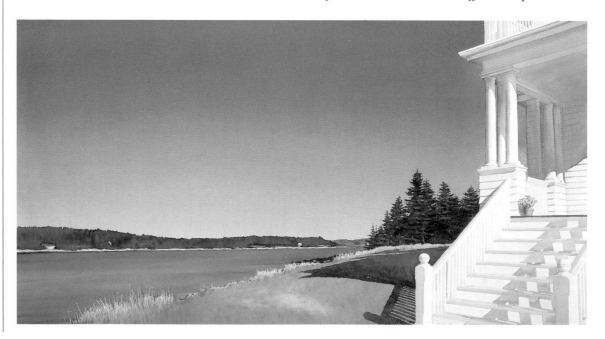

**George Harkins,
NEAR THE SHORE.**
Watercolor on paper,
40 × 60"
(101.6 × 152.4 cm),
1994. Courtesy Tatistcheff
Gallery, New York City.

*George Harkins has
been painting large-
scale watercolors for
quite some time. His
method, unlike mine,
is to work flat on
unstretched paper,
though like me he
also uses color chords
to get an intuitive
feel for the direction
his paintings will
take. Harkins's
mosaiclike approach
relies on optical
color mixing, which
produces an overall
harmony.*

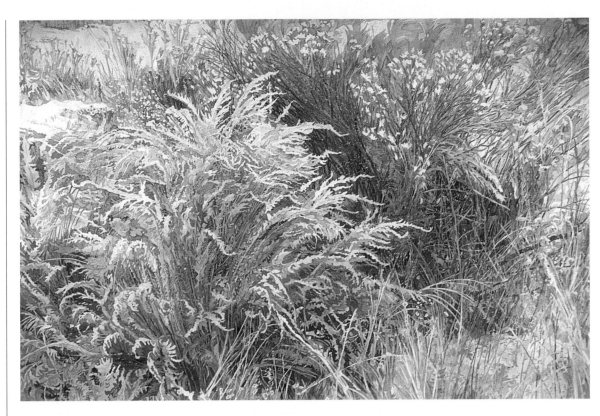

**Charles Burchfield,
SUMMER SOLSTICE
(In memory of the
American chestnut tree).**
Watercolor on paper,
54 × 60"
(137.2 × 152.4 cm),
1961–1966. Courtesy
Kennedy Galleries, Inc.,
New York City.

*The luminous,
irradiating effects
of the yellow and
white and the very
agitated brushwork
in this extraordinary
painting produce
an intense textural
vibration that seems
to expand the picture
beyond its borders.
Note the seam where
the artist joined
two pieces of paper.
This was perhaps
done as an intuitive
response to the needs
of the work as it
progressed, or was
necessitated by a lack
of larger-size sheets.*

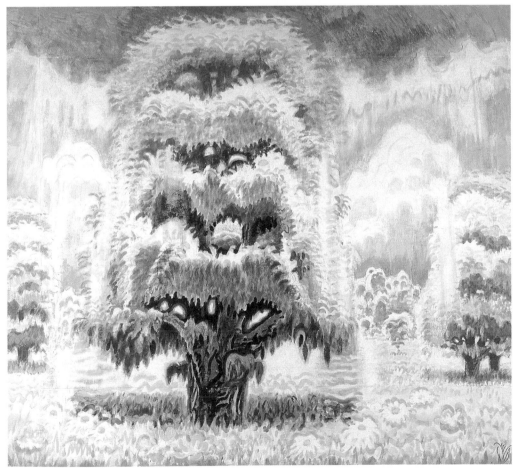

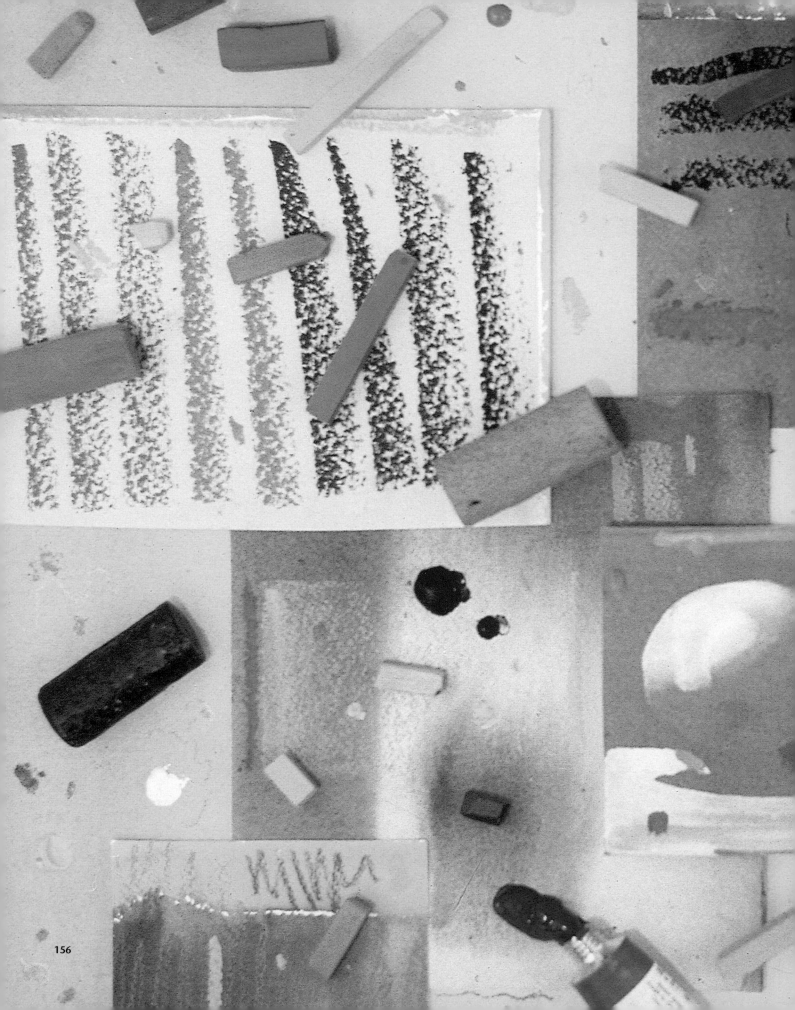

WATERCOLOR AND MIXED MEDIA

Mediums that are compatible with watercolor offer a kaleidoscopic array of opportunities for artistic expression. Merging mediums whose physical characteristics differ requires finding a common ground where they can be integrated into a visual whole that simultaneously celebrates the uniqueness of each medium. Gouache, colored pencil, pastel, and collage are but four possible mediums to combine with watercolor in ways that complement watercolor's unique transparent qualities while contributing their own textural and color effects. The important considerations in mixed-media painting are: 1) process—the technical aspects of joining two or more physically different substances on the same surface; 2) design—setting up a visual framework in which opposing parts can be ordered; 3) color—as with any medium, establishing an effective harmony; and 4) idea—the image in your mind's eye that defines a painting's direction and purpose.

GOUACHE AND WATERCOLOR

Gouache, or body color, as it was traditionally known, is dense, opaque watercolor. (See the chapter "Materials and Tools" for a fuller description.) It can be applied thickly in an alla prima manner, like oil paint, or diluted with water and laid on thinly in a semitransparent to transparent manner. Because gouache is a relatively thick paint, it doesn't flow readily the way transparent watercolor does and thus requires more vigorous brushwork to push and pull it across the paper. Smooth-surfaced paper has been the traditional support for this medium. Besides working on white surfaces, gouache can be applied to toned paper or to surfaces prepared with watercolor washes.

Because of its opacity, gouache reflects light, appearing to move forward off the paper's surface. Transparent watercolor, on the other hand, absorbs light and thus depends exclusively on the white of the paper for light effects. Combining these two water-based mediums by layering transparent and semitransparent washes can yield rich color and spatial effects with great expressive power.

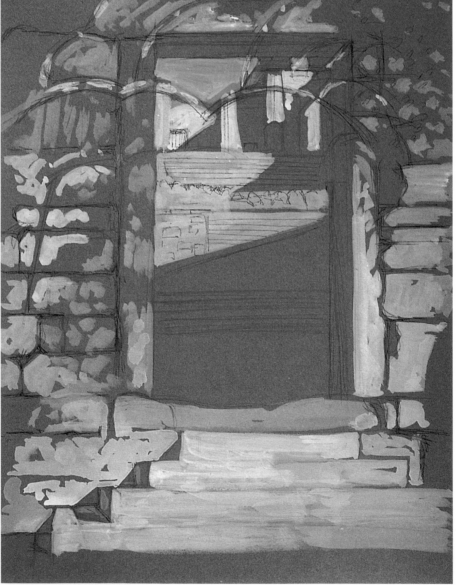

Lois Dodd, BEULÉ GATE, ACROPOLIS, ATHENS. Gouache on gray-toned paper, 9¹/₂ × 6" (24.1 × 15.2 cm), 1993. Courtesy the artist.

Lois Dodd achieved a feeling of reflected light and a sense of depth in her painting by using gouache in both a translucent and an opaque manner, playing the white and blue against a darker toned ground to convey the structural patterns of light and shadow.

These illustrations show how gouache looks on toned paper in transparent, semitransparent, and opaque applications in defining flat and three-dimensional forms in space. I used white gouache, known as Chinese white, for contrast and to heighten the illusion of three dimensions, while my painting surface contributes both its tone and color to this effect. When working with this method, start with strokes of semitransparent color, then build from there by using the paint more opaquely. You want your first strokes to help you determine the toned paper's relative value in your painting.

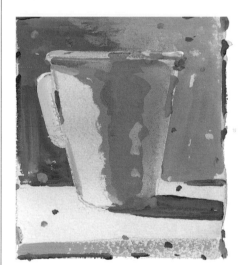

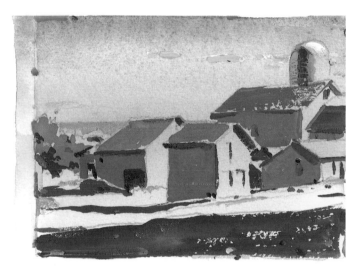

I began these two paintings with a warm pink and yellow wash of transparent watercolor, grading it into a cool blue-violet. When this was dry, I glazed over it with gouache, using the paint semitransparently at first and then opaquely, leaving some of the transparent color to show through as part of the overall harmony. (The color chord shows this in graphic terms.) In the image at left, the light pink on the side of the cup and the yellow in the foreground is the watercolor underpainting. The light blue gouache at the bottom edge was stroked on quickly to let the yellow show through. In the image at right, the sky and the illuminated parts of the barns and ground are transparent watercolor, while the clouds, shadowed sides of the barns, and foreground shadow are gouache applied over the transparent underpainting. Combining opaque and transparent paint applications can make for interesting contrasts and, as it does in these examples, create luminous spatial effects.

DEMONSTRATION

As a subject for this demonstration, I chose a view from the Acropolis looking toward the Erechtheum as it is silhouetted against an Athens sunset. My aim was to convey the quality of the scene's atmosphere and space by contrasting transparent watercolor passages with applications of opaque gouache.

My palette for this painting consisted of the colors you see at left in the diagram; in order, they are raw sienna, phthalo blue, French ultramarine blue, cadmium red, and cadmium lemon yellow. The horizontal band is transparent watercolor that is cool at left, thanks to a higher proportion of ultramarine in the wash, but becomes increasingly warm toward the right with the addition of permanent magenta (shown at far right). The four vertical bars laid over this band are semitransparent to opaque gouache mixtures of the warm and cool colors that dominate the painting. The bar at left is French ultramarine diluted with plenty of water to make it transparent enough to allow the color beneath to come through. To its right is a semitransparent violet mixture that only slightly reveals the wash underneath it. The opaque orange and yellow bars completely cover the underlying violet wash, contrasting with it optically.

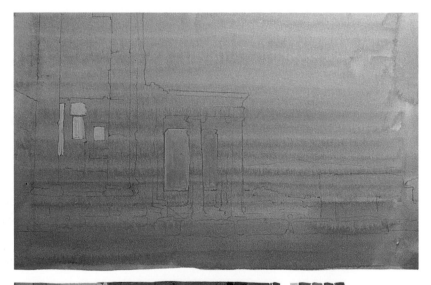

After creating an underdrawing in pencil, I covered it with a warm to cool, violet-pink to blue glaze to establish the painting's overall temperature structure. When this was dry, I applied the first warm orange and yellow opaque colors of the light, which push against the cool transparent blues of the structure and provide a vibrant and luminous contrast.

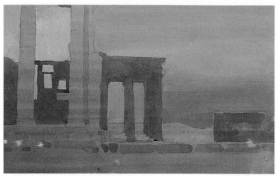

I completed the sunset background with gradated blends of yellow and red plus a touch of green to create the warm, luminous feel of the setting sun. Then, with glazes mixed from red and blue, I began to develop the three-dimensional form of the structure, pushing the columns forward to create the illusion of depth.

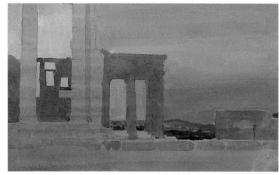

The landscape in the background was painted in with a mixture of yellow and red with a touch a raw sienna. I let bits and pieces of the initial violet-to-blue wash show through to contrast with the warm opaque color for a stronger, richer effect.

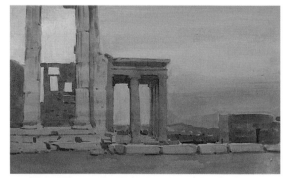

I added warm and cool darks throughout the structures and the stones to suggest form yet still allow the light of the transparent watercolor to breathe through. Note how it is pushed of forward by the intense light of the sky, resulting in greater spatial dimension.

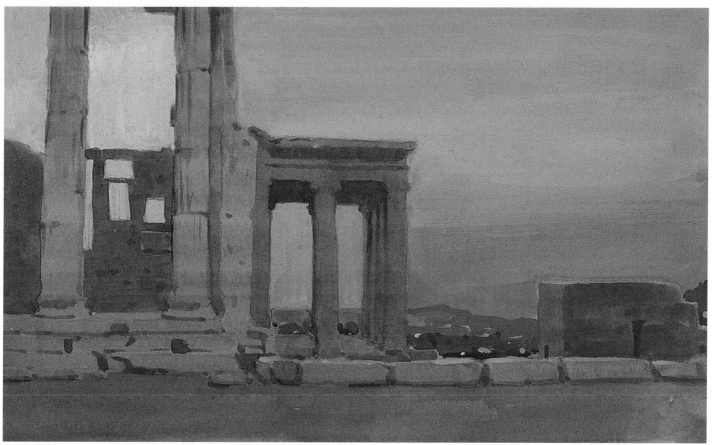

In the final stage I added highlights using white tinted with yellow and red to add luminosity and strength to the picture. Here, you can see the light effects produced by juxtaposing transparent watercolor with opaque gouache. The violet-to-blue colors of the buildings and foreground are the transparent watercolor washes I laid in the painting's first stage. They allow the underlying white of the paper to breathe through, in contrast with the reflected light that bounces off the adjacent opaque passages. The result overall is a rich visual interplay of light and color.

COLORED PENCIL AND WATERCOLOR

Vibrant transparent color effects can be created by layering colored pencil over watercolor. This can be done with hatching techniques and, especially on textured paper, by drawing with the tip of the pencil. Hatching leaves the watercolor visible between the pencil strokes; sweeping colored pencil across textured paper deposits pigment on the peaks of the surface, letting the underlying watercolor wash in the paper's recesses show through. Colored pencils are made with wax and cannot be erased, so apply them with care.

Colored pencil gives this illustration its lively quality. The airy feel results from the hatched strokes and the rough texture of the paper, both of which allow the watercolor to shine through.

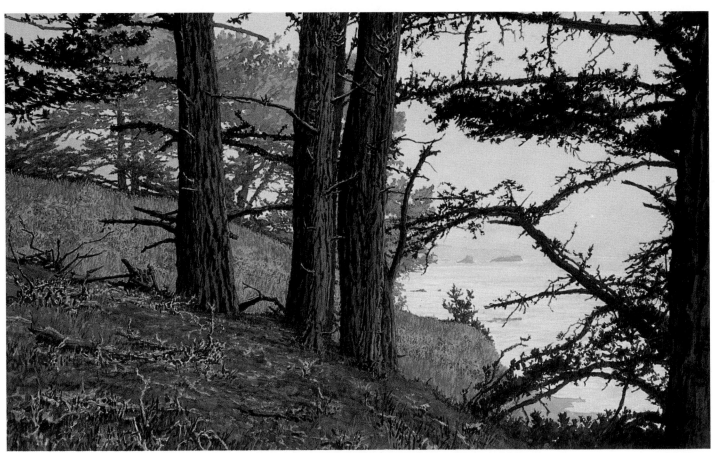

Peter Loftus, TOWARD GREYHOUND, HAZY MORNING.
Watercolor and colored pencil on paper,
24 × 40" (61 × 101.6 cm), 1993.
Courtesy Fischbach Gallery, New York City.

In this painting, transparent watercolor passages are welded together with textural strokes of colored pencil, resulting in a rich, harmonious atmosphere.

PASTEL AND WATERCOLOR

With their sparkling color characteristics in common, pastel and watercolor are particularly well suited to each other. Soft and hard pastels—both of which are water-soluble—can be used in conjunction with watercolor for striking results. Use the tip of the pastel stick to make linear marks, and the side of the stick for wider strokes. Pastel works best on paper that has some "tooth," or texture, which not only helps the dry color adhere but also makes it shimmer optically as the particles cling to the paper's little "peaks." Because of their opacity, pastel colors look darker and denser against a white or light-value ground, but against a middle- to dark-value ground, they appear brilliant. Of course, the color of the ground is as important as its tone, as your perceptual instincts should tell you by now. One of the most exciting grounds you can work on is one prepared with a wash of watercolor; opaque passages of pastel laid over this transparent surface have a beautiful glow. Applying pastel to a watercolor painting adds depth and richness of color and texture, enhancing the overall image.

Here are some of the pastel marks you can use to add color and textural interest to a watercolor painting. Compare the way the colors look against the dark watercolor wash and against the white of the paper. Note, too, how the pastel sits on top of the paper's "peaks," leaving bits of the white or colored background showing through in the "valleys" to contribute a lively, airy quality.

Nell Blaine,
CLOUDS OPENING.
Watercolor and pastel on paper, 18 × 24"
(45.7 × 61 cm), 1981.
Glen C. Janss Collection; photograph courtesy Fishbach Gallery, New York City.

Nell Blaine applied fluid strokes of pastel color to a loose, stainy watercolor to create this cheerfully vibrant interpretation of the landscape.

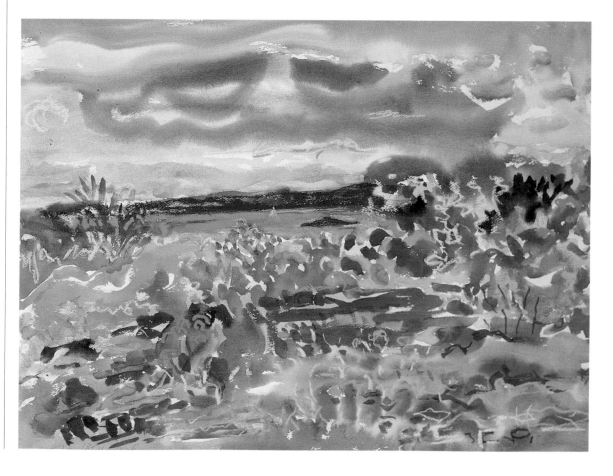

I laid down watercolor first to establish the individual color harmony of these four subjects, then applied pastel over them using a different technique for each. The green apple composition employs a split-complementary harmony of yellow-green and violet plus red-violet and blue-violet; pastel was stroked on in parallel vertical lines of color that blend optically with one another and with the underlying violet and yellow-green watercolor washes. The red tomato against the green background forms a complementary harmony; strokes of analogous pastel colors were applied in spots, optically mixing together in each area. I defined the shape of the orange with a wash of yellow-orange watercolor, surrounding it with a complementary blue wash. I then cross-hatched a range of warm and cool red-violet and blue-violet

pastel strokes over the background, and over the form of the orange I hatched analogous yellows, oranges, and reds along with complementary touches of blue and green. The plum was established with a violet wash and its background with a yellow-green wash, over which I layered analogous opaque colors using the flat side of hard and soft pastel sticks while allowing the watercolor washes to come through for heightened visual effect. Each of these examples illustrates how to combine the two mediums using techniques that weave them into a visually united fabric. Although here I layered pastel over watercolor, it is also possible to apply watercolor on top of pastel to create more organic mixtures; the results, however, are not as transparent and luminous as those yielded by the opposite approach.

DEMONSTRATION

Combining pastel with watercolor can mean layering simple linear notes of opaque color over a transparent, very fluid organic wash. Here, pastel strokes add welcome texture and brilliant light to an otherwise soft and quiet landscape.

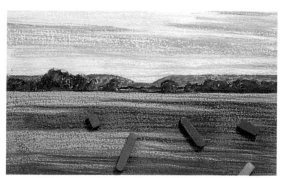

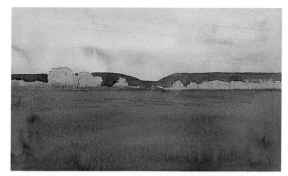

With organic, flowing washes, I established the major landscape patterns and the painting's color foundation.

When the watercolor was completely bone dry, I layered pastel color onto various areas in linear horizontal strokes. Using both hard and soft pastels, I allowed some of the marks to overlap but focused on letting the watercolor underpainting show through.

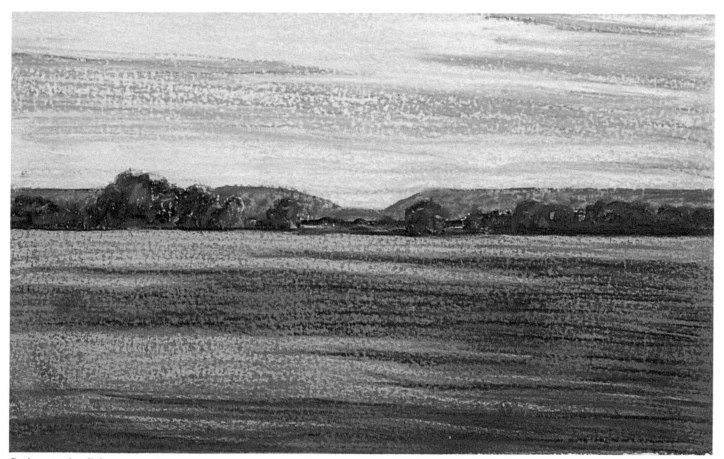

By juxtaposing light, warm colors with cool, dark ones, I established the light and shadow patterns that create the illusion of spatial depth. Note in particular how the warm yellow layered over the cool earth greens sets up a temperature contrast that suggests the feeling of sunlight in the middle ground and makes the foreground come forward in space.

DEMONSTRATION

The lotus, a recurring motif with sacred connotations in ancient Egyptian and Hindu art, is the subject of this demonstration. My idea was to create a watercolor underpainting of water lilies arranged in a pleasing design, then enrich the image visually by interweaving it with layers of pastel color. With the initial wash I established the strong patterns of the composition and its split-complementary harmony of red-violet, yellow-green, green, and blue-green, along with blue-violet.

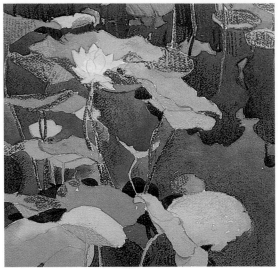

Using the scraping method and horizontal marks, I continued process of stroking on pastel color throughout the water and added greens over the cool blues, along with blue-greens and yellows to enrich the color effects. The pastel interacts with the paper's texture in a way that allows the underlying transparent light and dark greens and brilliant yellows to shine through, giving the surface a luminous, tactile appearance.

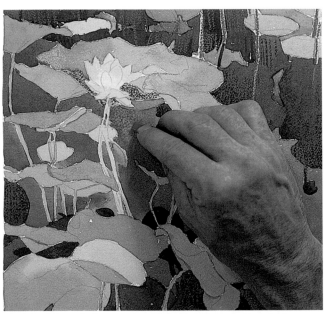

In the diagram to the left of the painting are the watercolor pigments I used; they are, from top to bottom, viridian, permanent magenta, French ultramarine blue, diluted permanent magenta, sepia, permanent rose, Winsor green, cadmium lemon, cerulean blue, aureolin, and, again, Winsor green. Alongside them are various wash mixtures as they look alone and layered over with strokes of analogous pastel colors. I began the painting by laying in the basic patterns and color harmony, flowing watercolor into the various shapes using the organic, wet-on-wet method. I started with the single, red-violet lotus blossom—the composition's main point of interest—and proceeded in turn with the other colors of my split-complementary scheme. When the watercolor was dry, I began to develop the various areas with layers of analogous pastel colors. Here, using the scraping method, I'm stroking hard pastel in a contrasting blue across the water in the background.

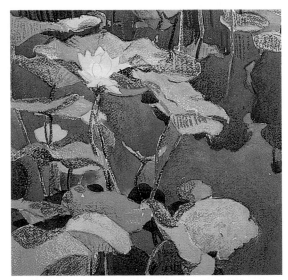

I added warm accents to increase the color's richness, the sense of spatial depth, and the tactile quality of the painting's surface. I applied white to the lower left part of the composition as well as to other areas of the plant forms to heighten their three-dimensional character and convey the feeling of brilliant light.

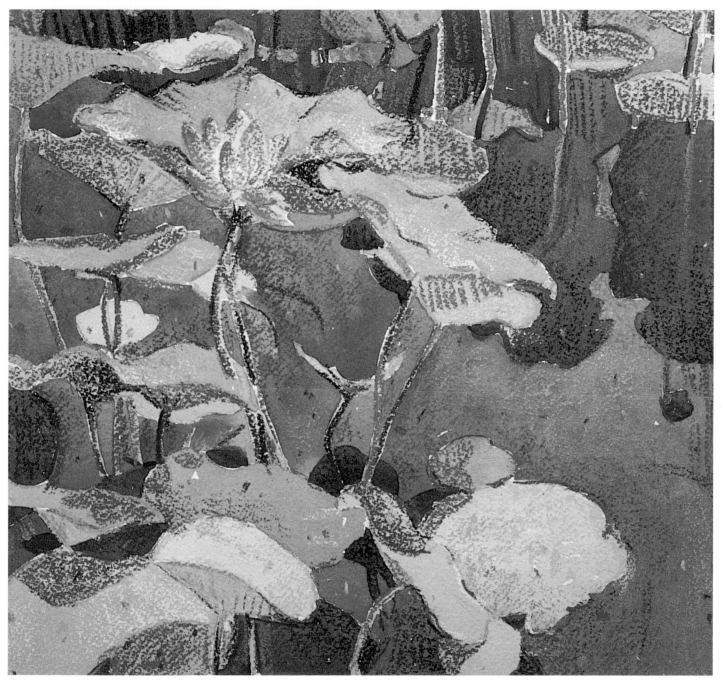

As its subject the lotus is obviously the key focal point of this painting, but note how pivotal its color is to the overall harmony and design of the composition. To further enliven the painting's texture and color relationships, I added complementary touches of orange, violet, blue, and brown pastel throughout, bringing the composition to a satisfying climax.

COLLAGE AND WATERCOLOR

In the medium of collage, bits of cut and torn paper and other materials are arranged and pasted onto a support, and often embellished with other mediums. In the early 20th century, Georges Braque and Pablo Picasso elevated the popular 19th-century French craft of *papier collé* ("glued paper") to a fine-art form that became an important means of serious artistic expression among the early Modernists. The medium continued to evolve, notably in the hands of Henri Matisse, whose colored-paper "cutouts" are among the most beautiful examples of collage ever produced.

Collage requires an eye for spotting artistic potential in everyday materials, and for envisioning how their colors, textures, and shapes might be woven together into a pleasing design. This is not unlike the process of choosing objects to furnish a room or an outfit of clothing to wear. Additionally, collage more often than not incorporates one or several other mediums. Watercolor and gouache, for instance, can be used to create some extraordinary spatial effects; imagine juxtaposing soft, stainy transparent washes with crisp-edged scraps of paper and accenting these ingredients with strokes and spots of opaque paint. The starting point for this kind of work is an intuitive sense of color, for it is what enables you to bring these diverse materials together to create harmonious abstractions.

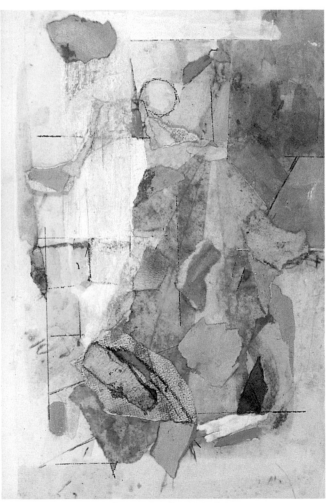

John Heliker, #6 WITH RED AND ORANGE.
Watercolor and collage on paper, 11 × 7¹/₂" (27.9 × 19.1 cm), 1957. Private collection.

John Heliker pasted opaque, textural elements onto his support and combined them with delicate watercolor washes to create visual contrasts within a harmony of pinks, yellows, and blues.

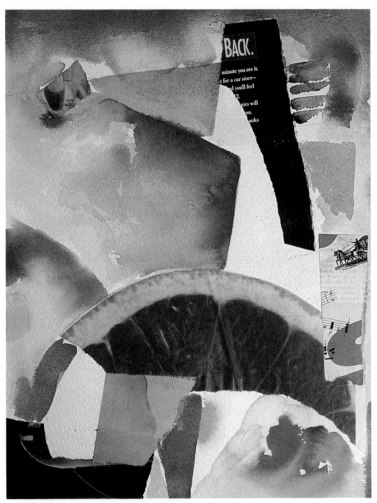

Robert Stortz, UNTITLED.
Watercolor and collage on paper, 16 × 12" (40.6 × 30.5 cm). Courtesy the artist.

Robert Stortz's collage exhibits a strong and playful use of color in the dynamic relationships between the bold, bright cutout shapes pasted onto vibrant, primary-colored fields of transparent watercolor.

DEMONSTRATION

In addition to scraps of variously textured and colored paper, I used watercolor, gouache, and pastel to create the collage for this demonstration. As with any work of art, you must pay constant attention to color, design, and visual purpose.

Before beginning to assemble my collage, I played with various scraps of colored paper and paint application techniques to determine the composition's color chord. Here, the underlying wash, which I painted wet-on-wet, is an analogous harmony of yellow, orange, and red. Superimposed on this backdrop are blue and violet paper scraps that are complementary to it. The sponge, toothbrush, and stencils are tools I used in applying paint to create textured layered effects and brilliant spots of wash.

I taped all four edges of my paper to the painting board and thoroughly wet its surface with water; then, working from left to right, I laid in analogous colors starting with yellows and touches of green, following these with oranges and reds and allowing the pigments to mingle organically.

When the paper was dry, I removed the tape, revealing the organic wash that serves as the background and basic color harmony for the abstract design I will build on it. I laid down the first of several stencils at left and, using a toothbrush dipped in paint, began to spatter color onto the selected area by dragging my thumb across the bristles. This technique allows me to create subtle, transparent structural effects with sharp and soft edges.

Here you can see the finished background, with all of the spattered shapes in place. Note how they create a sense of spatial structure.

I began to respond to the stenciled background patterns by placing the first collage shapes on the surface. I arranged these torn bits of paper, which are analogous in color, according to their visual weight, tying them in with the stenciled shapes to further define the organization of the design and its spatial structure. Before gluing down any collage elements, you should move them around until you understand their visual impact; only then should you secure them to the background and continue with the rest of the composition.

Adding complementary elements that interact with the yellows, oranges, and reds initiates color expression and depth. The contrasting touches of paint on the edges of the textured yellow and blue scraps at right enliven the design and augment the surface richness.

Here, you can see how I add accent colors to the borders of a collage element to excite the color within and to stimulate the visual effect of the paper scrap's torn edge.

I added this piece of painted paper to the lower middle part of the composition, creating a balance with the blue-violet collage element above it and contributing further textural interest.

In the upper right-hand corner I glued a smooth, painted blue collage element onto the surface and placed a small, textured red scrap over it to extend the color harmony of the design as well as add further texture.

I laid a curved stencil along the top of the composition and, using a sponge dipped in red paint, dappled color onto the paper, adding more texture to the design. Touches of gouache were added throughout as well, often as complementary color accents to stimulate the overall visual activity of the composition.

To bring the collage to completion and tie its color harmony and textural elements together, I added more bright touches of opaque gouache for contrast, as well as a few quick strokes of pastel color. The result is a very animated surface.

LIST OF SUPPLIERS

The most obvious source for watercolor paints, brushes, paper, and other materials is your local art-supply store. If you can't find a particular product or brand in stock, chances are your supplier will be able to order what you need from the appropriate dealer or directly from the manufacturer. But to learn more about the range of materials discussed in this book and even discover new ones, particularly specialty papers, try the following dealers, many of whom produce very useful and informative catalogs.

Daniel Smith Inc., 4130 First Avenue South, Seattle, WA 98134-2302. Toll-free: (800) 426-6740. This large art materials supplier has a store in its home city but is probably better known for its very handsome, lavishly illustrated mail-order catalog. Besides selling the wares of a range of manufacturers, this firm makes and markets its own superb product lines, including watercolor paints, mediums, brushes, palettes, easels, and more. Daniel Smith is also renowned for carrying one of the widest selections of quality papers, including hard-to-find large sizes and handmades.

Fostport, Inc., 65 Eastern Avenue, Essex, MA 01929. (508) 768-3350 or (508) 768-6164. This American firm imports the Russian-made Yarka line of art materials, including watercolor paints, remarkably inexpensive sable brushes, and palettes. Call to learn where Yarka products are distributed in your area.

The Italian Art Store, 84 Maple Avenue, Morristown, NJ 07960. Toll-free: (800)643-6440. The Italian Art Store sells a broad range of the finest artists' materials from around the world at substantial discounts, including Winsor & Newton, Schmincke, Holbein, and Rowney watercolor paints, Lana and Fabriano papers, and Raphael and Isabey brushes. Call for a free catalog.

New York Central Art Supply Co., 62 Third Avenue, New York, NY 10003. Retail store: (212) 473-7705. Telephone orders: in New York State, (212) 477-0400; elsewhere, toll-free (800) 950-6111. This art-supply firm has an exceptionally well informed staff and is known for helping artists find anything they might need, whether the product is in stock or not. Its paper department is internationally famous. Besides carrying a wide variety of high-quality materials in its retail store, New York Central sells through its two catalogs, one devoted to studio supplies and the other to papers.

Pearl Paint, 308 Canal Street, New York, NY 10013. Toll-free: (800) 221-6485. This large art-supply chain offers a wide variety of quality artists' materials at discount in its main New York and branch stores and through its exhaustive catalog. Pearl is a good source for sometimes hard-to-find brands such as Schmincke and Sennelier, and it carries the Russian-made Yarka products.

Savoir-Faire, P.O. Box 2021, Sausalito, CA 94966. (415) 332-4660. Savoir-Faire is America's principal importer of French-made Sennelier products, including watercolor paints. It also imports Isabey brushes and Lana papers.

INDEX

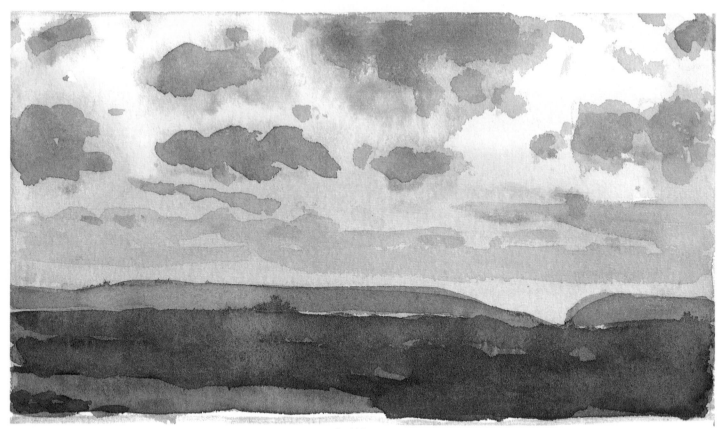

David Dewey,
DELAWARE WATER GAP, SUNSET.
Watercolor on paper,
4 × 7" (10.2 × 17.8 cm).

Editor: Marian Appellof
Designer: Areta Buk
Graphic Production: Ellen Greene
Text set in Caslon 540